PHOTOGRAPHS FROM DETROIT, 1975–2019

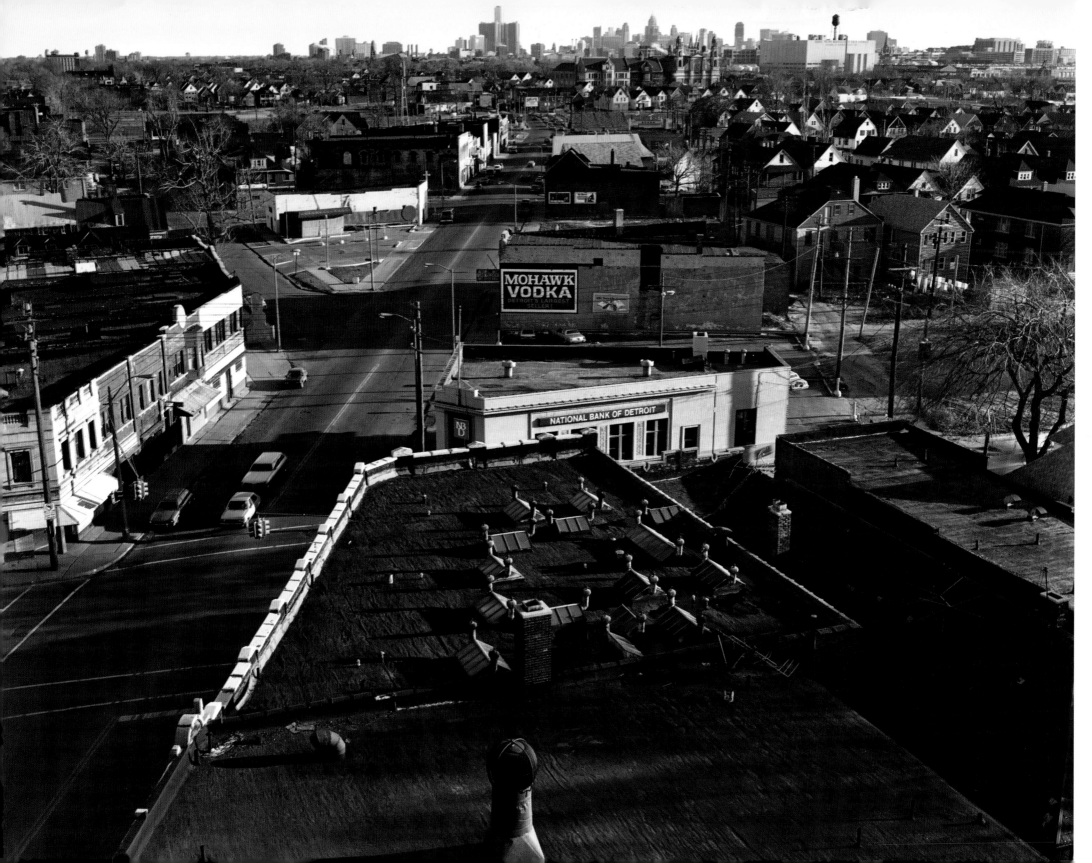

PHOTOGRAPHS FROM DETROIT

1975-2019

Bruce Harkness

edited by John J. Bukowczyk

SWALLOW PRESS / OHIO UNIVERSITY PRESS · ATHENS, OHIO

Swallow Press
An imprint of Ohio University Press, Athens, Ohio 45701
ohioswallow.com

To obtain permission to quote, reprint, or otherwise reproduce or distribute material
from Swallow Press / Ohio University Press publications, please contact our rights
and permissions department at (740) 593-1154 or (740) 593-4536 (fax).

Paperback ISBN: 978-0-8040-1238-6

Printed in China
Swallow Press / Ohio University Press books are printed on acid-free paper ∞ ™

30 29 28 27 26 25 24 23 22 5 4 3 2 1

Library of Congress Cataloging-in-Publication Data

Names: Harkness, Bruce (Bruce L.), photographer. | Bukowczyk, John J., 1950– editor, writer of introduction.
Title: Photographs from Detroit, 1975–2019 / Bruce Harkness ; edited by John J. Bukowczyk.
Description: Athens, Ohio : Swallow Press, [2022]
Identifiers: LCCN 2021050771 | ISBN 9780804012386 (paperback)
Subjects: LCSH: Photography—Michigan—Detroit. | Detroit (Mich.)—Social life and customs.
Classification: LCC F574.D443 H375 2022 | DDC 770.9774/34—dc23/eng/20220323
LC record available at https://lccn.loc.gov/2021050771

publication supported by a grant from

The Community Foundation for Greater New Haven

as part of the Urban Haven Project

To Gregory Pace

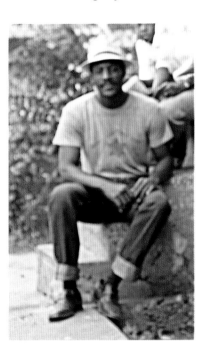

Contents

Preface

I am not sure why I chose to be a camera operator. I was never much of an equipment guy, not much interested in discussing cameras, lenses, filters, or, later, megapixels. I was never big on technique and felt no compulsion to make the perfect print. I struggled with the business aspects of photography. In a 1977 Center for Creative Studies (CCS) student exhibition, I priced my prints at twenty-five cents apiece and was thrilled when they all sold. Although I like to travel, I did not travel to photograph. Distant, dramatic, or exotic subject matter may be compelling, but it would not have magically made me a better photographer. Except for several opportunities I had to photograph well-known musicians, I generally eschewed celebrity subjects. I never referred to myself as an artist, nor did I care if what I produced was art. I often found as much beauty and mystery in a family photo album as I found in an art-photography gallery. Photographic prints do not need to be big to touch the soul.

When Walter Farynk, instructor of studio photography and lighting at CCS in the 1970s, would arrive at his classroom, one of the first things he would do was write a phrase on the chalkboard, food for thought for his students. One, easy to remember, was "The harder I work, the luckier I get." Good, solid advice, and often true. One morning when I arrived, the board was blank, so I wrote a quote from a book I had recently read: "The thing that is important is the thing that is not seen." When Walter arrived, he read it and smiled with knitted brow, and a few of us present at the time briefly pondered what relevance these words could have to a visual medium.

I acknowledge and thank John J. Bukowczyk for all he has done, and done for me, these past thirty-seven years. The day we met was a good day, much like other days of that time, but I know now what a very special day it was. Thank you also to Zlatan Sadikovic for that small table at the Oloman Cafe in Hamtramck where John and I plugged in my laptop, spread our photos and papers, and, coffee in hand, assembled this book. Thank you, Barbara, my wife, for your suggestions and support throughout this process. You have helped me more than you may know.

Bruce Harkness

Acknowledgments

Bruce Harkness's photography has been supported by the Michigan Council for the Humanities, National Endowment for the Humanities, Michigan Council for the Arts, National Endowment for the Arts, Ohio Arts Council, Detroit Council of the Arts, Arts Foundation of Michigan, and various units and offices of Wayne State University, including the Department of History, the Office of Research, the Humanities Council and the Humanities Center, the College of Liberal Arts and Sciences, and the College of Urban, Labor, and Metropolitan Affairs. Support from these sources is gratefully acknowledged. We also wish to express thanks to the staff at Ohio University Press, in particular Beth Pratt, interim director; Tyler Balli, editorial coordinator and our copyeditor; Sally R. Welch, acquisitions administrator; and Jeff Kallet and Laura André of marketing for their thoughtful and professional work in publishing this book. We also thank the Swallow Press board, who saw value in this work, and to the two anonymous readers who supported its publication.

Introduction

John J. Bukowczyk

In 1976, Bruce Harkness, a college kid from semirural Brighton, Michigan, discovered America. Of course, when Bruce, as a photography student, began wandering the streets of Detroit with his camera, Detroit—and, more particularly, his urban piece of it—was not lost, except insofar as all of America's Rust Belt cities and neighborhoods were lost in the late twentieth century. But for Bruce, new to the city and to its streetscapes, it was a New World, and there he also discovered his socially conscious—some now would say "woke"—artistic self that became and has remained the heart and soul of his work in documentary photography.

Bruce was born in 1953, the fourth son of a Canadian-born father, a tradesman of decidedly progressive political sensibilities, and a Hoosier mother who was, as Bruce described her, "smart and strong-willed." Bruce's nondescript, exurban, small-town upbringing perhaps attuned him to an appreciation for his natural surroundings, and natural elements, in understated ways, run through many of Bruce's photographs. It is hard to divine what influences endowed him with a natural sympathy for ordinary people, heroic and dignified amid their own private, anonymous, personal struggles. Bruce attributed it to just something in his nature.

After short stints at Michigan State University and Oakland Community College, Bruce enrolled at the Center for Creative Studies—College of Art and Design (CCS) in 1974,[1] and study there channeled his social and artistic sensibilities. Under the mentorship of several CCS faculty,[2] Bruce encountered the work of Jacob Riis, Eugène Atget, Walker Evans, Helen Levitt, Diane Arbus, Roy DeCarava, and the Farm Security Administration photographers and developed an interest in social documentary and urban street photography. "I was not apprehensive about exploring the city on my own during those years," Bruce remarked. It was during this time that he engaged in two years of intermittent photographic work at the Niagara Apartments, a run-down apartment building in the Cass Corridor that was a last stop for many down-and-out Detroiters who made up a portion of that Rust Belt city's destitute underclass.[3]

Bruce graduated from CCS in 1978. In 1981, uninterested in either commercial photography or photojournalism and without a clear career direction, he entered the MFA program in photography at Wayne State University. During the first year in the program and upon the suggestion of Nick Valenti,[4] a student colleague, Bruce and Valenti photographed in the Poletown area of Detroit, that portion of Detroit's old east side that was selected for demolition to make room for the new Central Industrial Park, which would house General Motors' new Cadillac assembly (Poletown) plant.[5] Bruce made ninety visits to the area

between February and November 1981, documenting homes, street scenes, and the process of demolition. In 1982, Bruce photographed in the Woodbridge area of the city and along Grand River Avenue heading downtown, west of the Wayne State campus, where Bruce was now living. This combined work became the basis for Bruce's final review in the Wayne State MFA program, and he was awarded the degree in 1982.

From 1983 to 1986, Bruce served as a part-time instructor of photography at Henry Ford Community College in Dearborn, Michigan, teaching introductory courses in black-and-white photography, his specialty, and also working as a black-and-white darkroom technician in several Detroit commercial photography studios. During this time, Bruce met Bill Schwab, who later became the photographer for the City of Dearborn. After Schwab left the city job (after five years) and Bruce had moved from Detroit to Dearborn, Bruce was appointed to the same position, one he held for twenty years, until 2010, when he retired.

It was while Bruce was still living in Detroit that I met him. I was then an assistant professor of history at Wayne State University and was advising a doctoral student whose daughter, photographer Carla Anderson, had attended CCS with Bruce. Through Carla, we became acquainted. As a specialist in Polish American history working on a study of Poletown,[6] I was interested in Bruce's Poletown work, so we teamed up to mount an exhibition of Bruce's photographs at the Purdy/Kresge Library on the Wayne State campus in 1986.[7] Shortly thereafter I proposed to Bruce that we collaborate on a large oral history and documentary photography project on Detroit's east side. From 1987 to 1990, under the auspices of what we called the Urban Interiors Project, Bruce photographed neighborhood residents in their homes and we both conducted interviews with them.[8]

Since the 1970s, Bruce has shown work from these and other smaller photographic studies at numerous venues throughout metropolitan Detroit, including in several one-person shows. But after he started working full-time in 1990, there was little time left for urban street photography. Nonetheless, Bruce did produce a vast body of "official work" during these years while in the employ of the City of Dearborn and has continued to take pictures on his own, including in Detroit's Brush

Park area, in the Zone Coffee House near the former Dearborn City Hall, and in various blues venues in and around Detroit. Bruce's photographs in the Arab American community in Greater Detroit appeared in exhibitions at the National Museum of American History (Smithsonian Institution) in Washington, DC (1995), and at the Michigan State University Museum in East Lansing (1998).[9] In addition to supplying individual photographs for various publications, Bruce also provided all of the photographs for two book projects. The first of these was Lois Johnson and Margaret Thomas's *Detroit's Eastern Market: A Farmers Market Shopping and Cooking Guide*.[10] The second was L. Glenn O'Kray's *Before Fair Lane: Historic Houses from Henry Ford's Hometown, Dearborn, Michigan (1832–1916)*, which won a Historical Society of Michigan State History Award in 2018. The photos in both books, but especially those in *Detroit's Eastern Market*, were still street photography of a sort. But wandering the streets and snapping photographs Bruce has, for the most part, left behind.[11]

Some may accuse documentary photographers of being exploiters. They take and commodify images of their subjects, turning subjects into objects and in the process stealing their privacy and portions of their lives. The moral ambiguities in the relationship between photographer and subject/object, particularly when that photographer sometimes befriends his subjects while claiming a social consciousness, create perplexing moral and ethical dilemmas. What to shoot? With what level of participation and acquiescence on the part of the subject? How to present—or disseminate—the images? These dilemmas extend to social scientist collaborators, exhibition organizers, archival curators, and book editors and publishers when they collaborate with contemporary documentarians. In collaborating with photographers, they too may be accused of becoming exploiters of the living, while their work focusing on the past can exploit the lives and memories only of the dead.

These issues become all the more complicated in America, with its history of racial inequality, when the subjects are African American, as many are in Bruce's work, and the photographers and interpreters are white. In many ways, though, Bruce's work is the empathetic product of a guileless curiosity. The images Bruce made were less taken than

given through the open and generous cooperation of subjects who allowed themselves to be photographed, who seemed to intuit, just as Bruce himself showed he believed, that the central imperative of multiculturalism is showing an interest in other cultures and in crossing cultural borders and racial boundaries.

In the end, the work of documentarians and their associated collaborators and facilitators aspires to more fundamentally humane goals that transcend the dynamics of race and class. Documentary photographs give voice to the voiceless. They record and thereby ennoble the wonderful, ordinary human lives simply lived for their own sake. They freeze in time places and people that the passage of time and the engines of change remake or efface. They are a record of our collective days, our society, and our civilization, in which all things are ephemeral. For the subjects photographed, the photos affirm: We were here. For the photographer, too, the photographs say: I was here. The often anonymous photographer must be eternally respectful of and grateful to the individuals photographed, whose collaboration enables these existential assertions.

The arrangement of the photographs in a collection such as this also is fraught with methodological and ethical issues. Although the final decision on all content was Bruce's, he and I together selected the photographs for this volume based upon several considerations, including classic artistic criteria like technical aspects of the photographs, composition, content, and balance of subject matter. We reviewed the body of Bruce's work and went through successive cuts, finally selecting photographs that one or both of us simply liked (or, for Bruce, images that held special resonance or meaning). We were mindful, though, that what we judged a "good" or "compelling" image may really be just a photograph that fits the template of what a documentary photograph is *supposed* to look like.

We also decided to organize the photographs into sections, arranged in roughly chronological order, thus grouping photographs from the larger studies or projects—Cass Corridor (12–35), Poletown (36–65), Urban Interiors (72–131), Brush Park (132–137), Detroit blues (142–145), Concert of Colors (146–151), and Zone Coffee House (152–159)—with miscellaneous images from Bruce's career placed between these more discrete sections. Within each section, we have tried to keep related subjects

together, although we have sought to pair photographs on facing pages with an eye toward composition and visual balance.

Within these rather commonplace parameters, we nonetheless encountered issues of selection and presentation that underscore the subtleties of subjectivity, bias, and perspective in photography as a representational medium. For example, in a book of Detroit photographs, we included the image of a burning car on a street at night (photo 71), tempting the racialized associations such images may invoke in white viewers who recall the Detroit riot—the urban insurrection—of 1967. Here we aim to challenge viewers to examine their preconceptions and prejudices, as the image is in fact one of a car set ablaze by a crowd of likely white suburban revelers following the victory of the Detroit Tigers in the 1984 World Series. Likewise, in juxtaposing images of a street-worn Black man (photo 34) and a young white girl (photo 35), we perhaps entice dark speculations and racially charged surmises about a man who in fact was only candid and open with Bruce, whom he did not know, and who seemed, at worst, just down on his luck.

We alternatively might have paired the young white girl (photo 35) with a young Black boy (photo 68), as both figures, positioned on staircases, could be thought of as parallel images. Or the young Black boy (photo 68) and the older Black woman (photo 57), whose poses make these into parallel images of a different sort. But we pointedly rejected these pairings so as to avoid suggesting the "universality" or "commonality" of the human experience, irrespective of race, gender, or age. To the contrary, we believe in the situation and context specificity of such photographed moments in time and also that in America the dynamics of race and class are pervasive and, in a social and economic sense, determinative.

I am deeply grateful to Bruce Harkness for agreeing to assemble his work in this book and then for inviting me to edit it. I met Bruce when we both were young, when we both believed that right beats might and that anything was possible. My now almost forty-year association with him has been one of the most valuable chance discoveries of my own seventy-plus years of life. Alas, I no longer think that the good will triumph or that there is an infinite number of sunrises and tomorrows. Bruce still believes.

NOTES

1 Until 1975 it was still the Art School of the Detroit Society of Arts and Crafts. In 2001 it became the College for Creative Studies.

2 The faculty included Walter Farynk, George Phillips, William Rauhauser, Richard Timm, and Robert Vigiletti.

3 Selections from Bruce's work at the Niagara Apartments were published in the *Detroit Free Press Sunday Magazine*, November 12, 1978, 22–23, 26–27, 30–31.

4 Valenti later became head of the Department of Photography at the Orchard Ridge Campus of Oakland Community College.

5 For the background and context of the Central Industrial Park redevelopment project, see John J. Bukowczyk, "Decline and Fall of a Detroit Neighborhood: Poletown vs. G.M. and the City of Detroit," *Washington and Lee Law Review* 41 (Winter 1984): 49–76.

6 See *Poletown: Urban Change in Industrial Detroit: The Making of Detroit's East Side, 1850–1990*, historical monograph prepared for the Community and Economic Development Department, City of Detroit (1991).

7 Bruce subsequently donated a large selection of prints from the project to Wayne State University's Walter P. Reuther Library. Samples of Bruce's work from the Niagara Apartments and Poletown were later selected for inclusion in *Detroit Images: Photographs of the Renaissance City* (Wayne State University Press, 1989), a photographic volume organized by me and CCS faculty member Douglas Aikenhead.

8 Another spin-off of the Urban Interiors Project was a series of workshops, conducted in Detroit schools in 1989, organized around the twin themes of family and community. The Families of the City Project, also grant funded, produced two booklets, posing the questions "What is a family?" and "What is a community?" The project director of this Urban Interiors Project spin-off was associate professor Nora Faires of the University of Michigan-Flint, my then partner and collaborator. See Nora Faires, with photographs by Bruce Harkness, "What Is a Community? Taking Documentary Photographs of Urban Americans into the Middle School Classroom," *OAH Magazine of History* 10, no. 4 (Summer 1996): 73–77.

9 Some of these images were published in Nabeel Abraham and Andrew Shryock, eds., *Arab Detroit: From Margin to Mainstream* (Wayne State University Press, 2000).

10 Lois Johnson and Margaret Thomas's *Detroit's Eastern Market: A Farmers Market Shopping and Cooking Guide* (Johnson Book Print & Binding, 1999; Painted Turtle Books, 2005; Wayne State University Press, 2016) has gone through three editions.

11 In 2001, Bruce married Barbara Krol, and the two reside together in Dearborn. Bruce retired from full-time employment in 2010 but continues to freelance and exhibit his photographs in Detroit and suburban locations.

PHOTOGRAPHS FROM DETROIT, 1975–2019

Annotations to the photographs can be found
in the "Photographer's Notes" section.

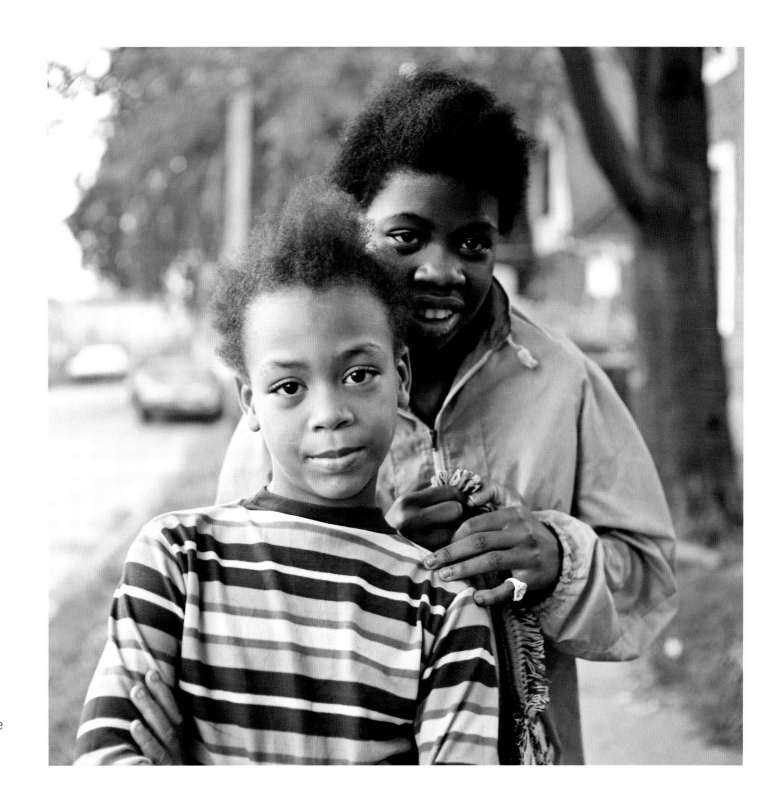

1. Two girls near Ste. Anne Street, ca. 1975

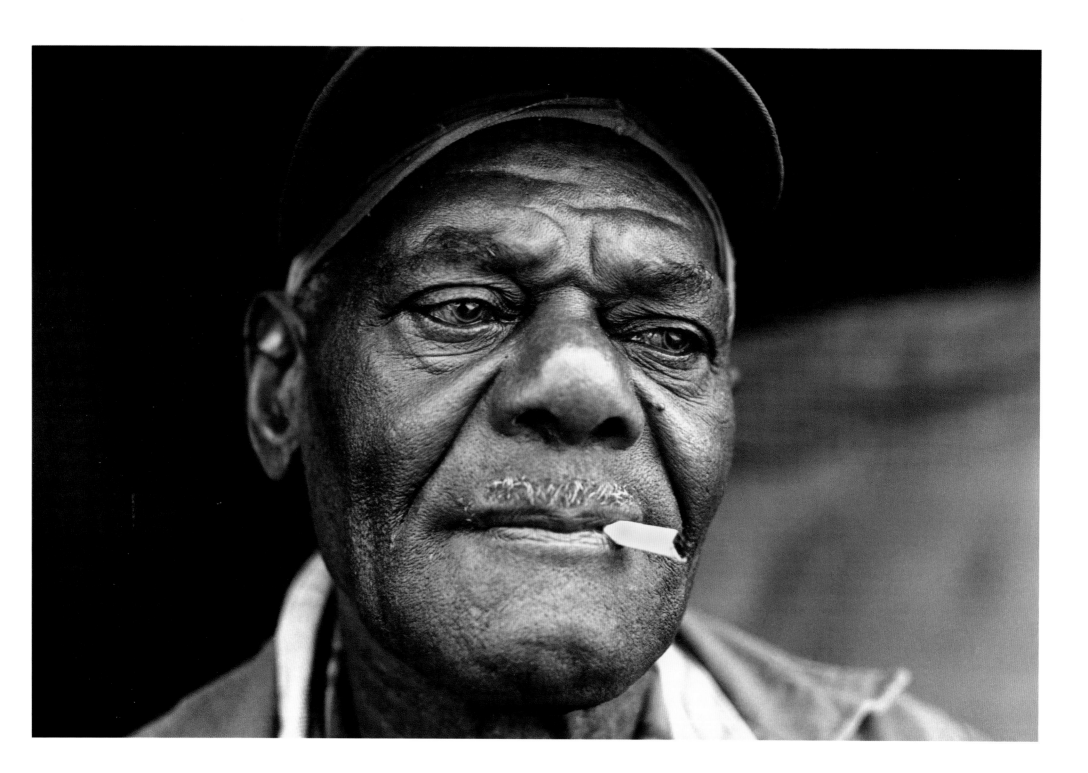

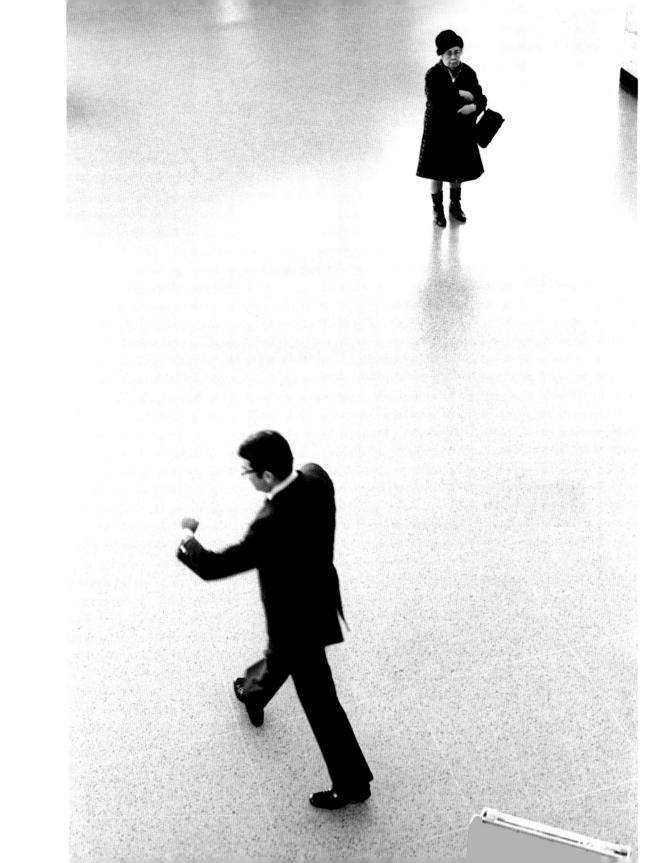

2. (*l*) Man with cigarette, John R Street, ca. 1975

3. (*r*) At Detroit Metropolitan Airport, ca. 1976

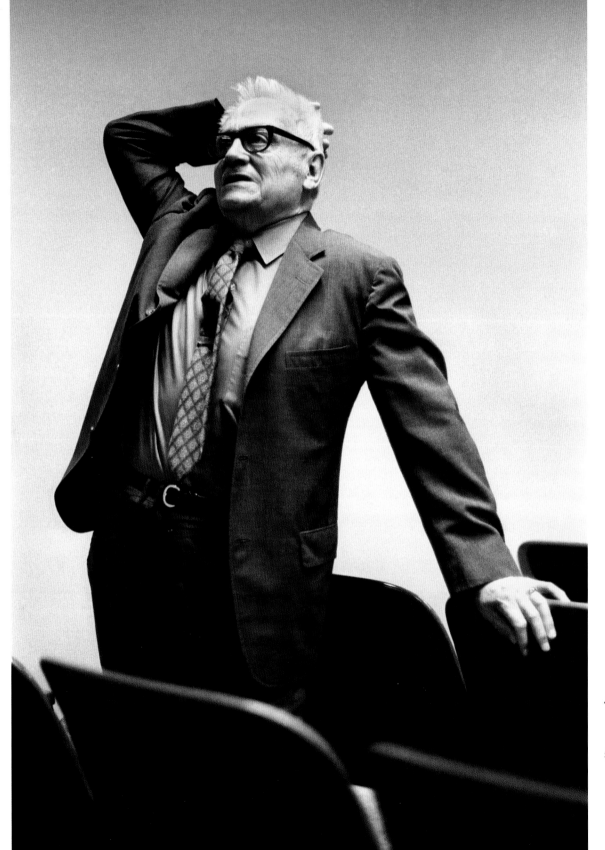

4. (*l*) Professor Raymond Hoekstra, Center for Creative Studies, ca. 1976

5. (*r*) Darryl (*left*) and John, Renaud Apartments, Selden Street, ca. 1979

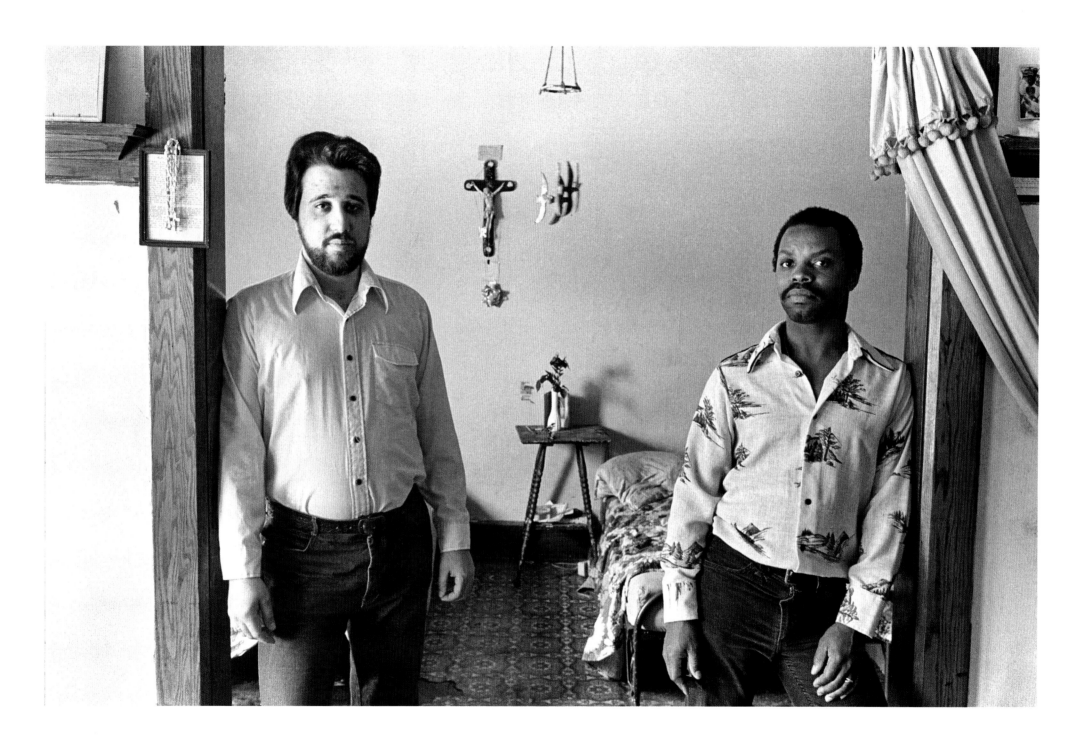

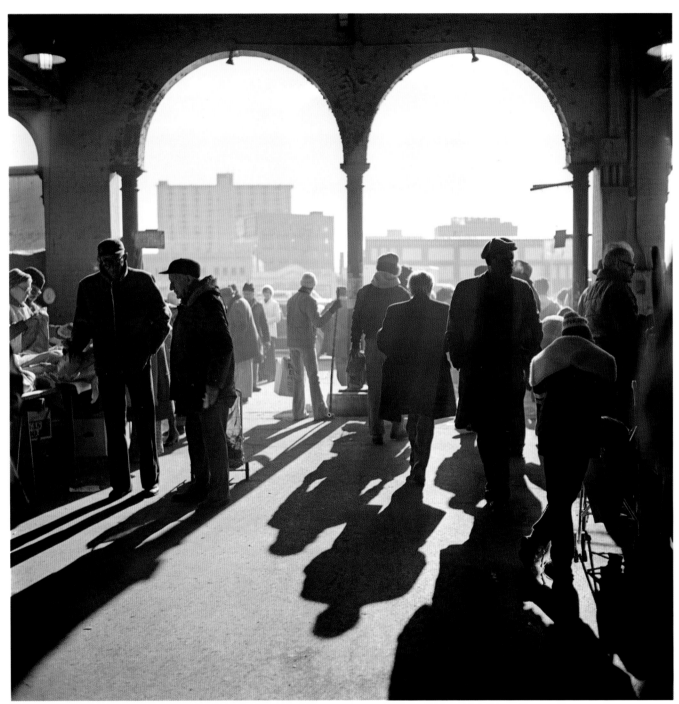

6. (*l*) Eastern Market, ca. 1977

7. (*r*) Detail from Eastern Market Lounge sign,
 Adelaide Street at Riopelle Street, ca. 1983

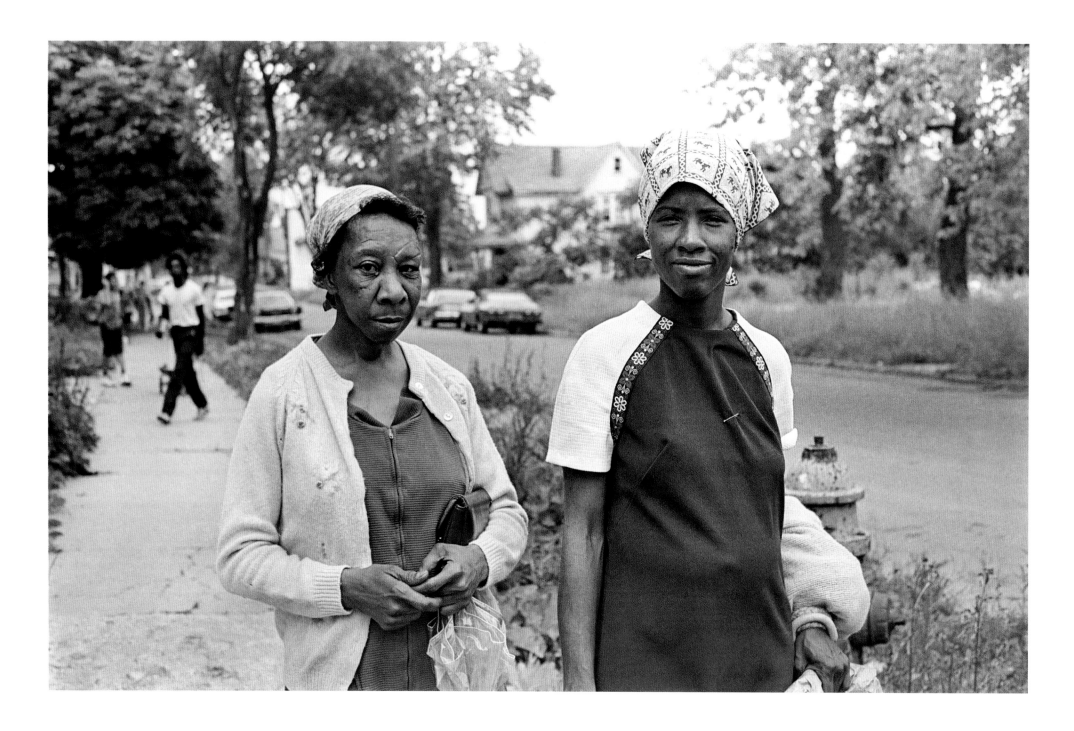

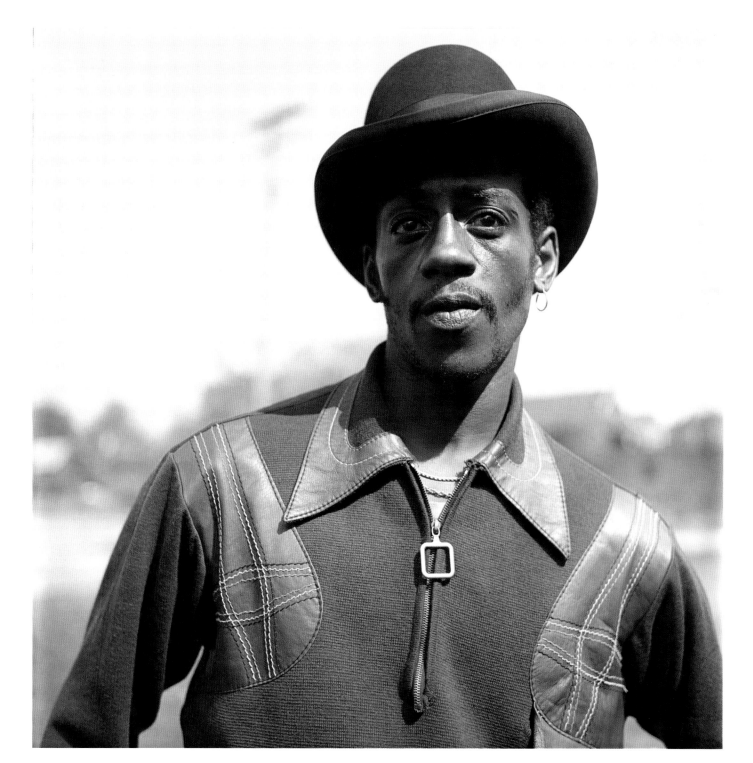

8. (*l*) Two women near Buchanan and
 Fifteenth Streets, ca. 1982

9. (*r*) Man with earring, near Buchanan
 and Fifteenth Streets, ca. 1983

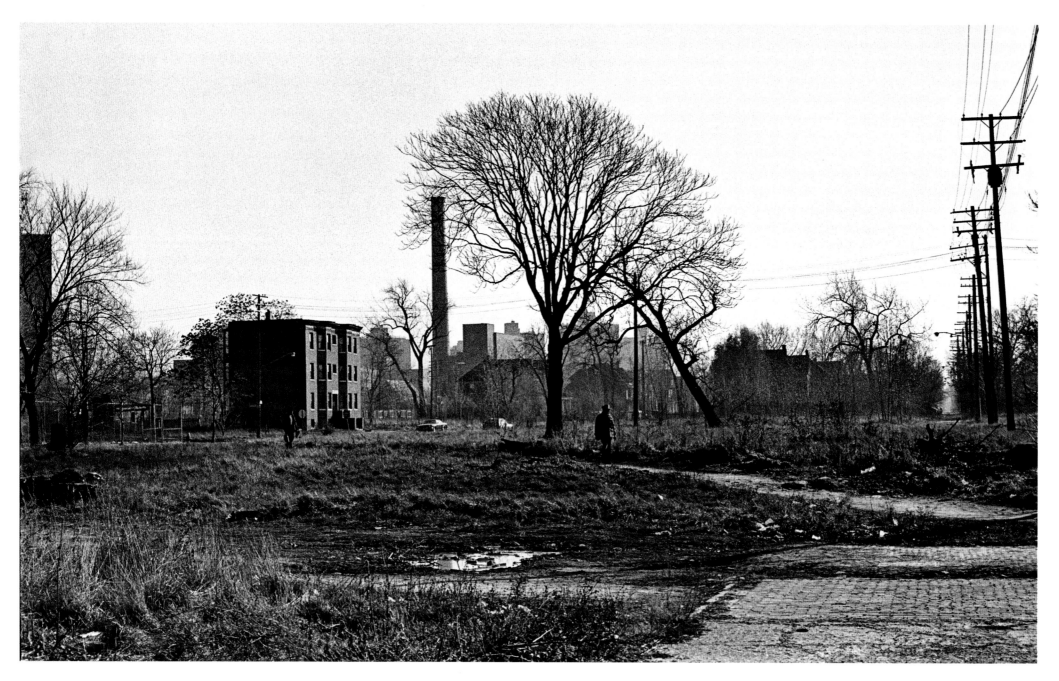

10. Looking southeast from Lysander Street, ca. 1981

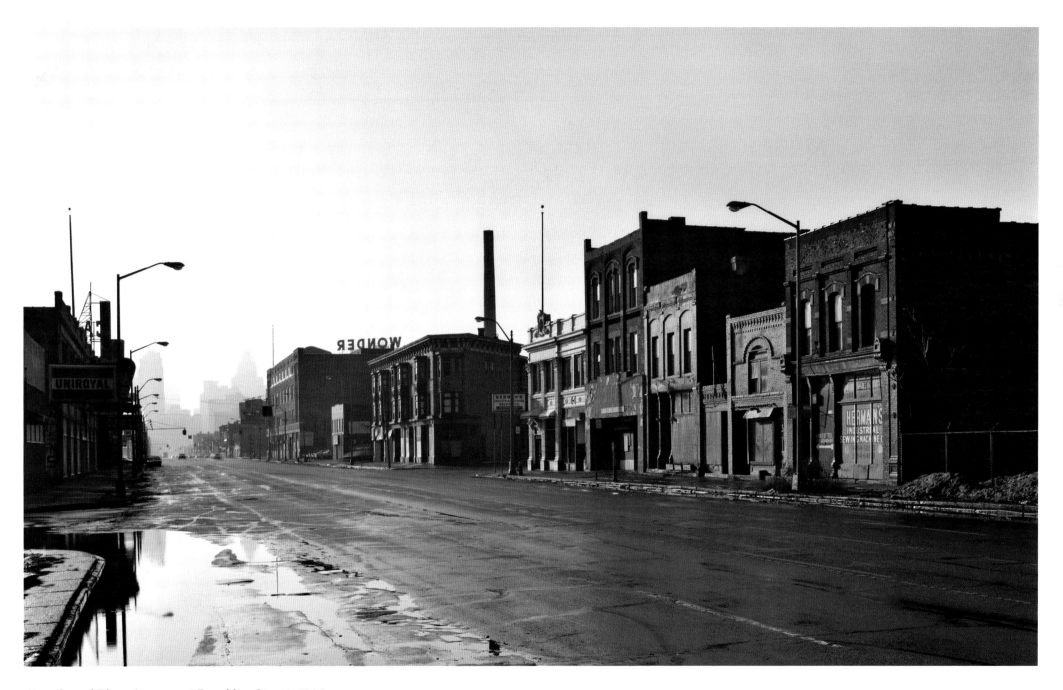

11. Grand River Avenue at Brooklyn Street, 1982

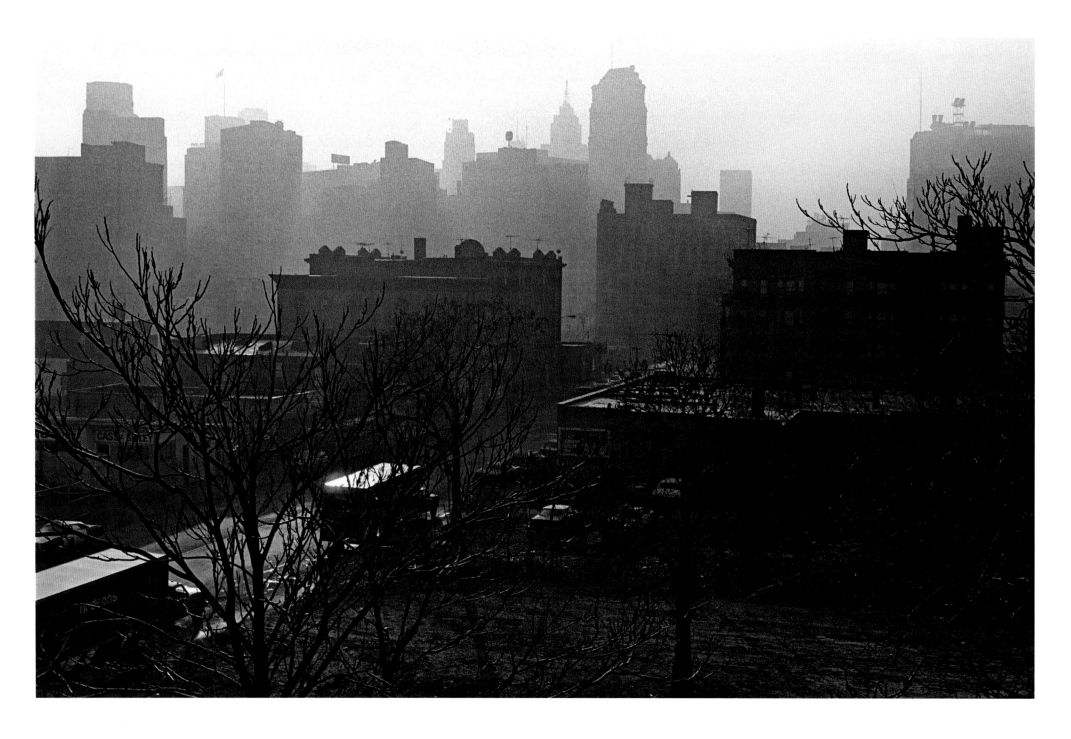

12. (*l*) Looking south from Cass Avenue near Temple Street, ca. 1980 (Cass Corridor)

13. (*r*) Man on Third Avenue, ca. 1976 (Cass Corridor)

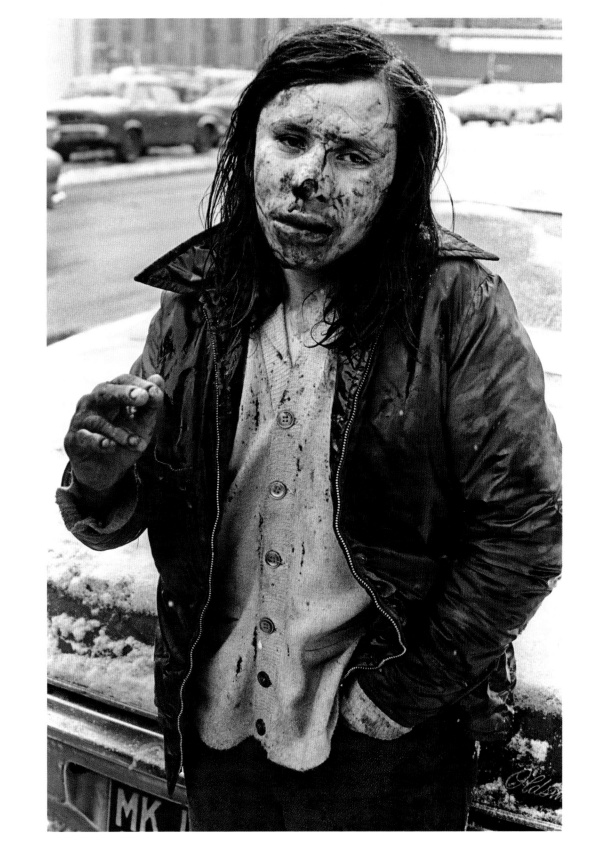

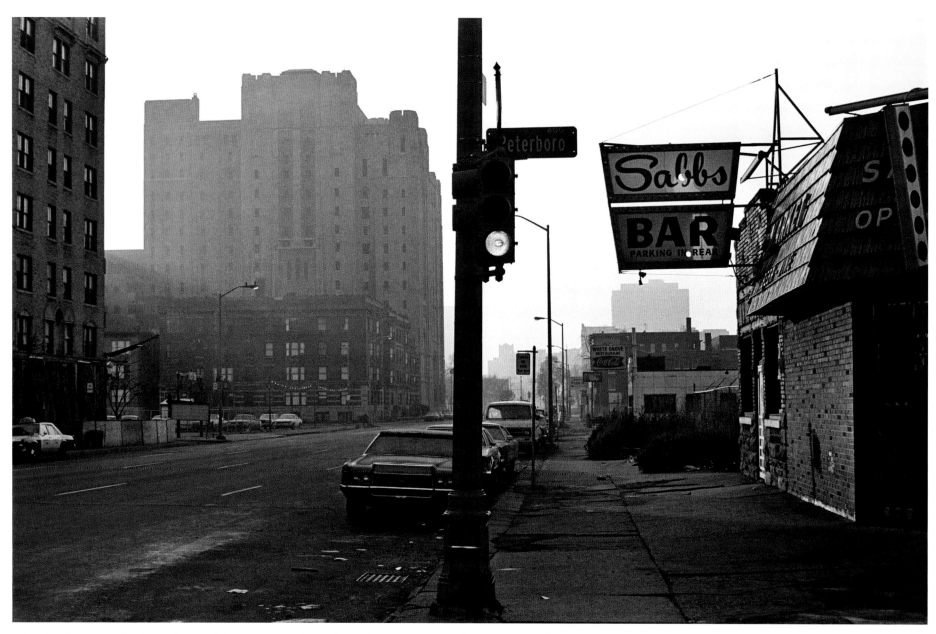

14. Looking south along Second Avenue near Peterboro Street, ca. 1980 (Cass Corridor)

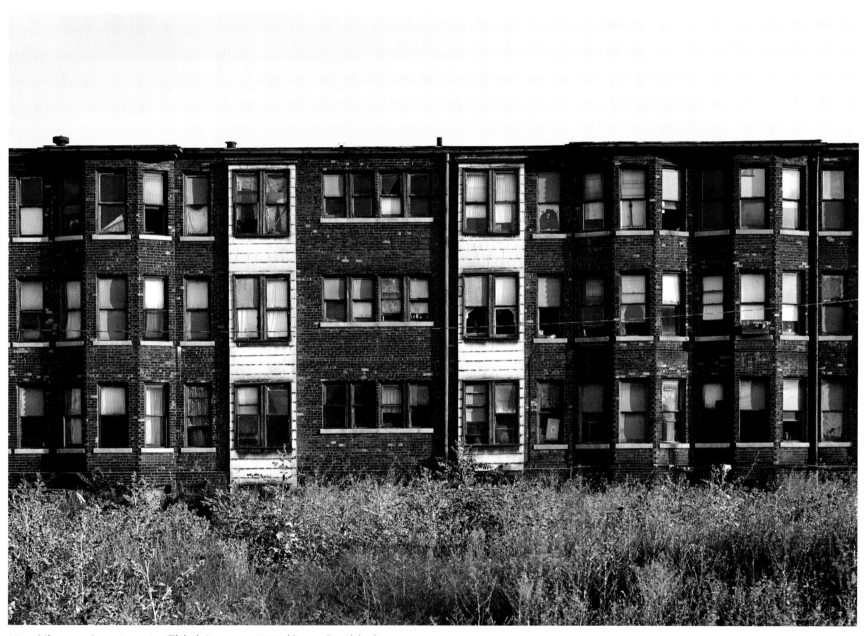

15. Niagara Apartments, Third Avenue, 1978 (Cass Corridor)

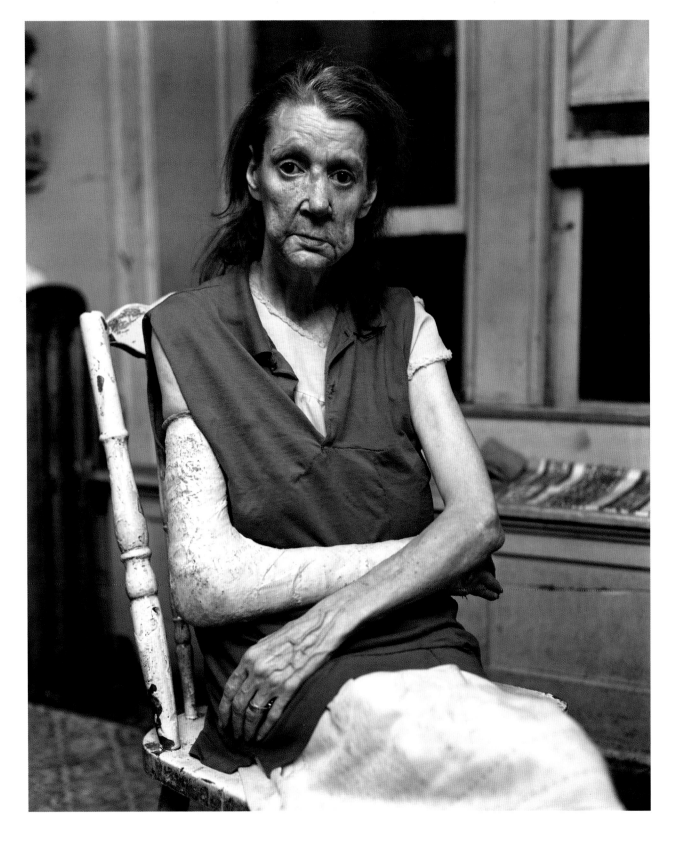

16. Mary Caffery, Niagara Apartments, 1978 (Cass Corridor)

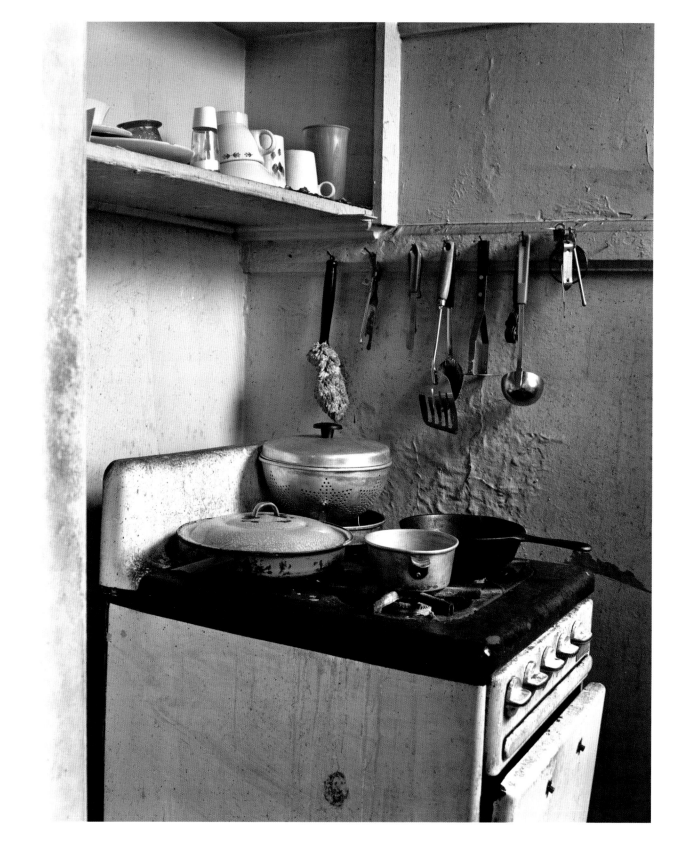

17.	Kitchen area, Mary Caffery's
	apartment, 1978 (Cass Corridor)

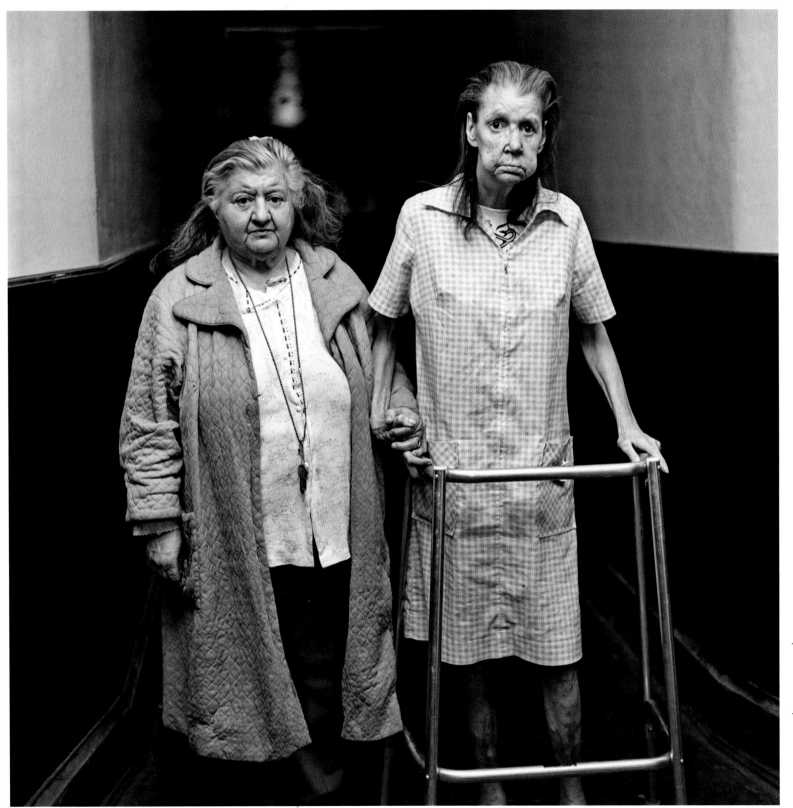

18. (*l*) Rosie and Mary, Niagara Apartments, 1977 (Cass Corridor)

19. (*r*) Marilyn Tribble and Don Mason, Niagara Apartments, 1977 (Cass Corridor)

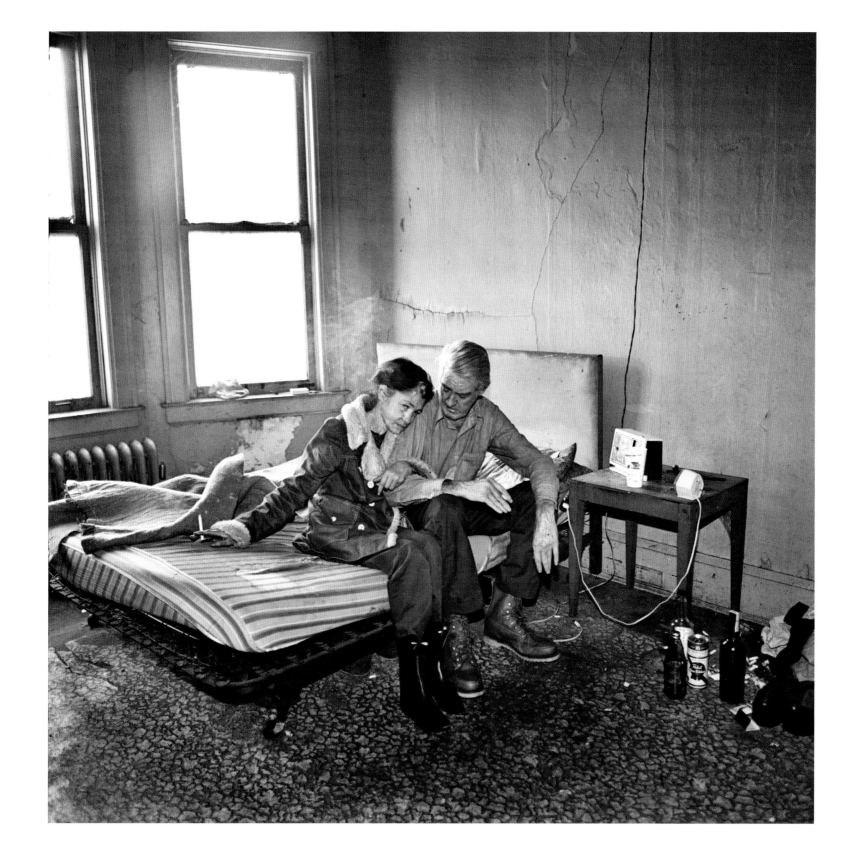

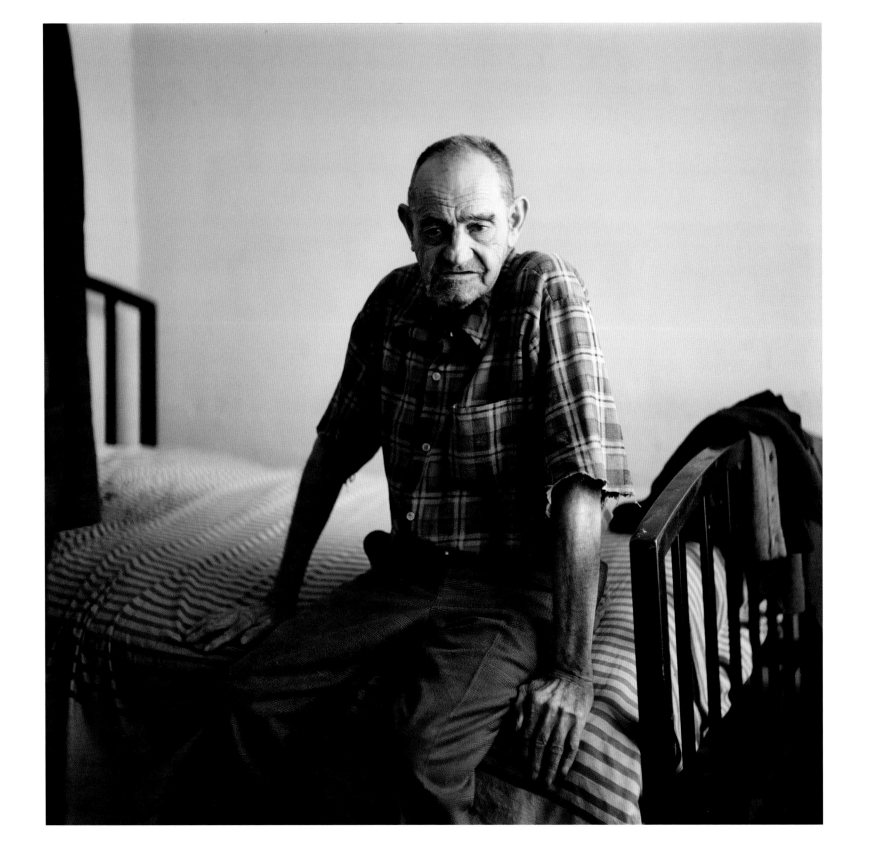

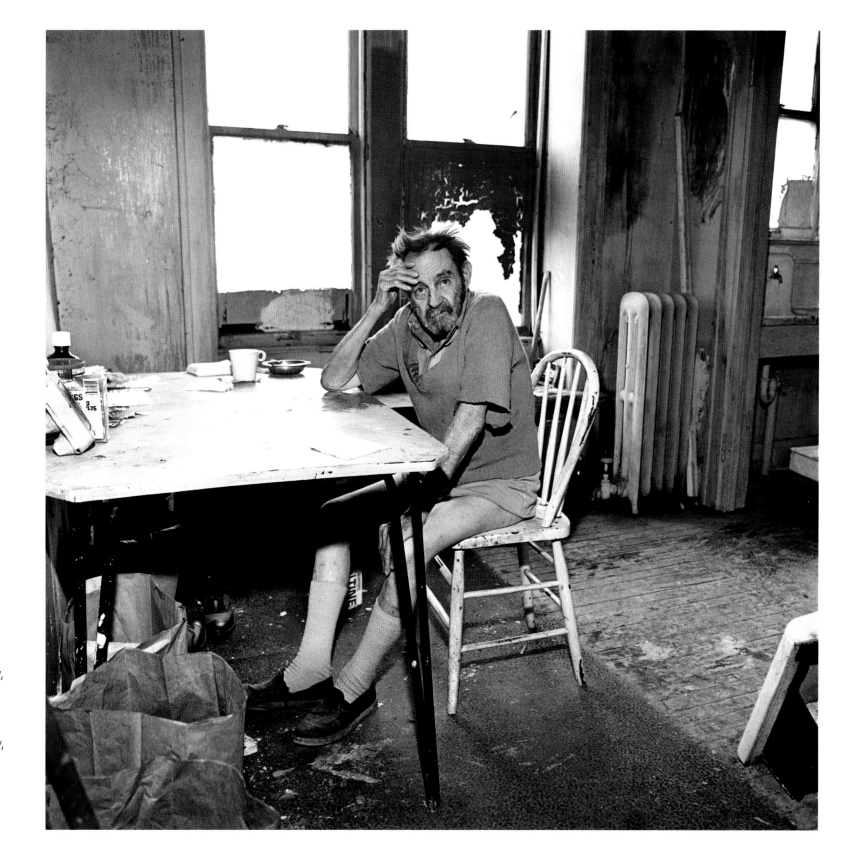

20. (*l*) Lawrence Godfrey, Niagara Apartments, 1976 (Cass Corridor)

21. (*r*) Lawrence Godfrey, Niagara Apartments, 1978 (Cass Corridor)

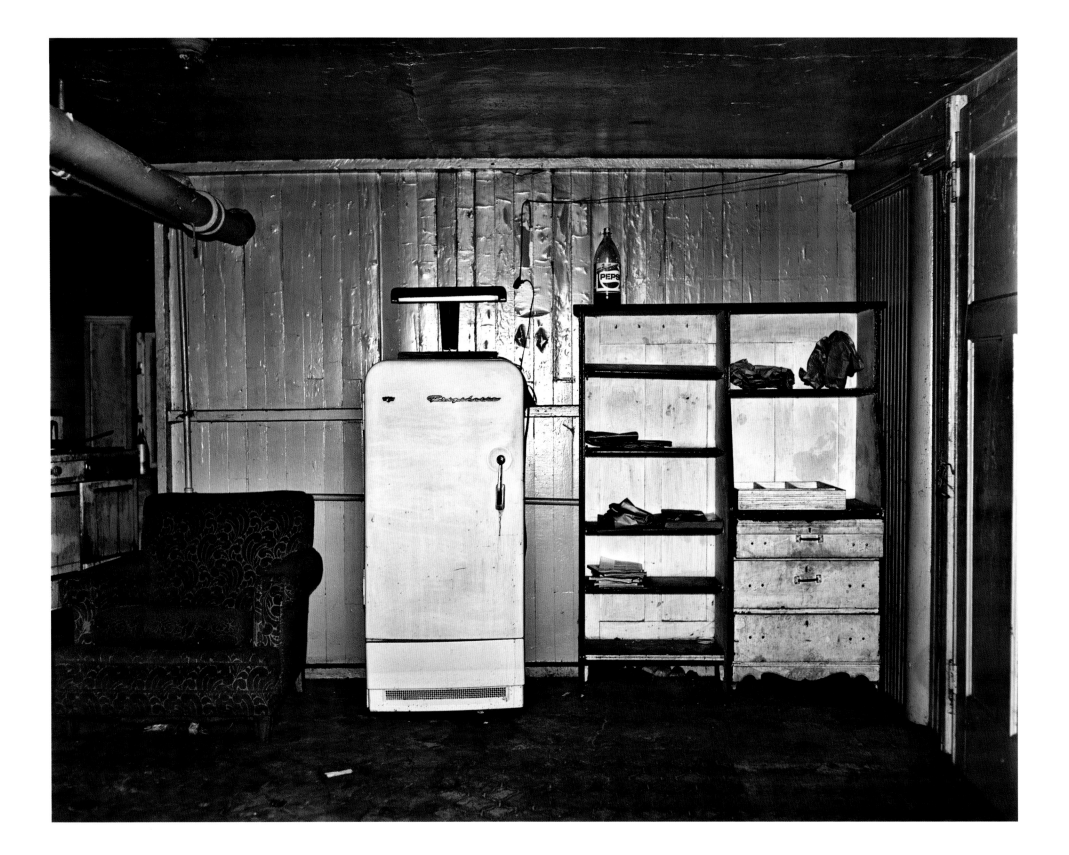

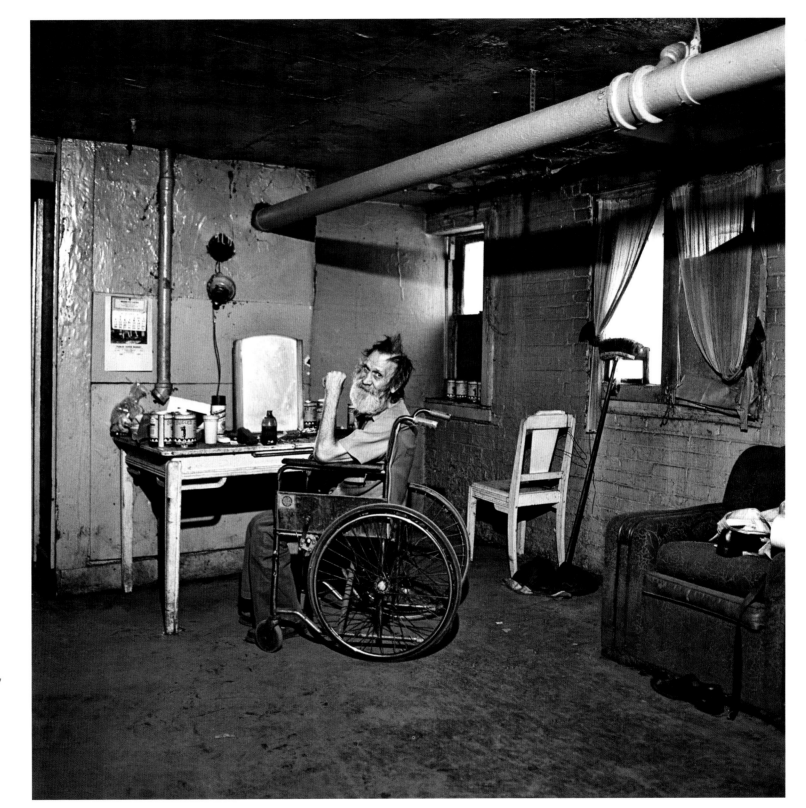

22. (*l*) Norman Brandenburg's
room, Niagara Apartments,
1977 (Cass Corridor)

23. (*r*) Norman Brandenburg,
Niagara Apartments, 1977
(Cass Corridor)

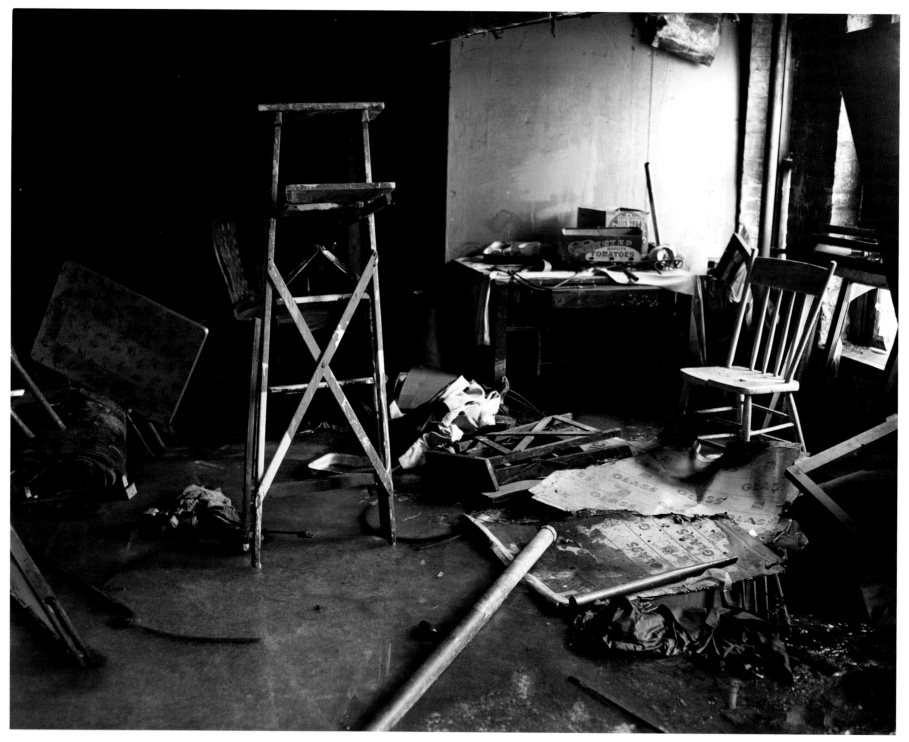

24. Abandoned room, Niagara Apartments, 1978 (Cass Corridor)

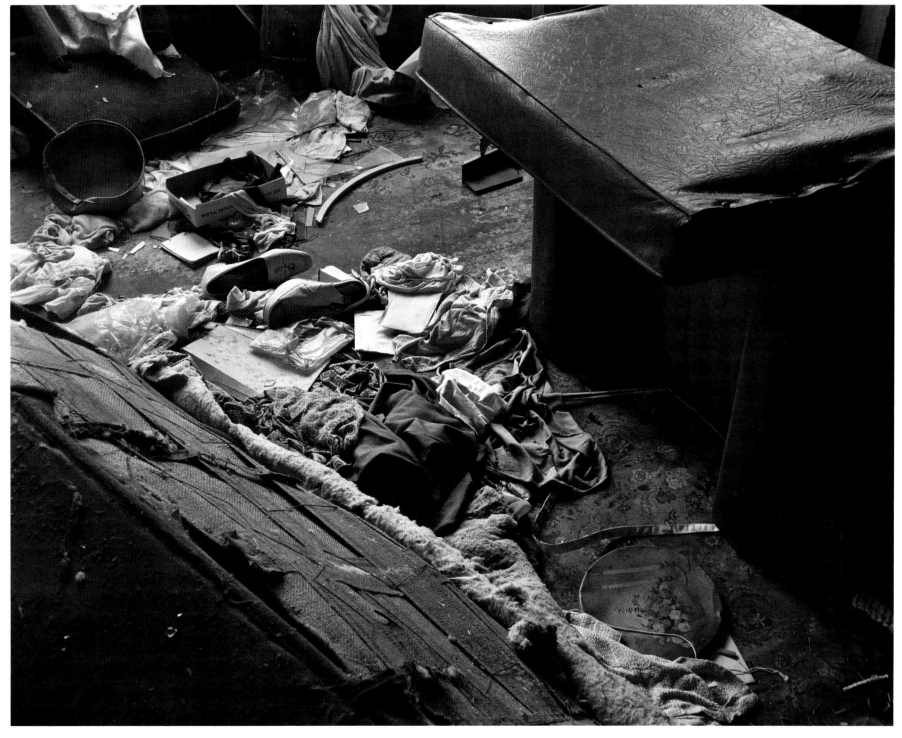

25. Abandoned room, Niagara Apartments, 1978 (Cass Corridor)

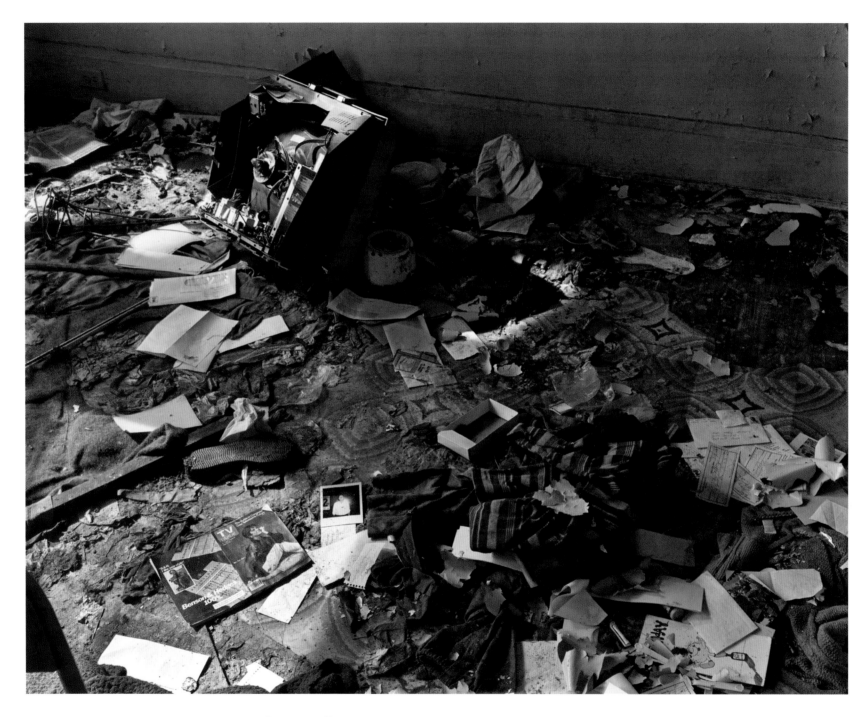

26. Abandoned bedroom, apartment of Mary Caffery, 1978 (Cass Corridor)

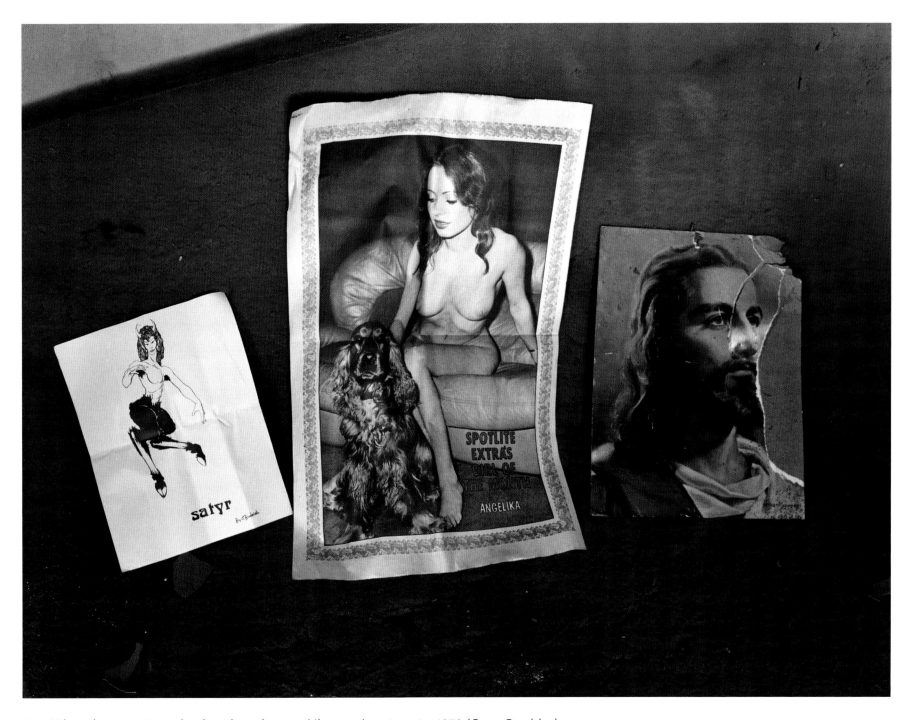

27. Triptych on mattress in abandoned room, Niagara Apartments, 1978 (Cass Corridor)

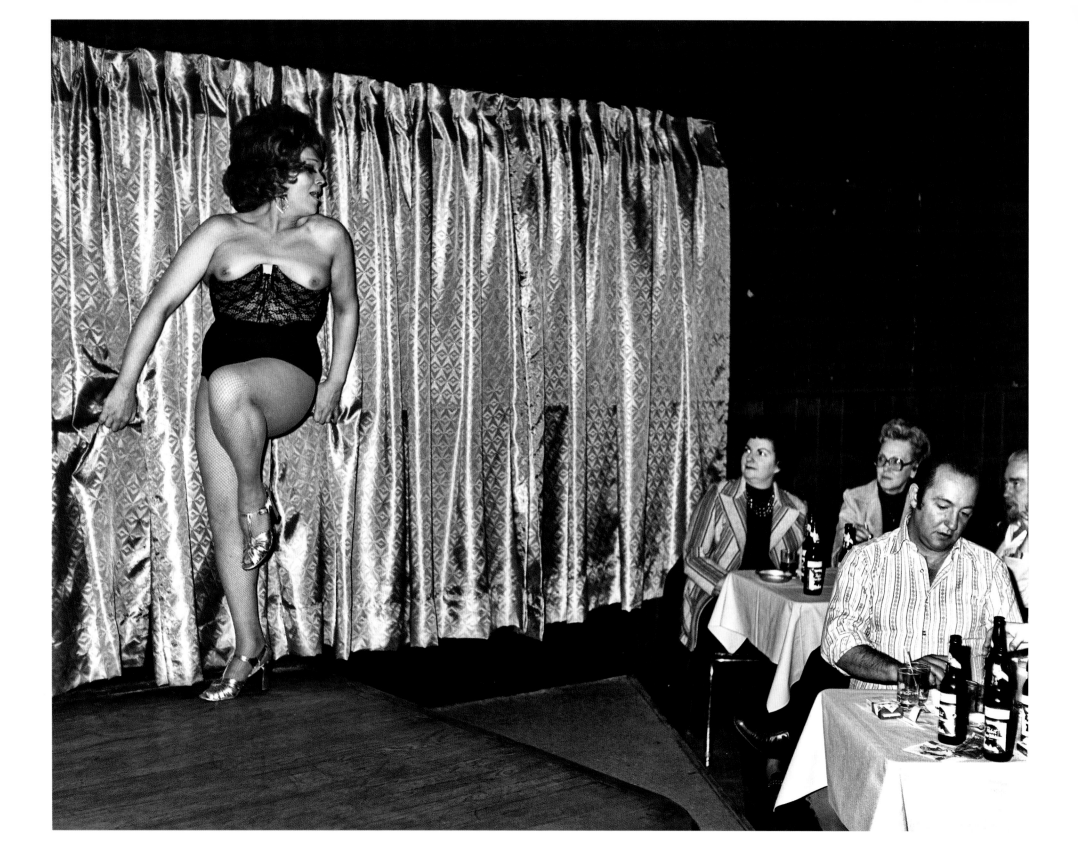

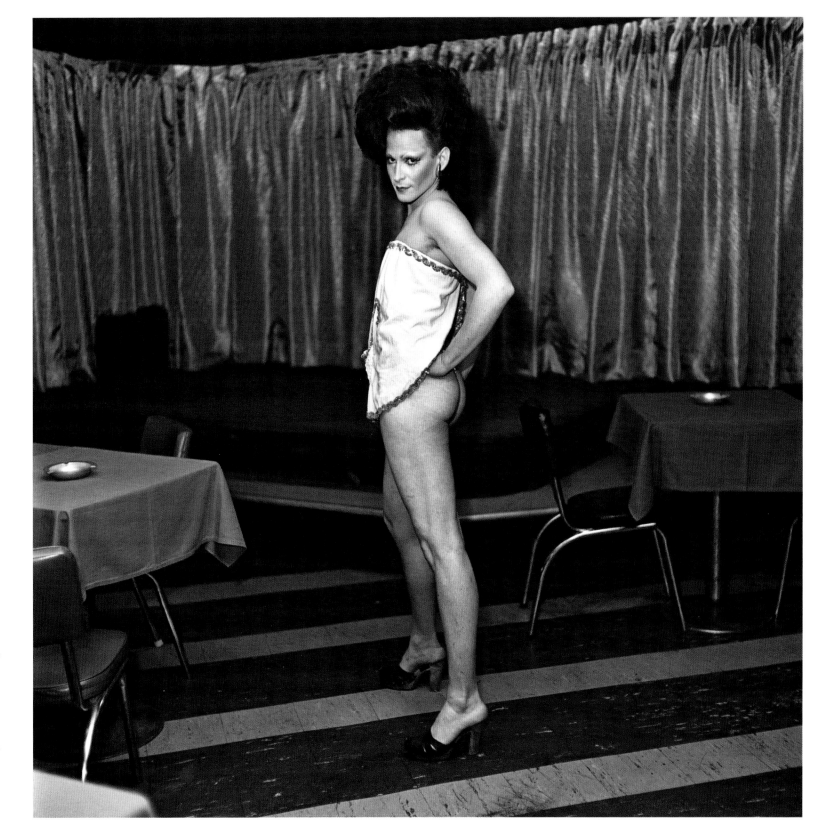

28. (*l*) Jackie, Gold Dollar Show Bar, Cass Avenue, ca. 1978 (Cass Corridor)

29. (*r*) Dee Dee, Gold Dollar Show Bar, Cass Avenue, ca. 1978 (Cass Corridor)

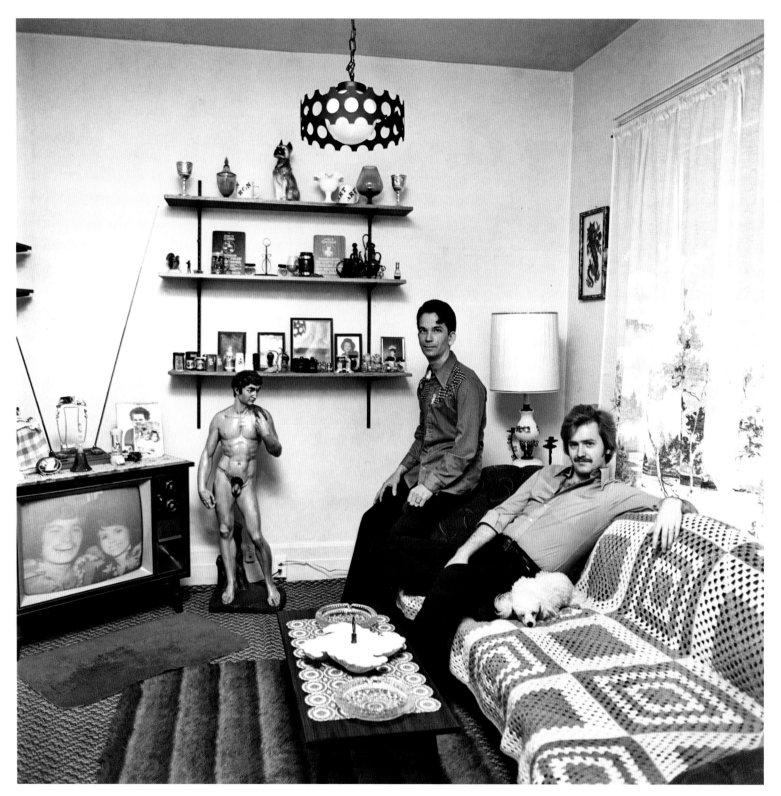

30. Ron (*left*) and Art, Spaulding
Court apartments,
Rosa Parks Boulevard,
ca. 1978 (Cass Corridor)

31. Ron and Art, Halloween
party at Verdi Bar on
Sibley Street, ca. 1978
(Cass Corridor)

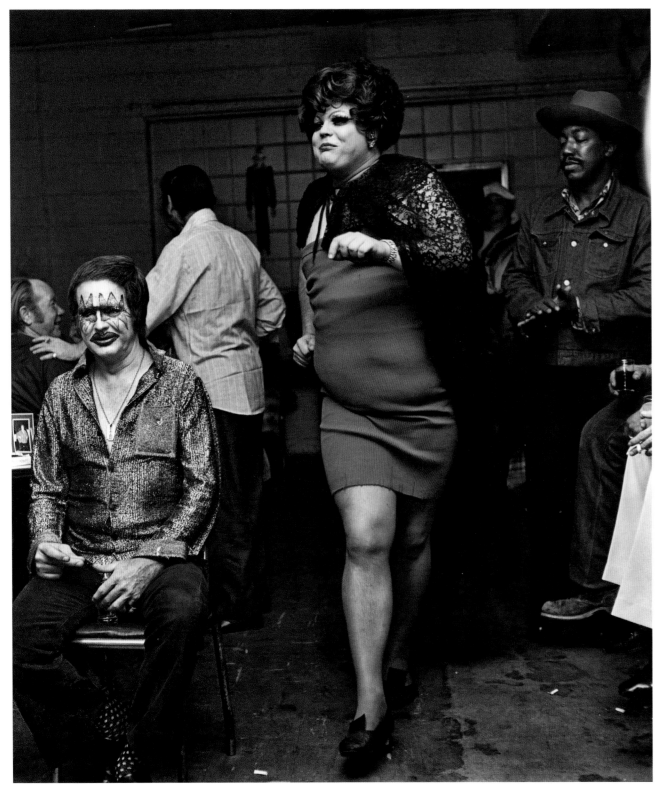

32. (*l*) Gloria T., Halloween party at Verdi Bar,
 ca. 1978 (Cass Corridor)

33. (*r*) Willis Bar, Third Avenue at Willis Street,
 ca. 1979 (Cass Corridor)

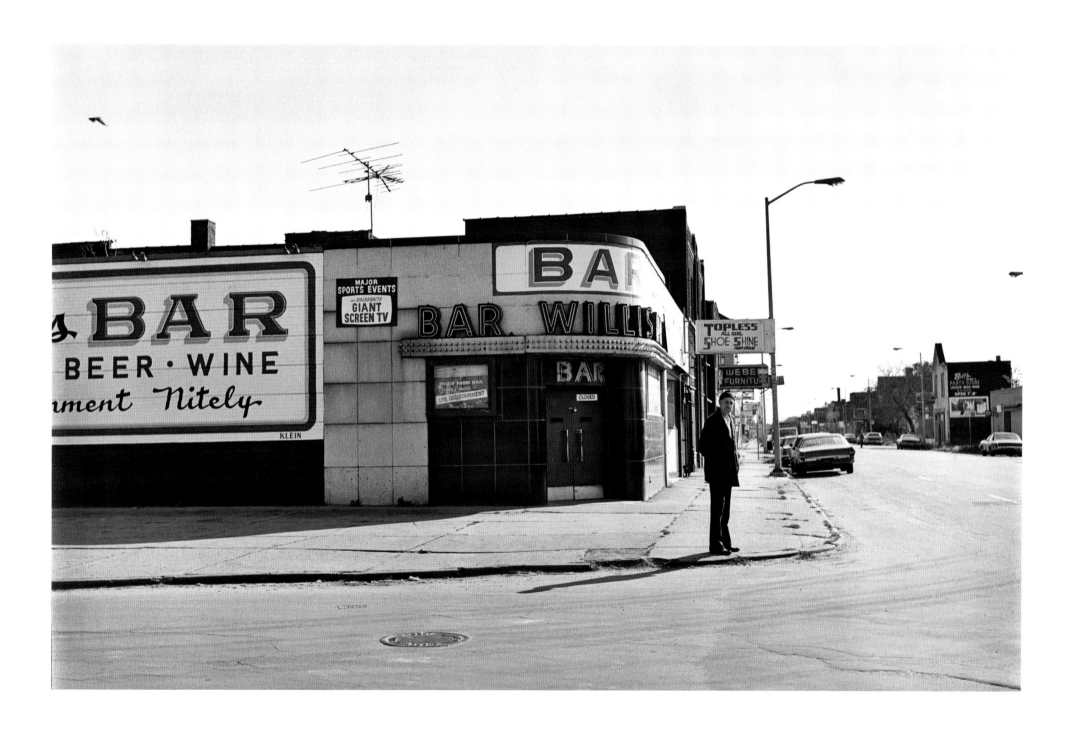

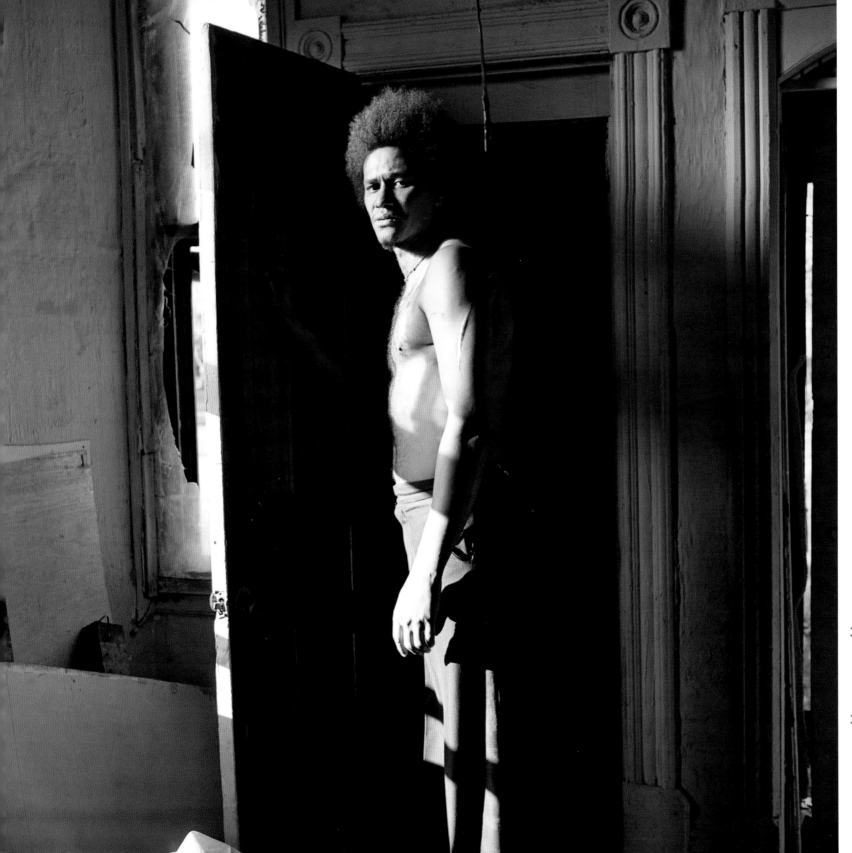

34. (*l*) Man in abandoned house, Fourth Street near Peterboro Street, ca. 1979 (Cass Corridor)

35. (*r*) Girl on porch, Myrtle Street (Martin Luther King Jr. Boulevard), ca. 1978 (Cass Corridor)

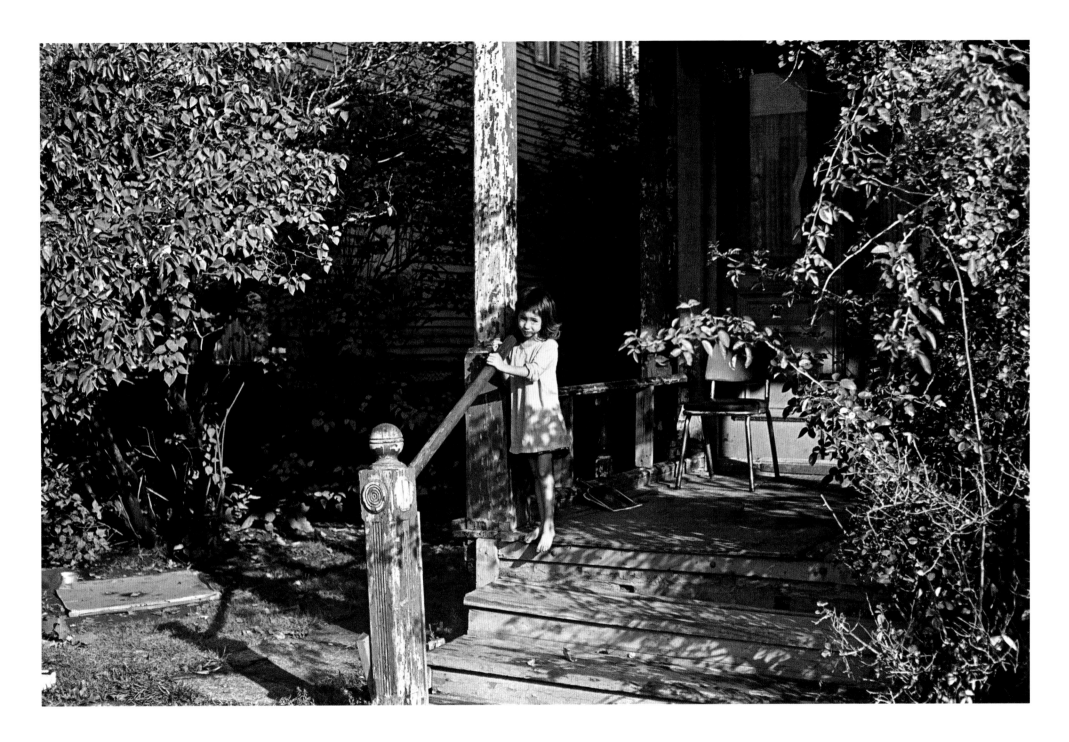

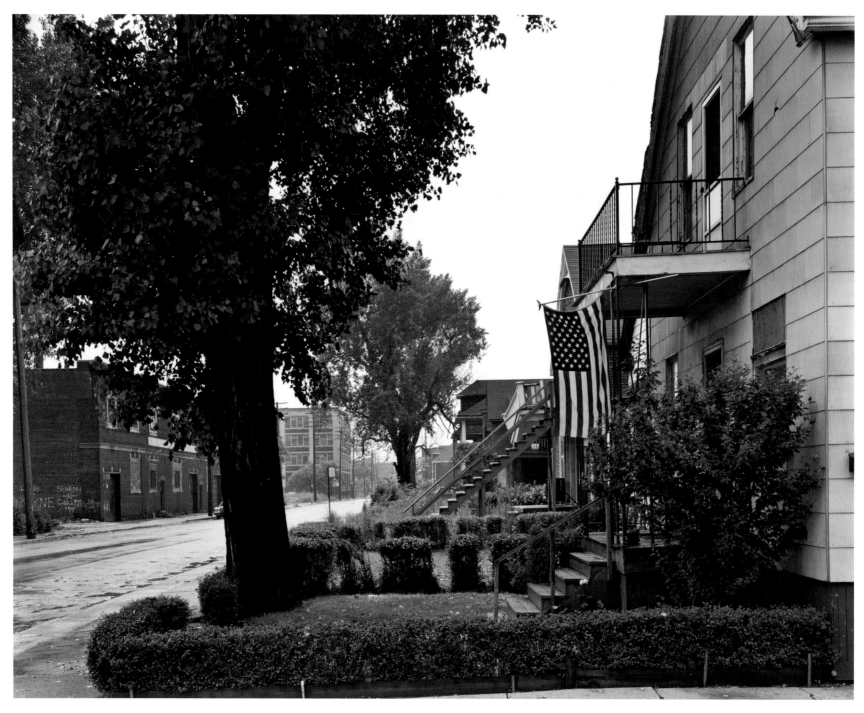

36. Fourth of July, Milwaukee Avenue, 1981 (Poletown)

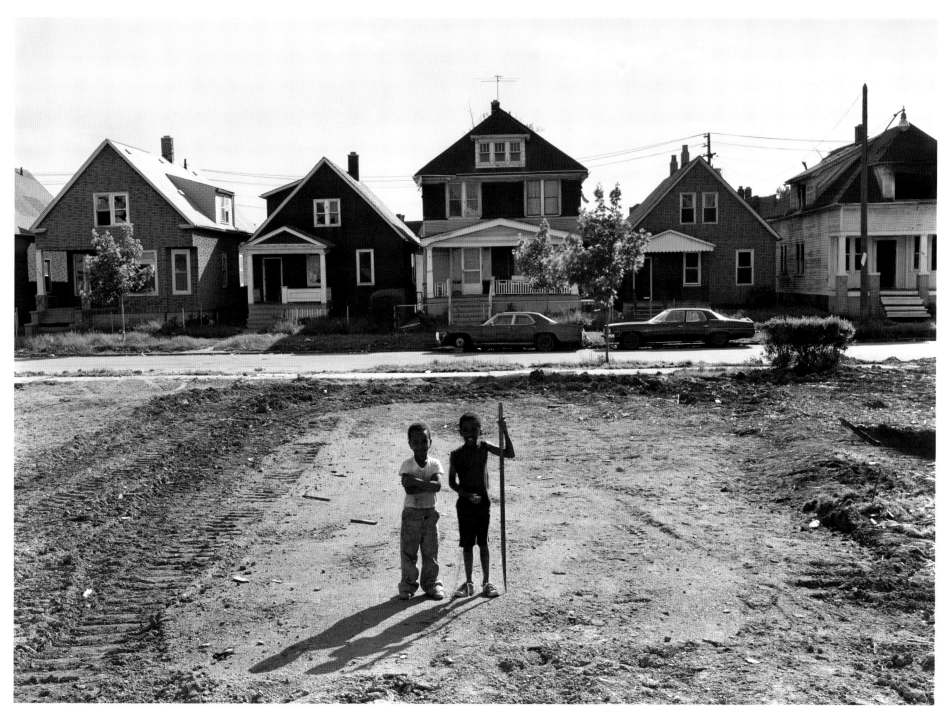

37. Two boys, Joseph Campau Avenue near Trombly Street, May 1981 (Poletown)

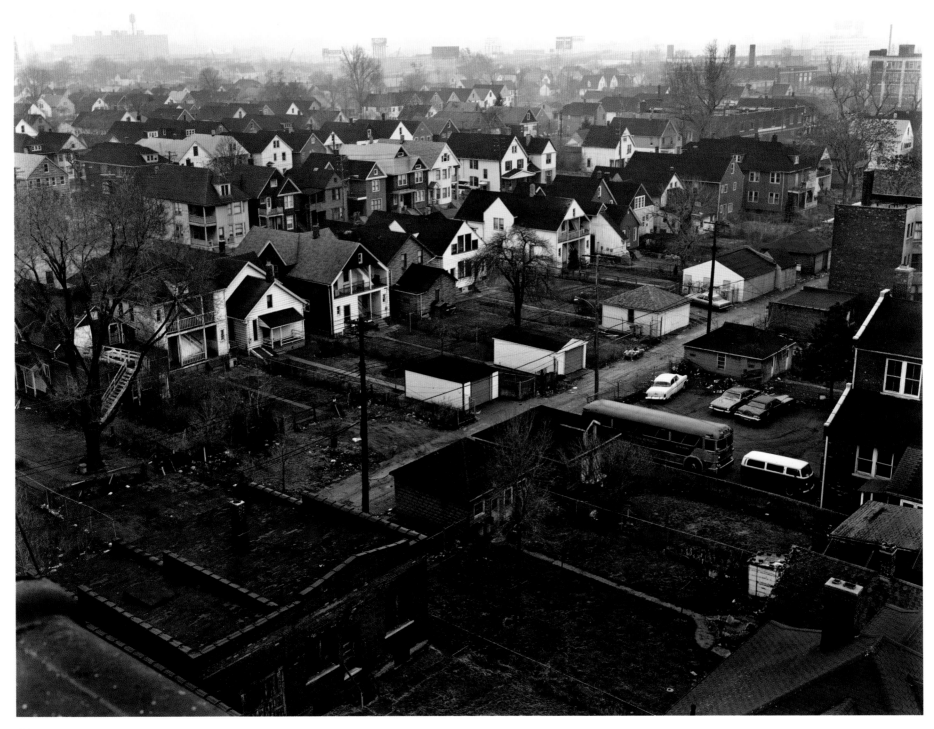

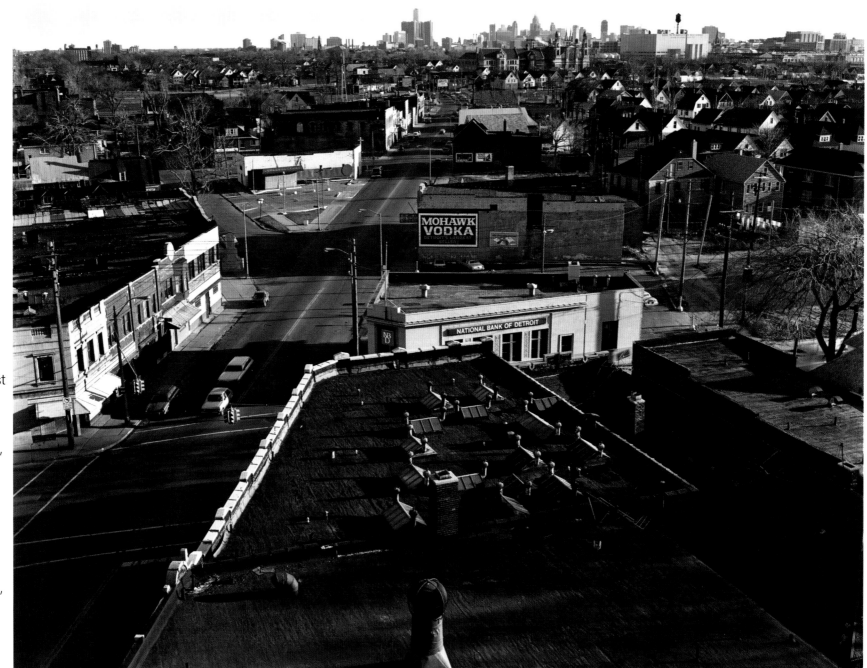

38. (*l*) View southwest from Greylawn Apartments, East Grand Boulevard and Chene Street, March 1981 (Poletown)

39. (*r*) View south from Greylawn Apartments, East Grand Boulevard and Chene Street, March 1981 (Poletown)

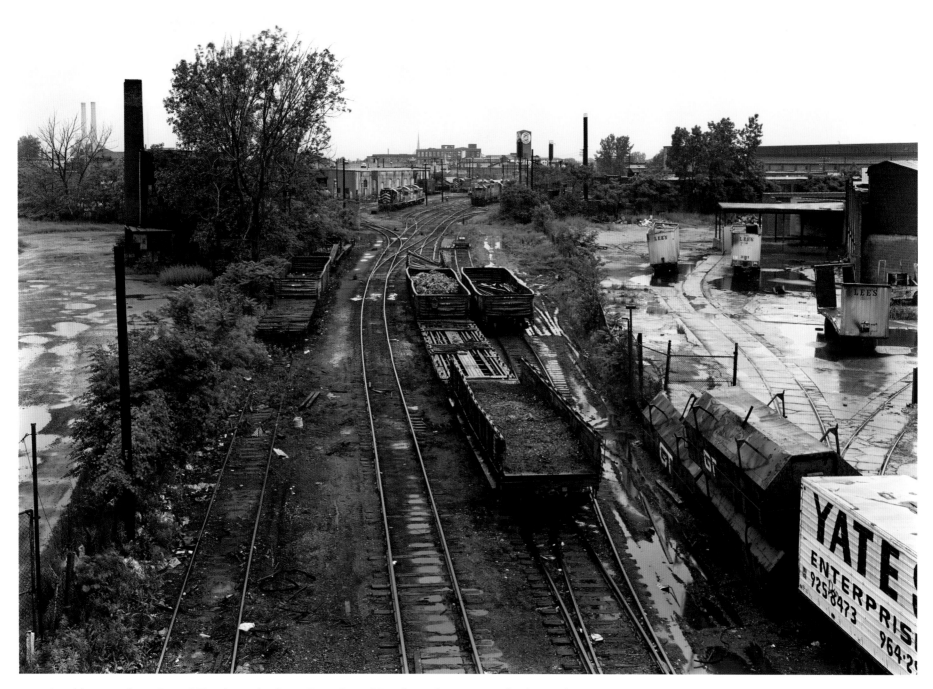

40. Looking north at Grand Trunk tracks from East Grand Boulevard, June 1981 (Poletown)

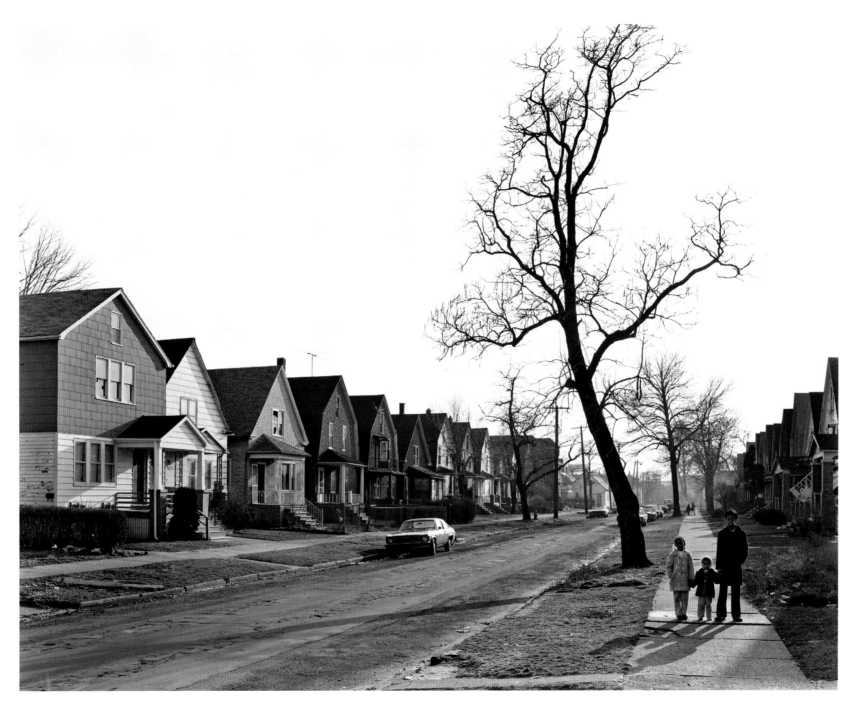

41. Adele Street, March 1981 (Poletown)

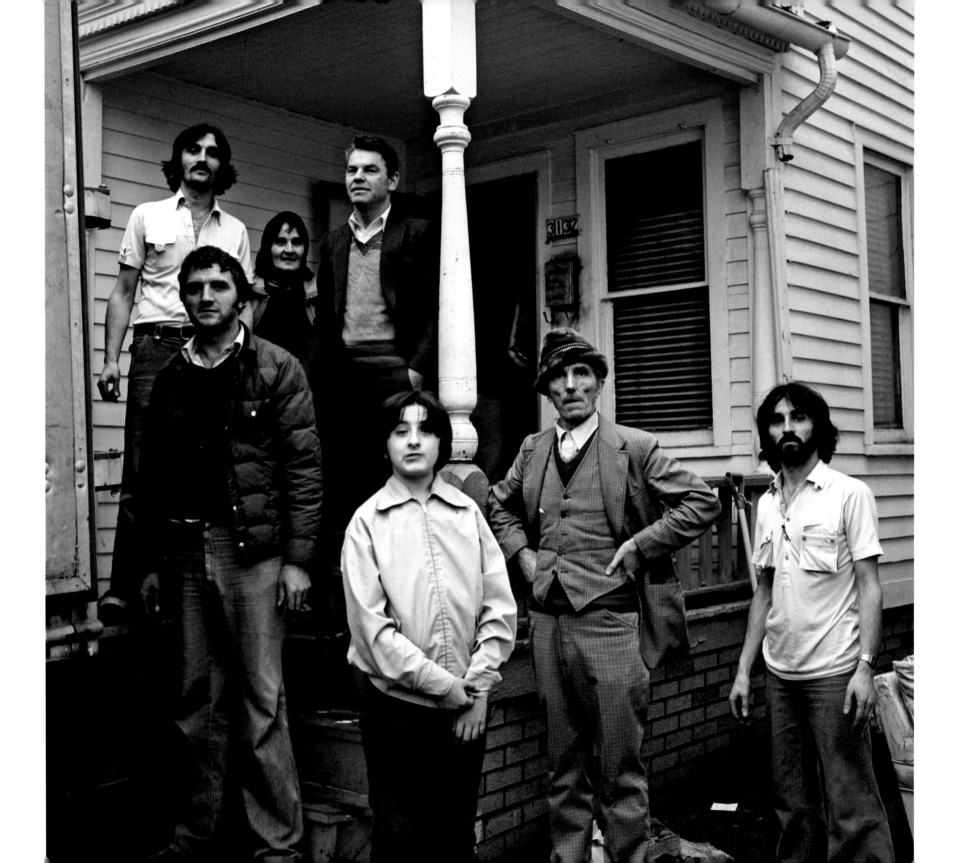

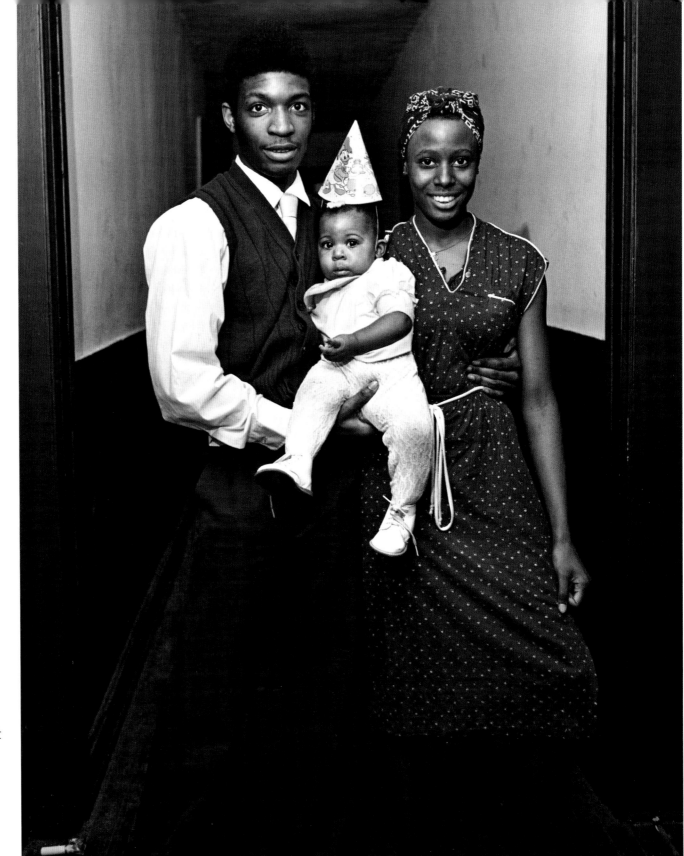

42. (*l*) Family moving from home near Dane Street, March 1981 (Poletown)

43. (*r*) First birthday, Dubois Apartments, East Grand Boulevard, 1981 (Poletown)

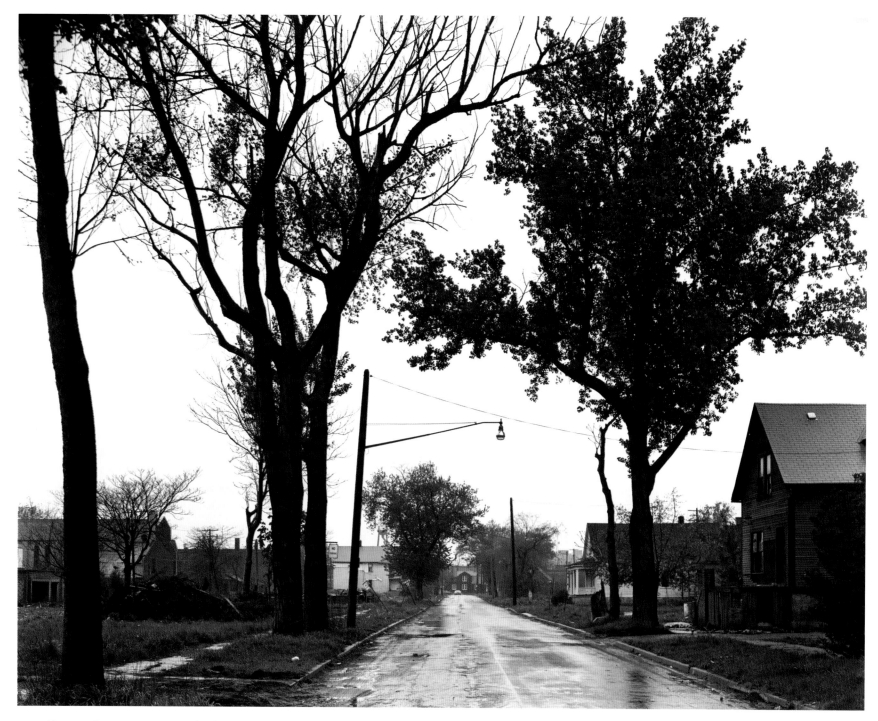

44. Horton Street, May 1981 (Poletown)

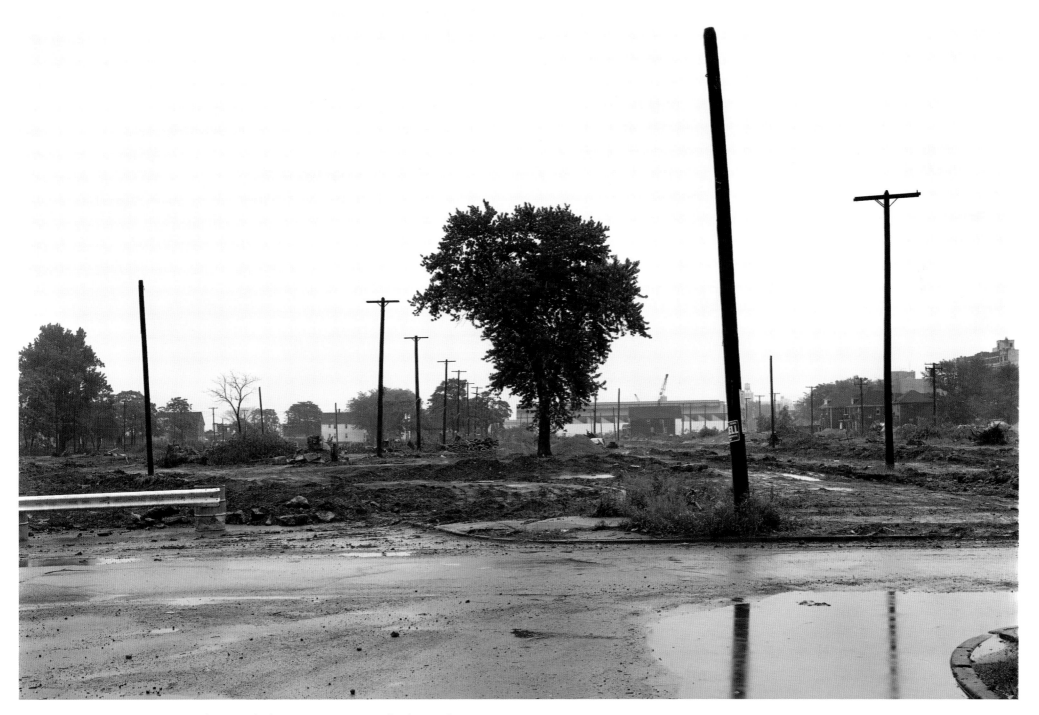

45. Horton Street area, from Dubois Street, June 1981 (Poletown)

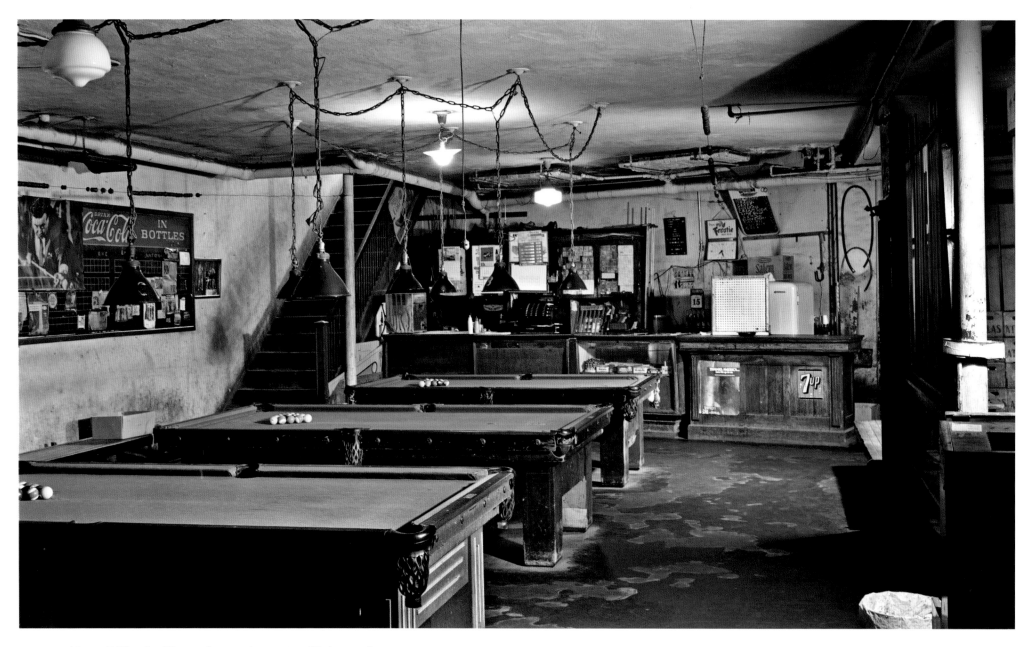

46. Hupp Billiards, Chene Street, June 1981 (Poletown)

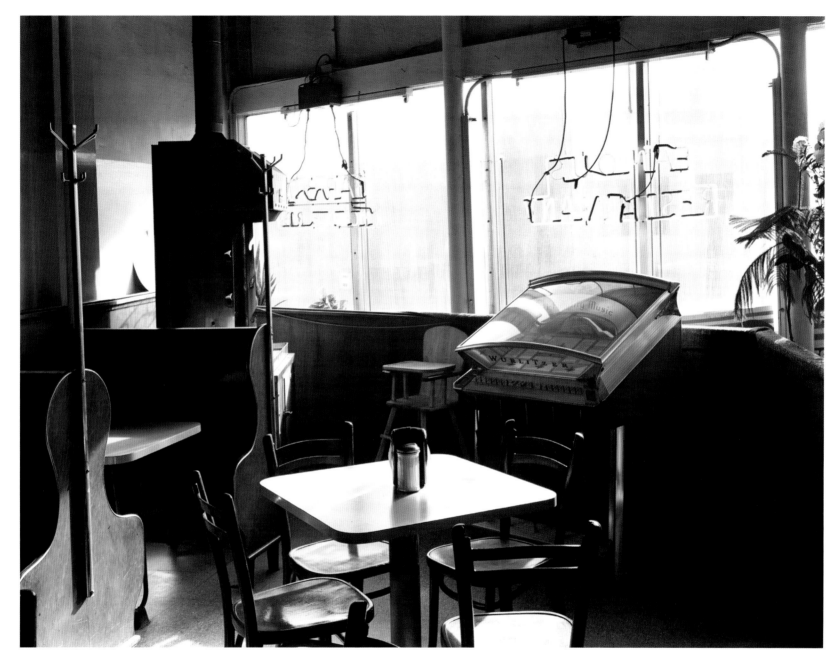

47. Famous Restaurant and Bar-B-Q, Chene Street, June 1981 (Poletown)

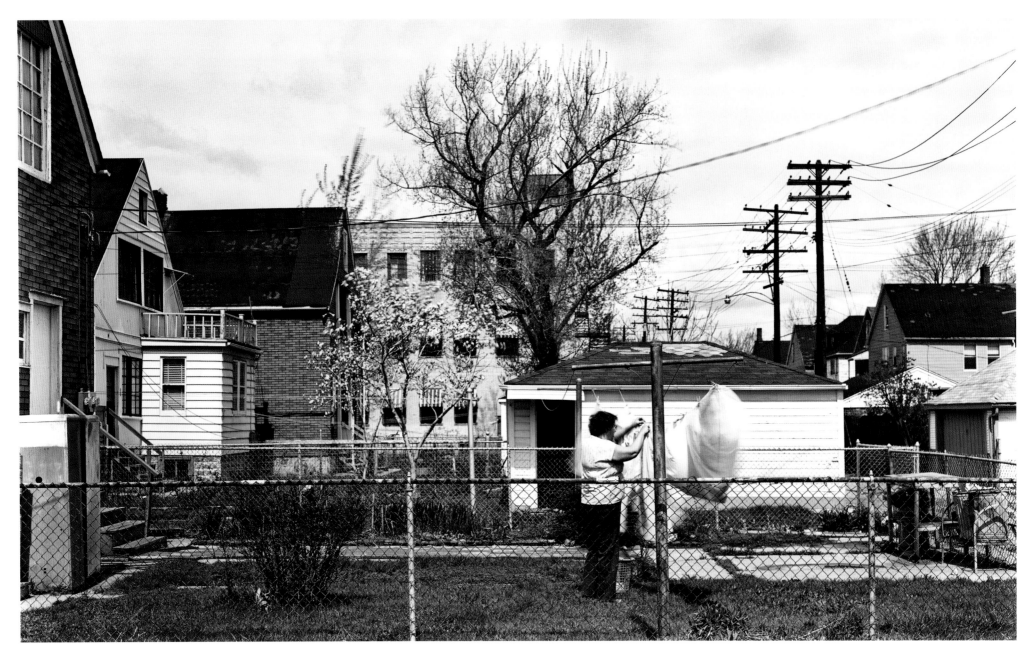

48. Woman hanging laundry, Joseph Campau Avenue at Edsel Ford Service Drive, April 1981 (Poletown)

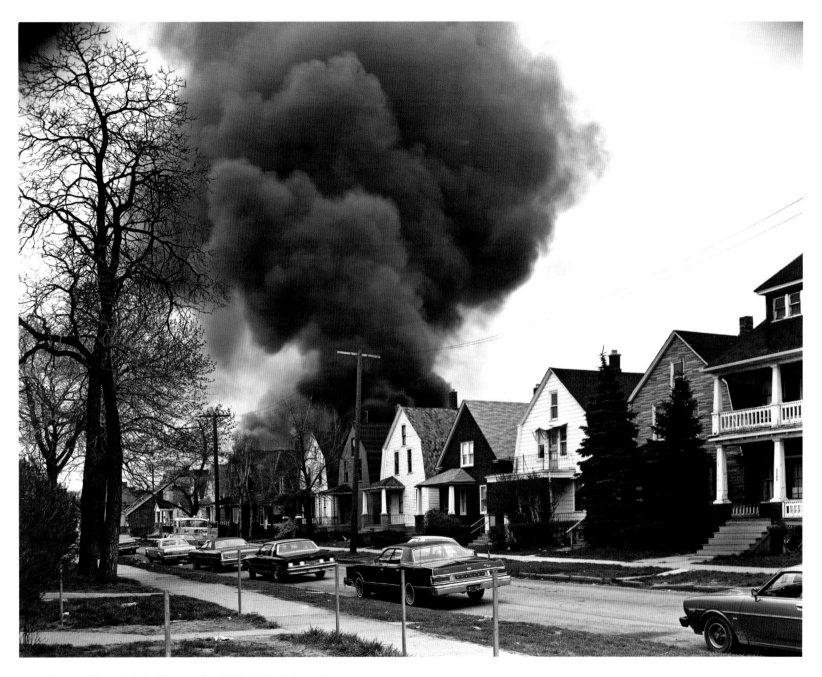

49. House fire, Adele Street, April 1981 (Poletown)

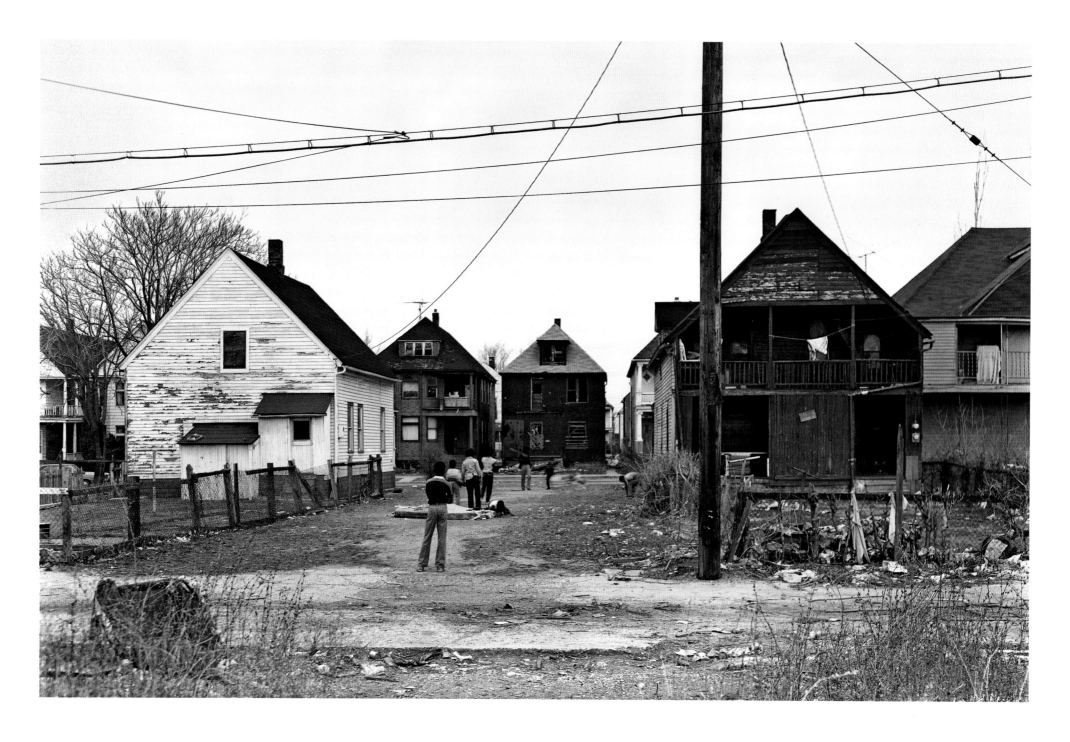

50. (*l*) Baseball game, alley between Adele and Trombly Streets, March 1981 (Poletown)

51. (*r*) Front porch, East Grand Boulevard, June 1981 (Poletown)

52. (l) Smoker, backyard of house on Newton
 Street, February 1981 (Poletown)

53. (r) Garden, Widman Street near Milwaukee
 Avenue, April 1981 (Poletown)

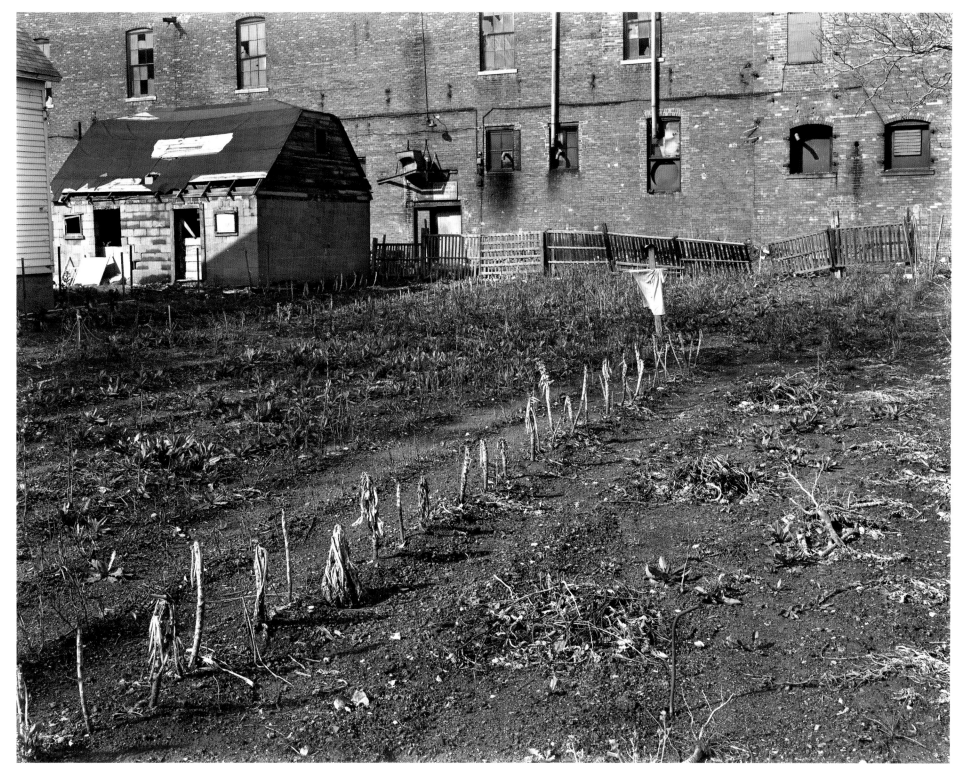

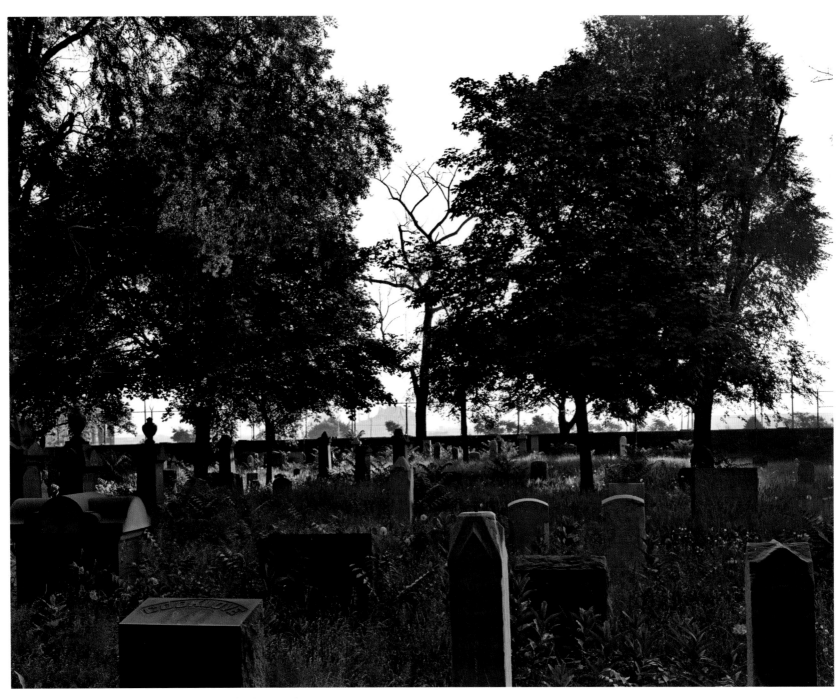

54. Beth Olem Cemetery, June 1981 (Poletown)

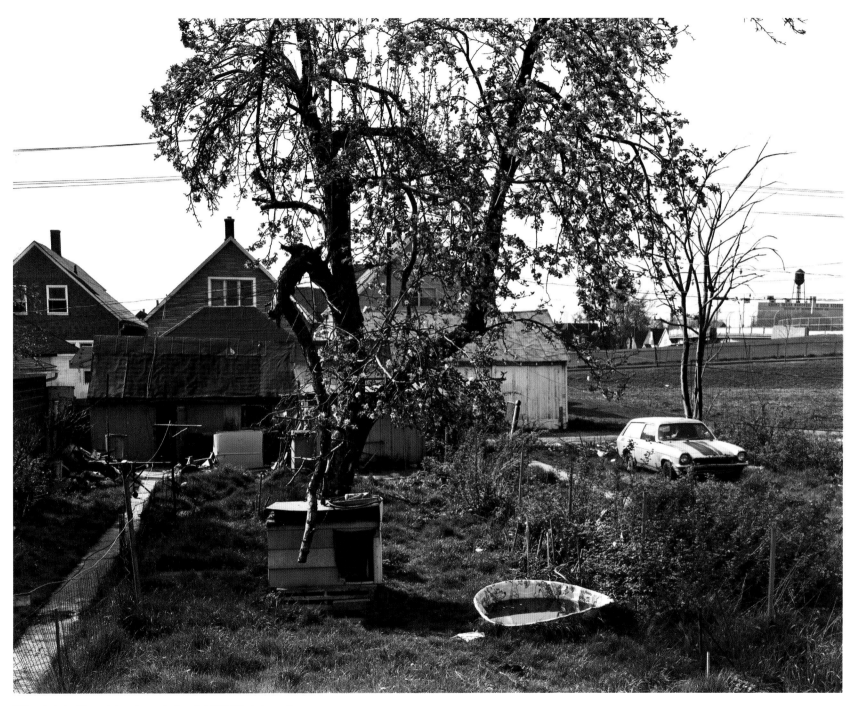

55. Adele Street backyard, April 1981 (Poletown)

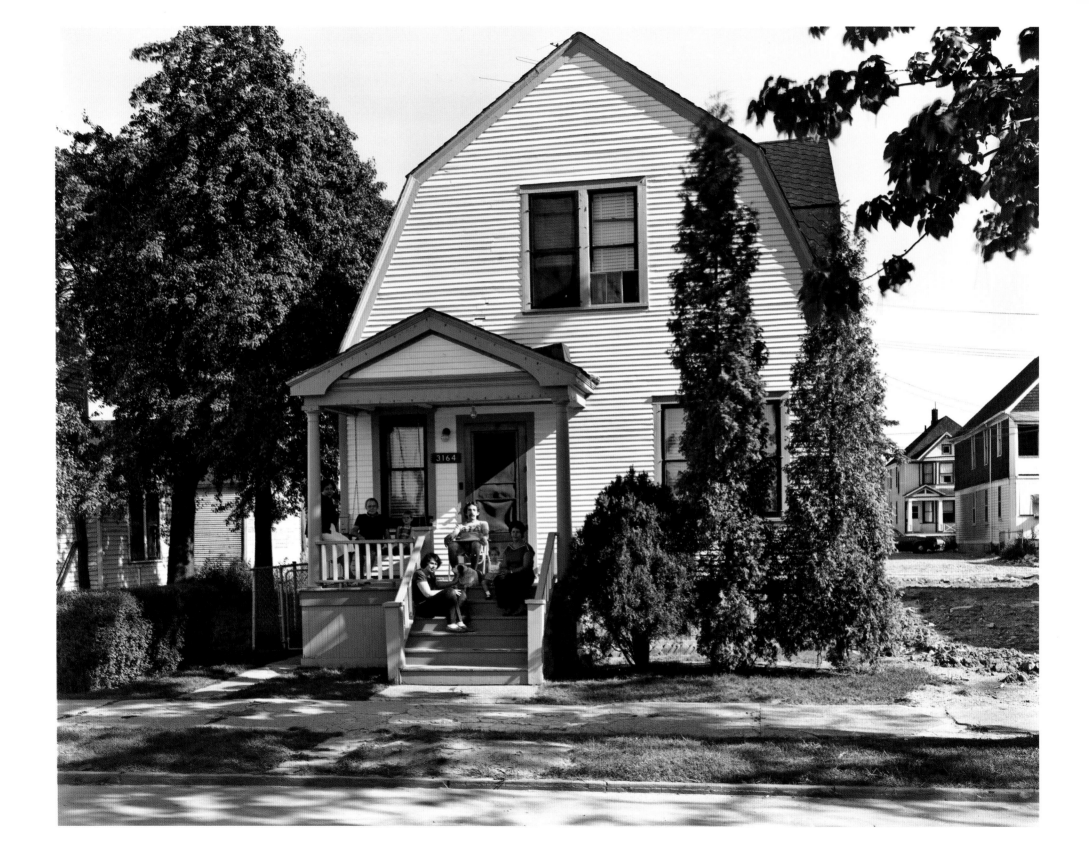

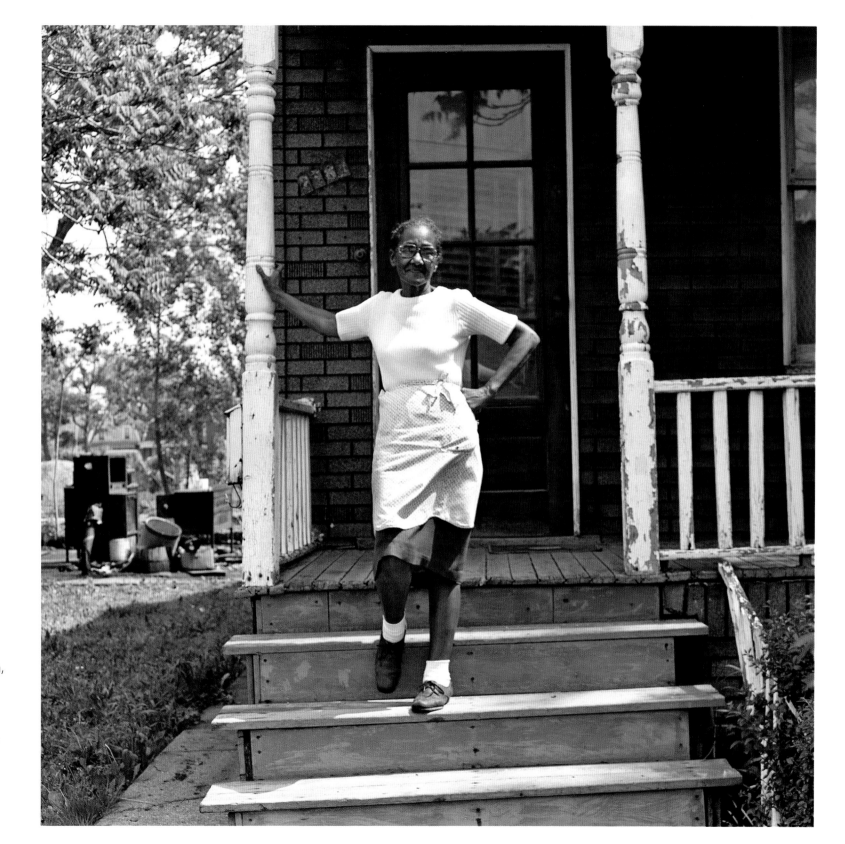

56. (*l*) Family on front porch,
Kanter Street, August
1981 (Poletown)

57. (*r*) Woman on front steps,
Finley Street, June 1981
(Poletown)

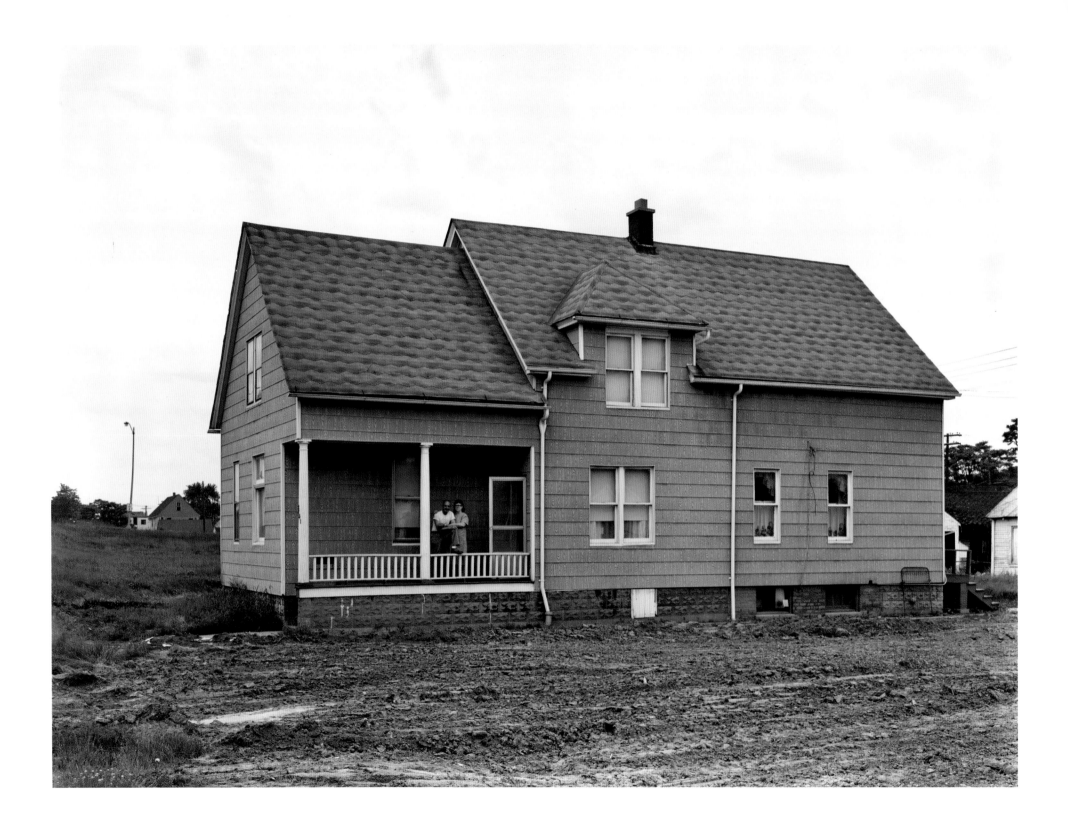

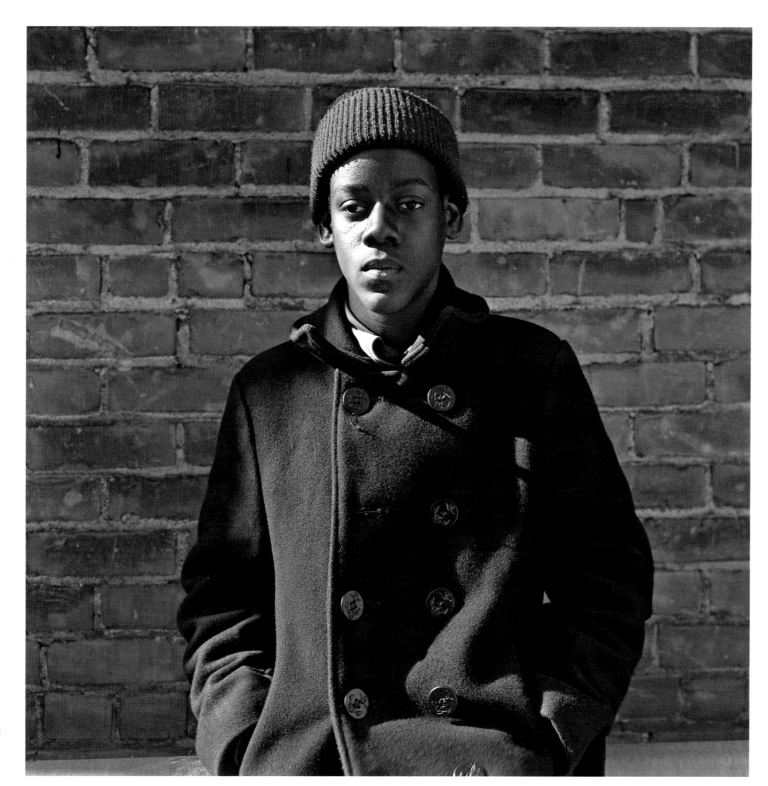

58. (*l*) Home on Edsel Ford
Service Drive, June 1981
(Poletown)

59. (*r*) Young man, Chene
Street, April 1981 (Poletown)

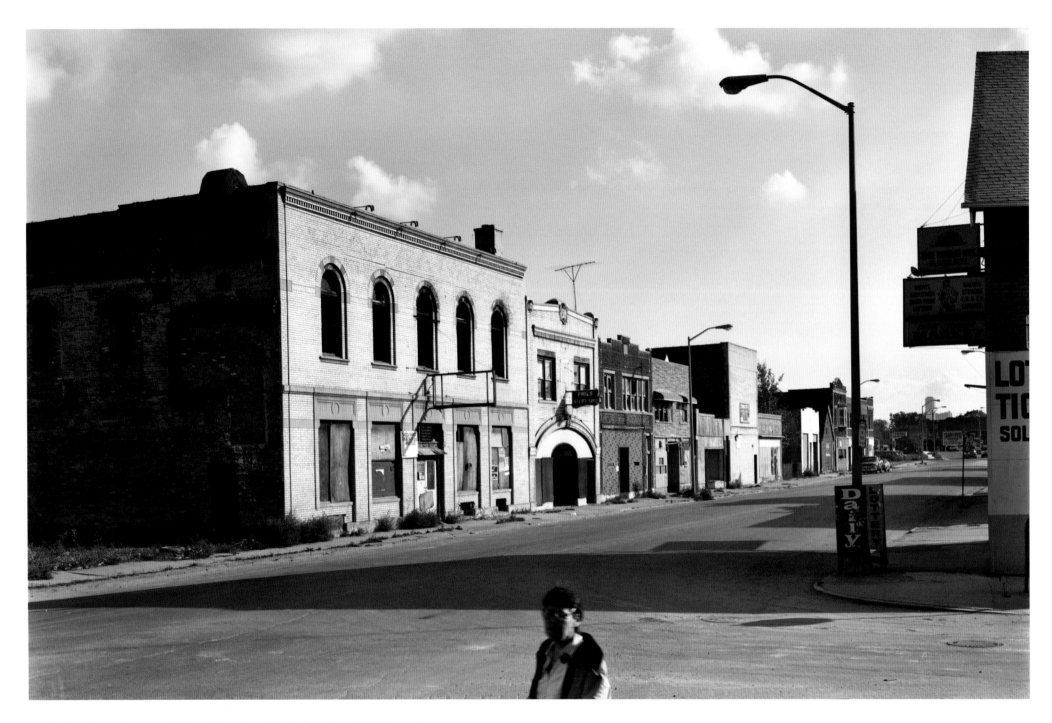

60. Chene Street at Trombly Street, October 1981 (Poletown)

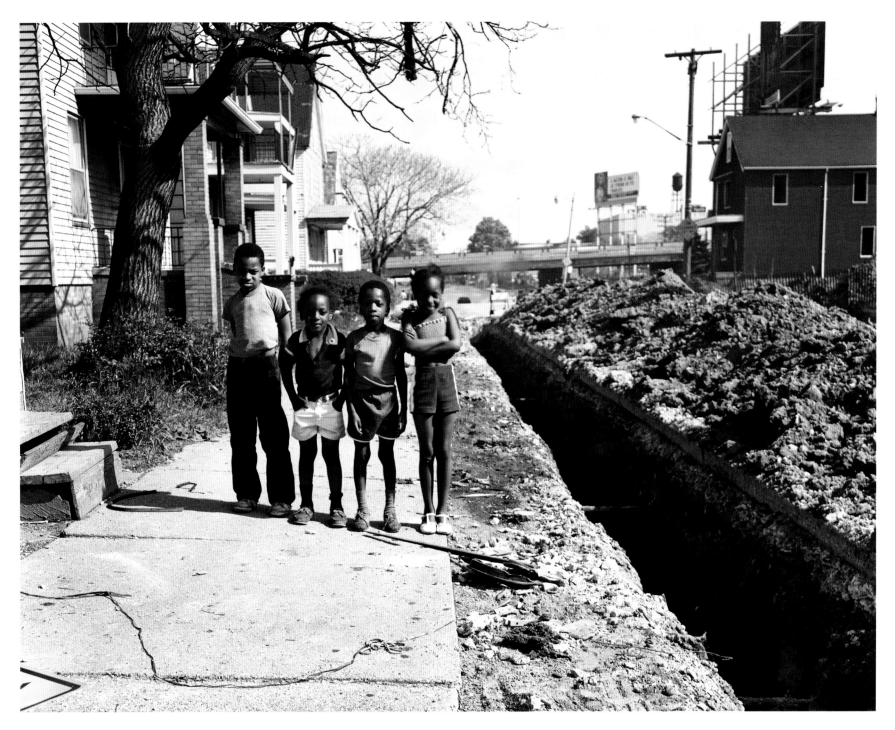

61. Children on St. Aubin Street, May 1981 (Poletown)

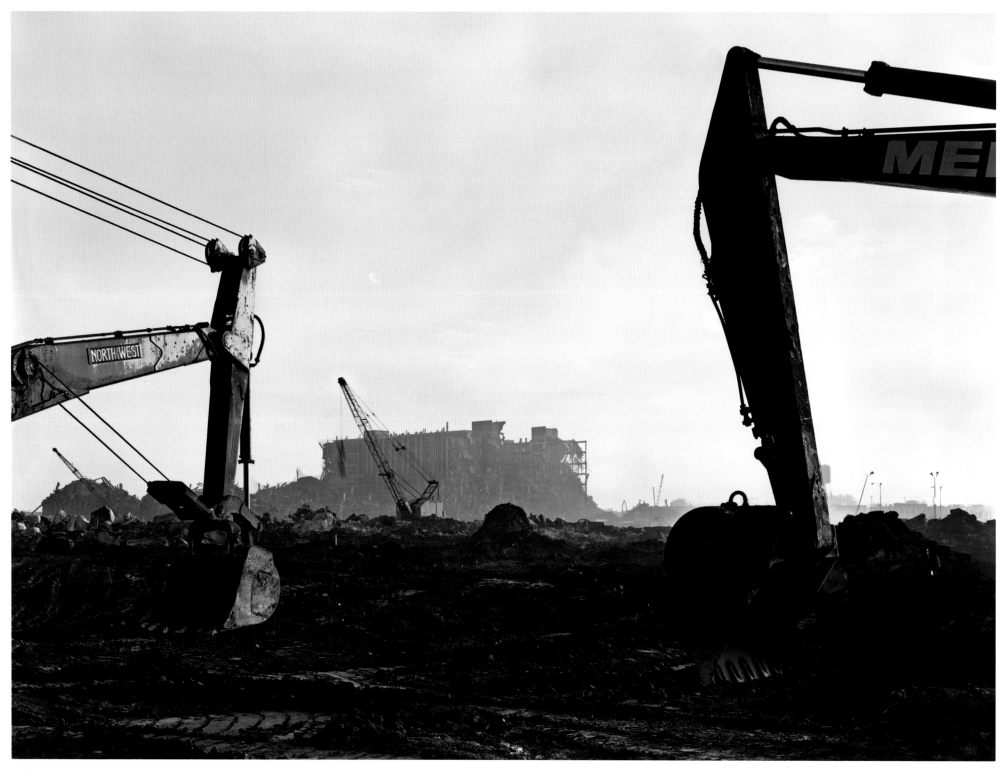

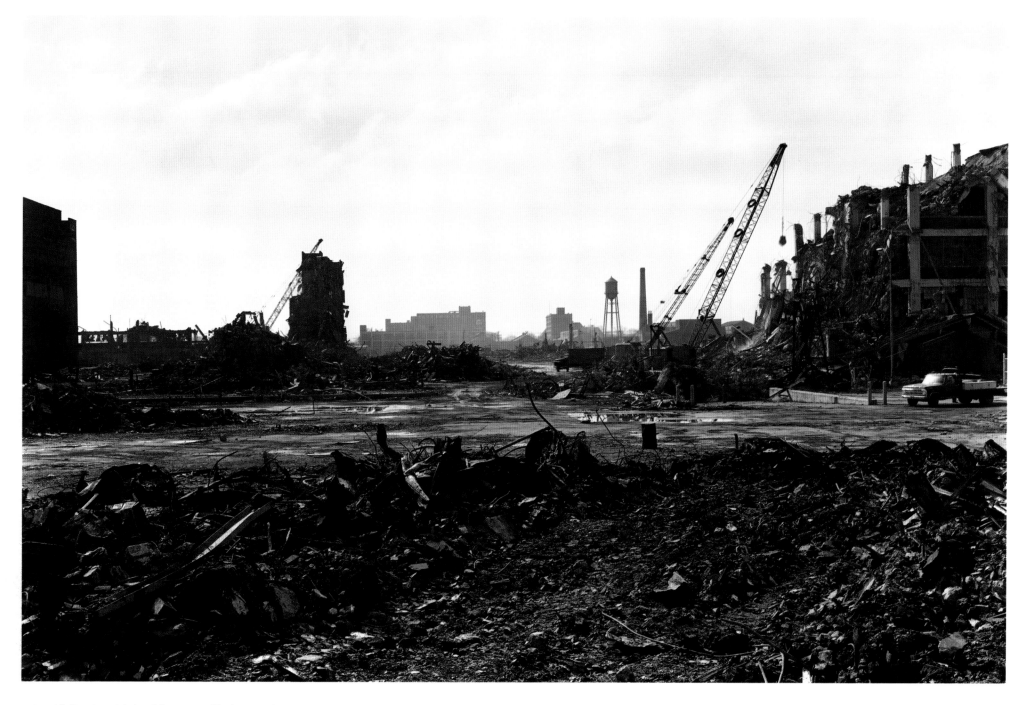

62. (*l*) Dodge Main, May 1981 (Poletown)

63. (*r*) Dodge Main demolition, looking south from Denton Street, March 1981 (Poletown)

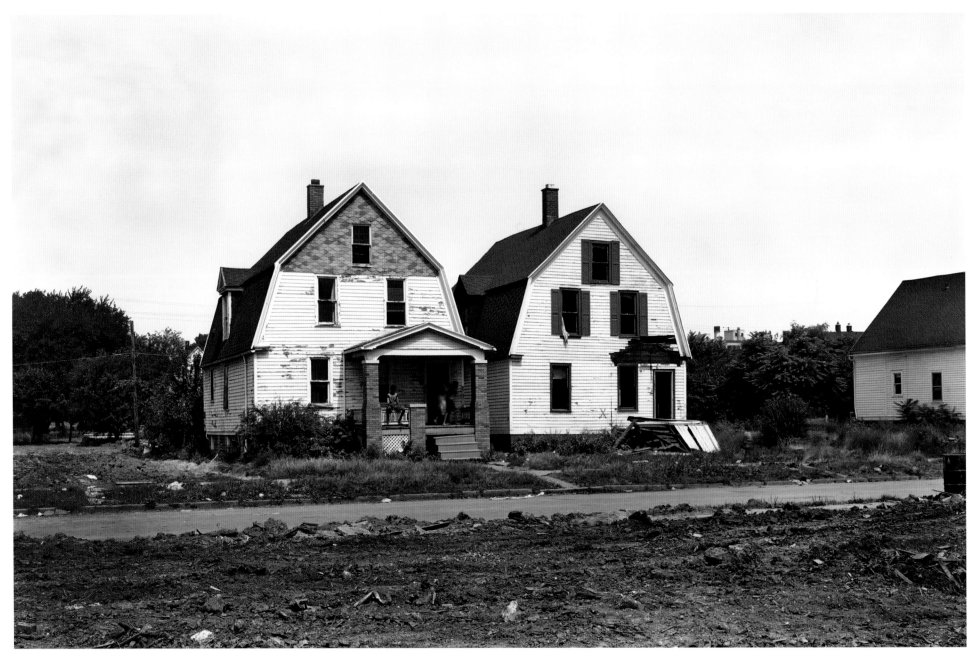

64. Homes on Adele Street, August 1981 (Poletown)

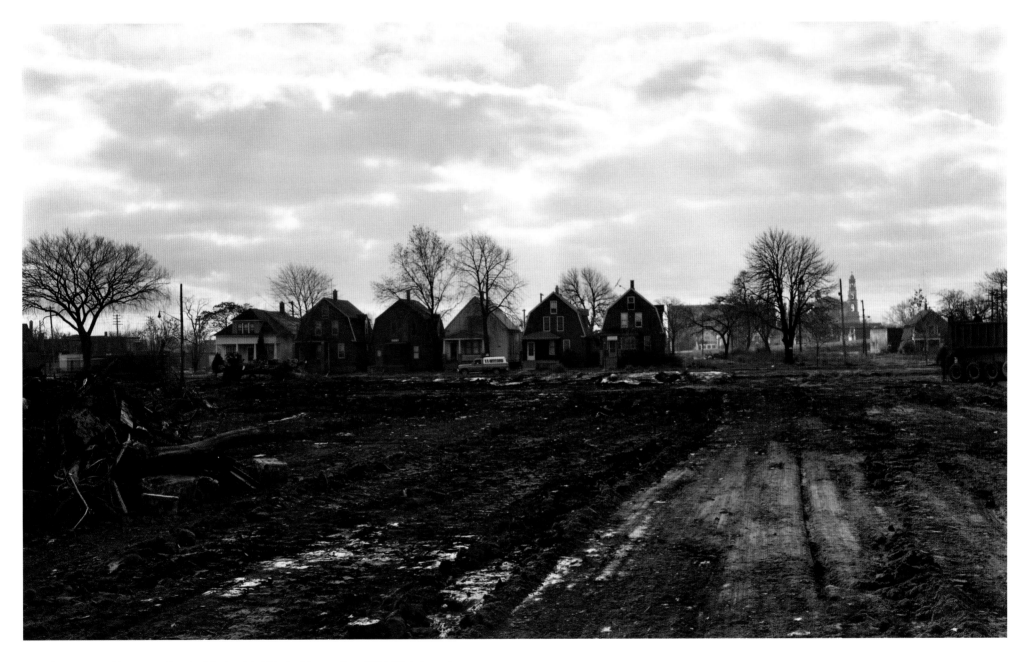

65. Last row of houses, Central Industrial Park, November 1981 (Poletown)

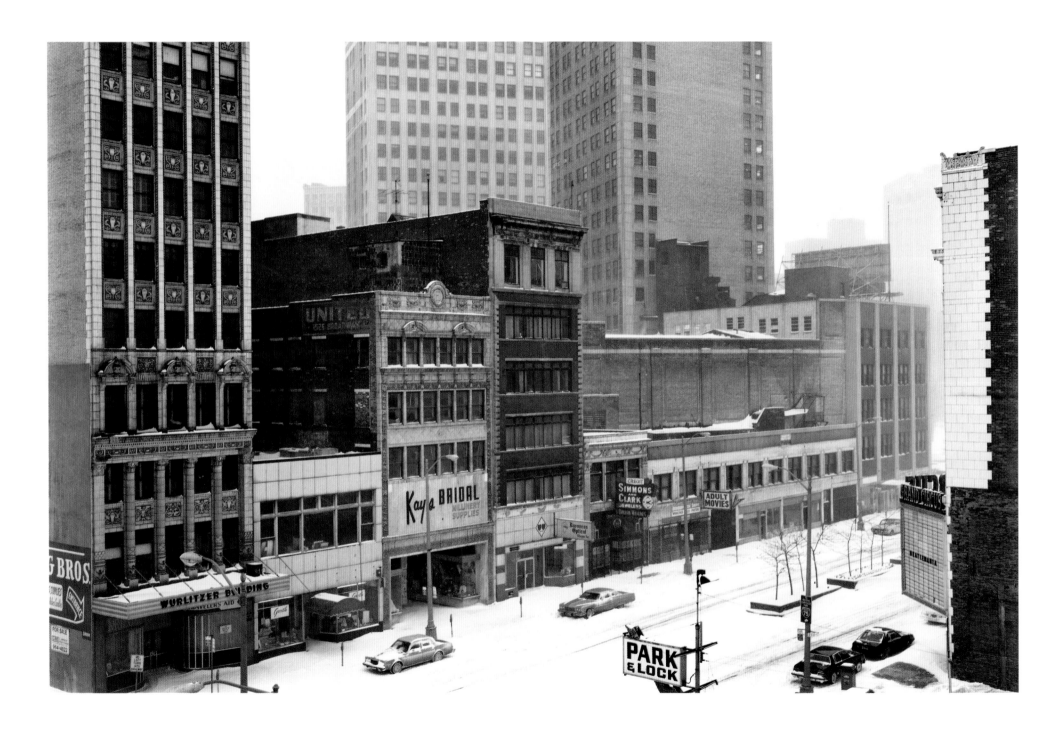

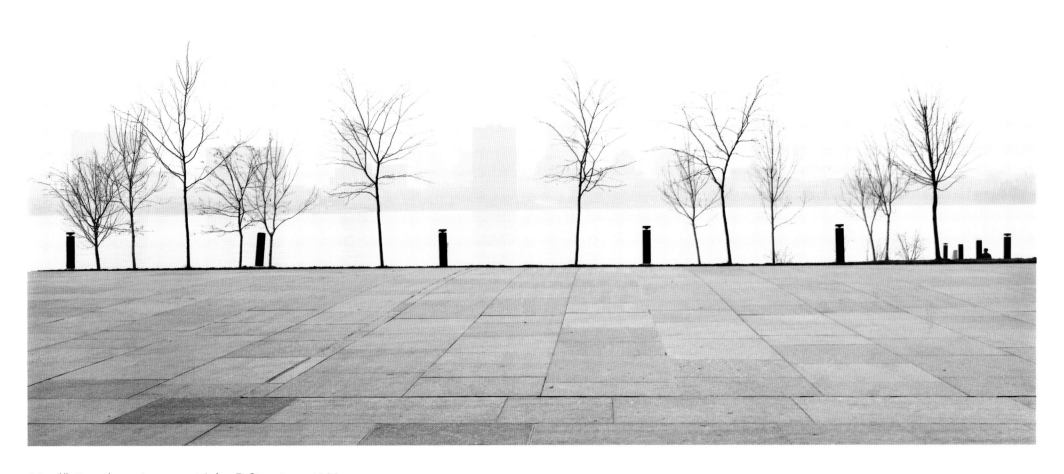

66. (*l*) Broadway Avenue at John R Street, ca. 1982

67. (*r*) Hart Plaza, facing Windsor, Ontario, ca. 1979

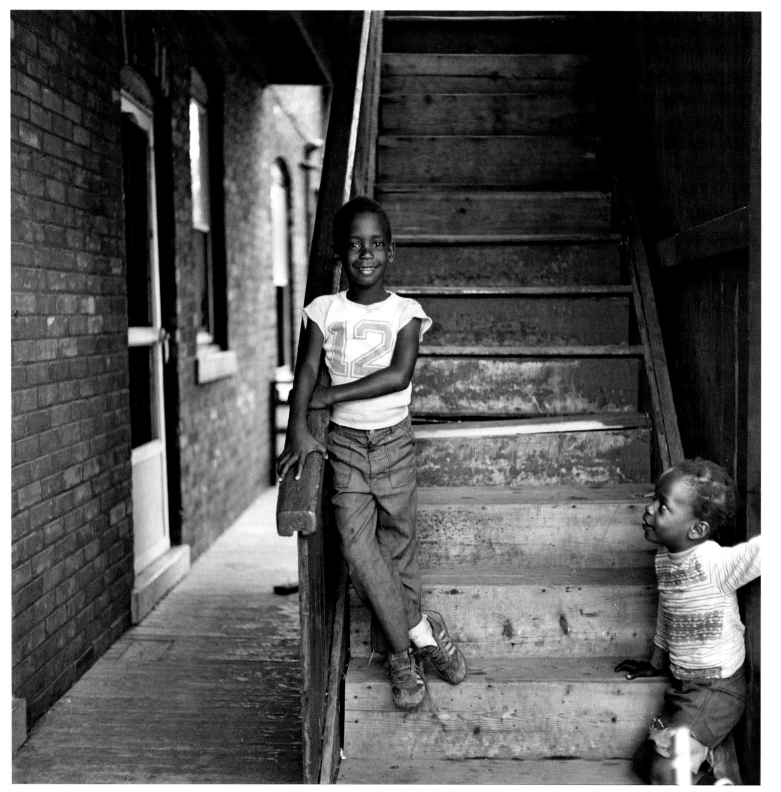

68. Children on staircase,
near Avery Street, ca.
1983

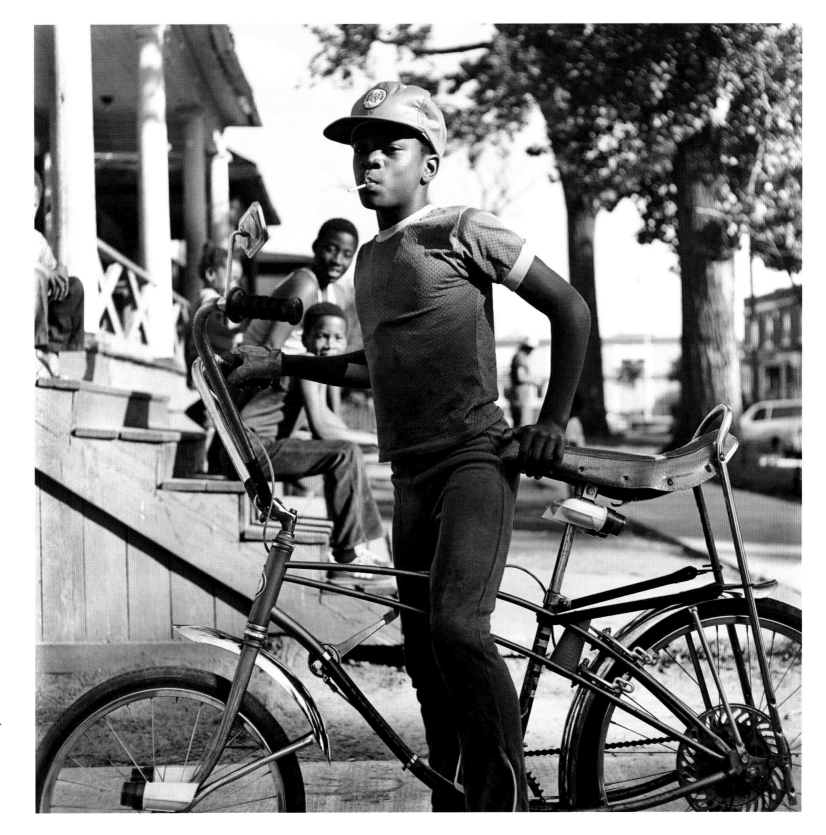

69. Boy on bicycle, near
Commonwealth
Street, ca. 1983

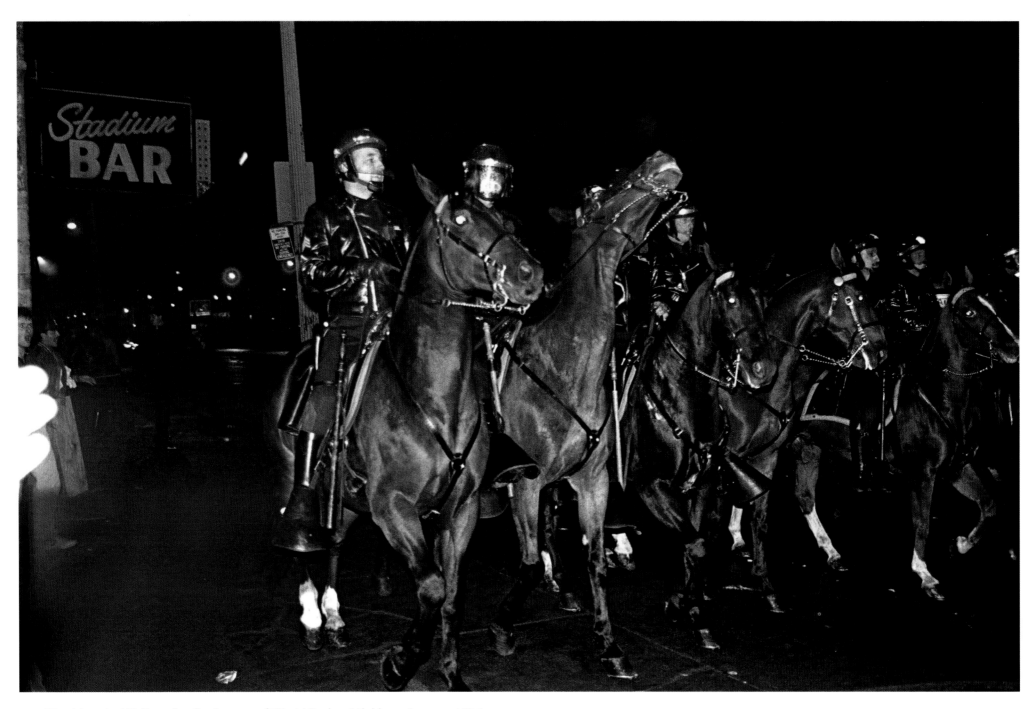

70. Mounted Police after final game of World Series, Michigan Avenue, 1984

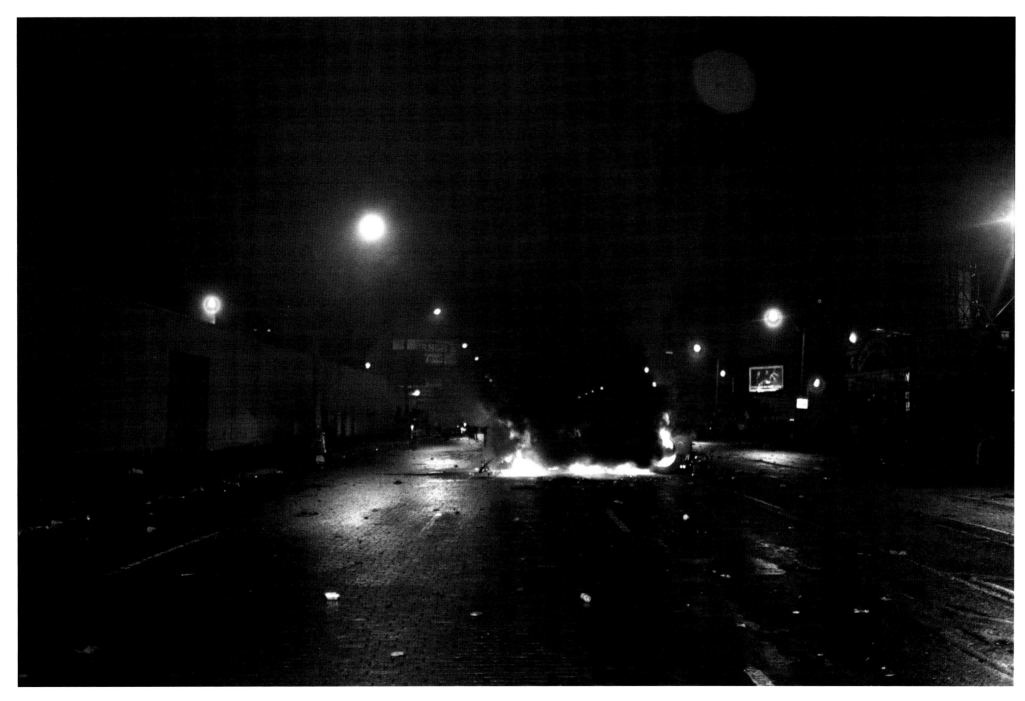

71. Car on fire after final game of World Series, 1984

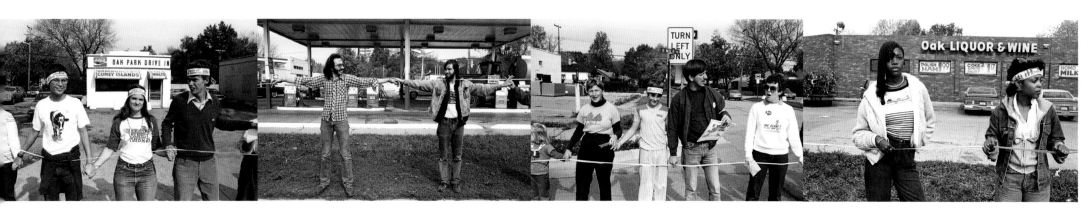

Plate 1. Survival Line, Eight Mile Road, Oak Park, October 1984

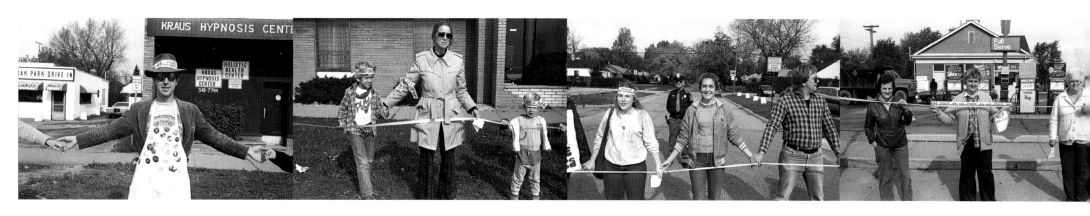

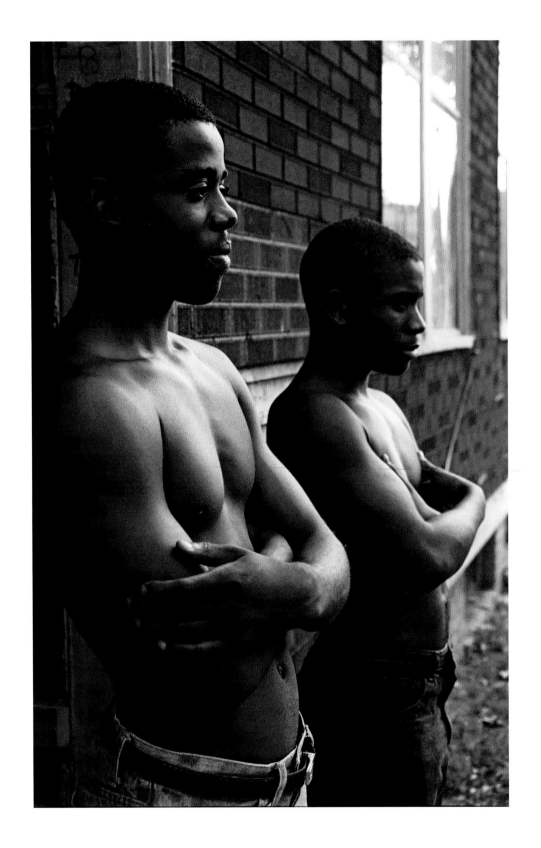

72. (*l*) Young men on Hale Street, 1988 (Urban Interiors)

73. (*r*) Chene Street from Palmer Street, 1988 (Urban Interiors)

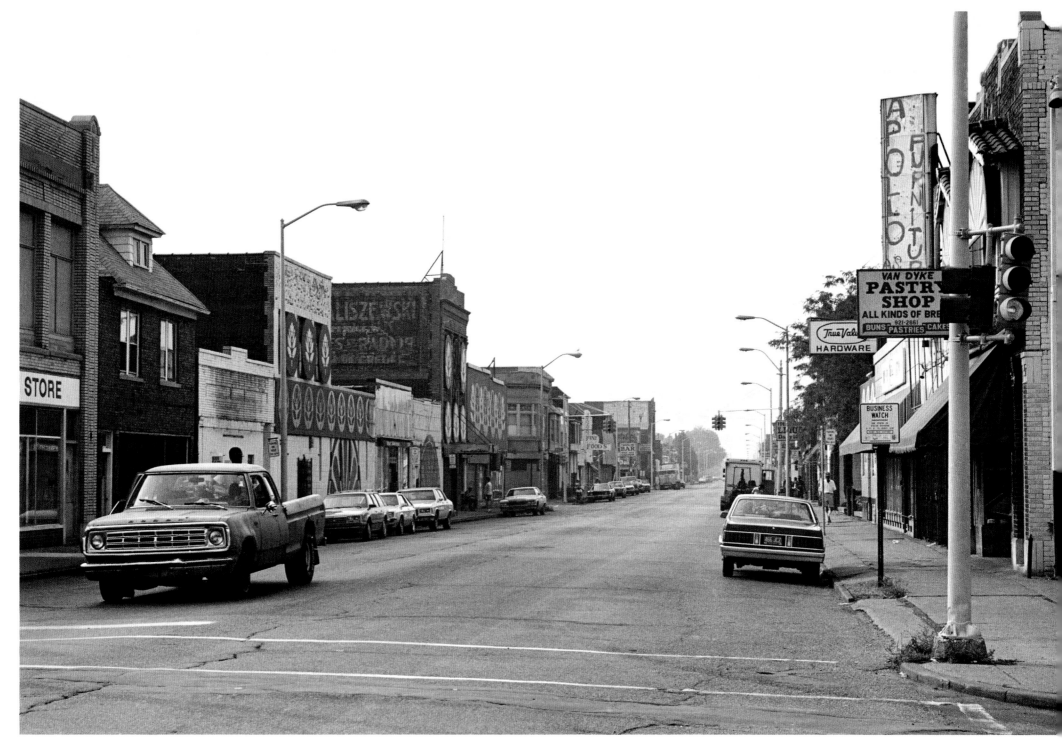

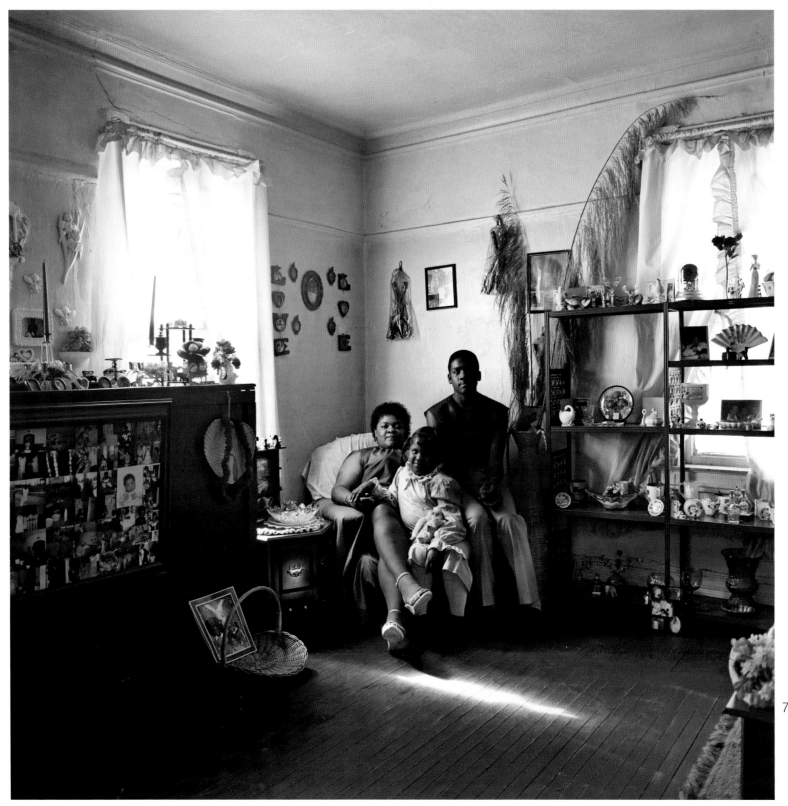

74. Lillian Guyton and children, Willis Street, 1988 (Urban Interiors)

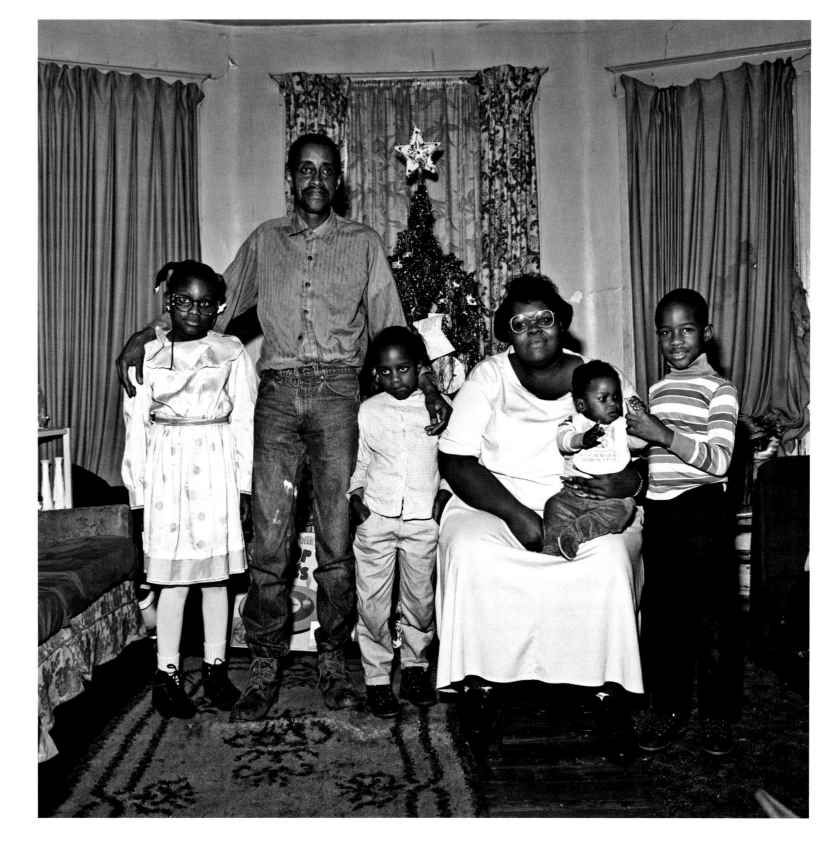

75. Clarence Sherman, Nita
Guyton, and children,
Weitzel Court, 1989
(Urban Interiors)

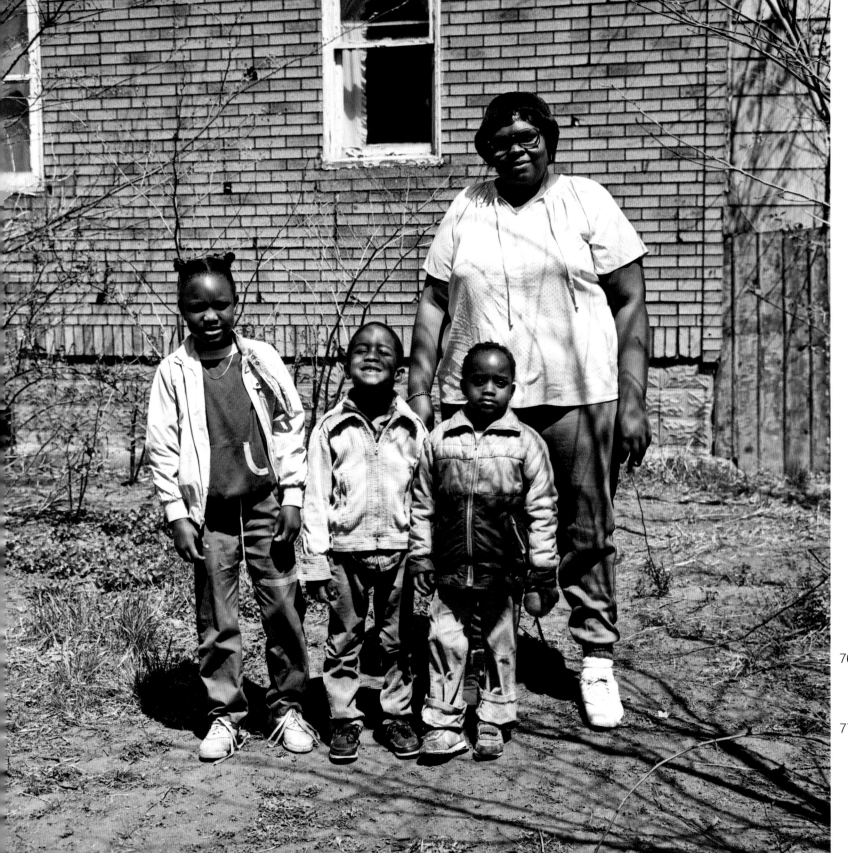

76. (*l*) Nita Guyton and children, Weitzel Court, 1988 (Urban Interiors)

77. (*r*) Filling the pool, Weitzel Court, 1988 (Urban Interiors)

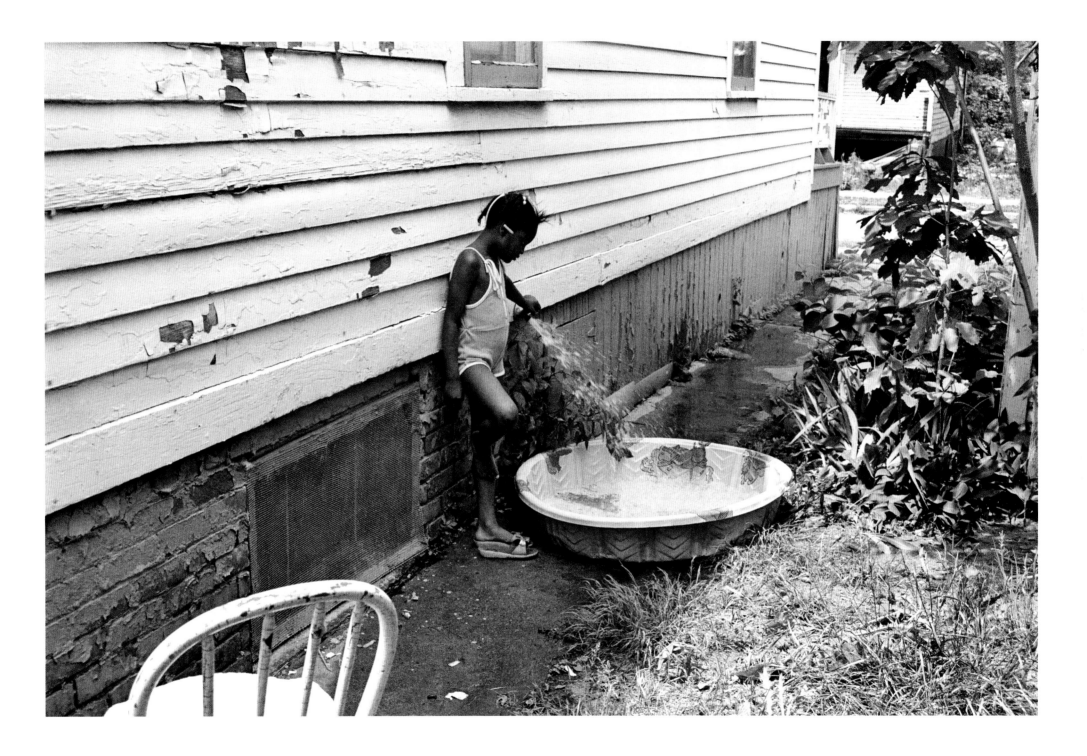

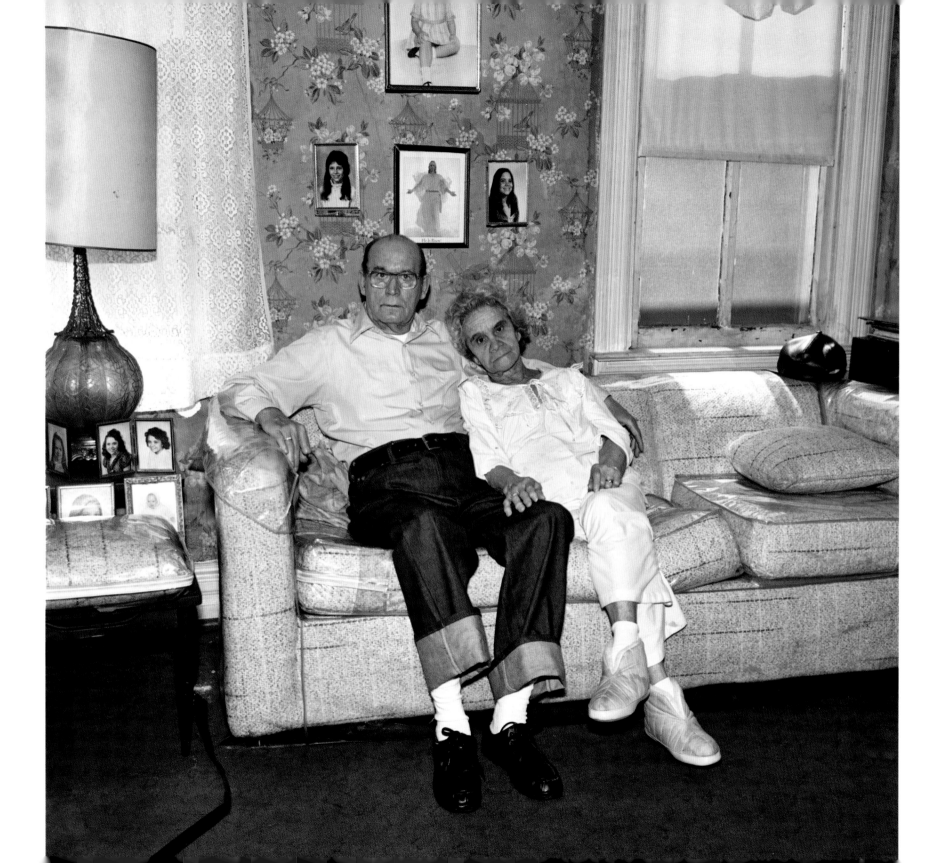

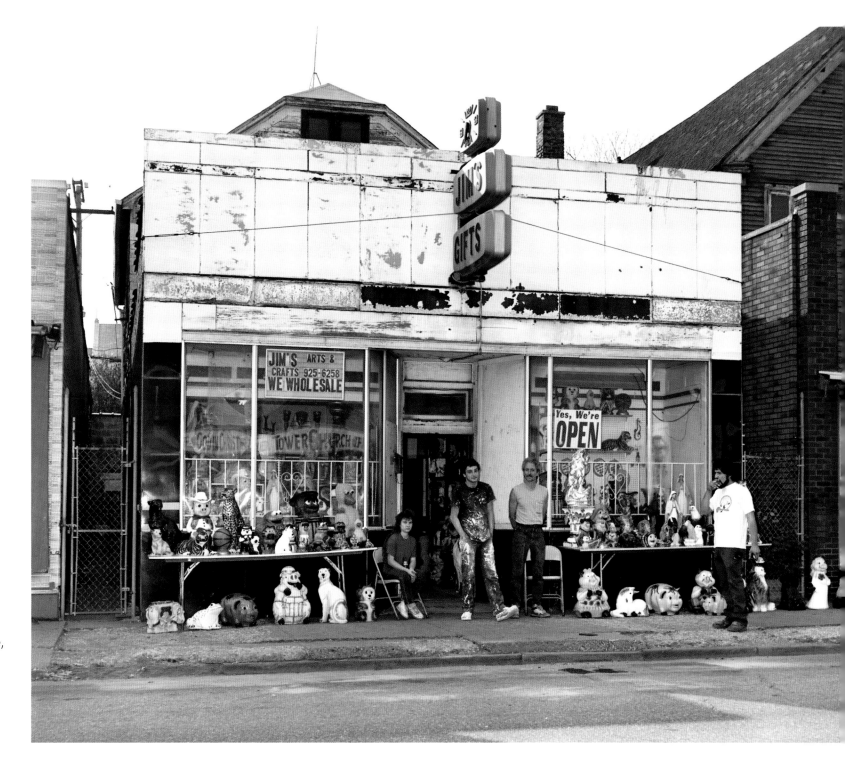

78. (*l*) Helen and Emery Meade, Dubois Street, 1988 (Urban Interiors)

79. (*r*) Jim's Gifts, Chene Street, 1989 (Urban Interiors)

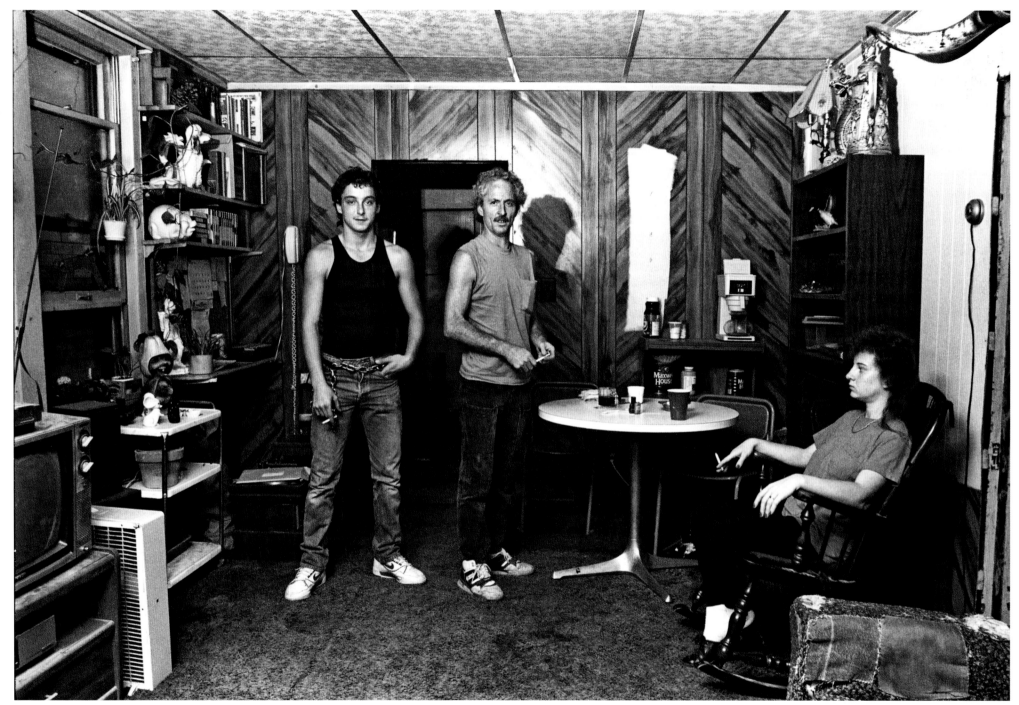

80. Eric Wilmoth, Jim Wilmoth, and Janine Werts, Chene Street, 1989 (Urban Interiors)

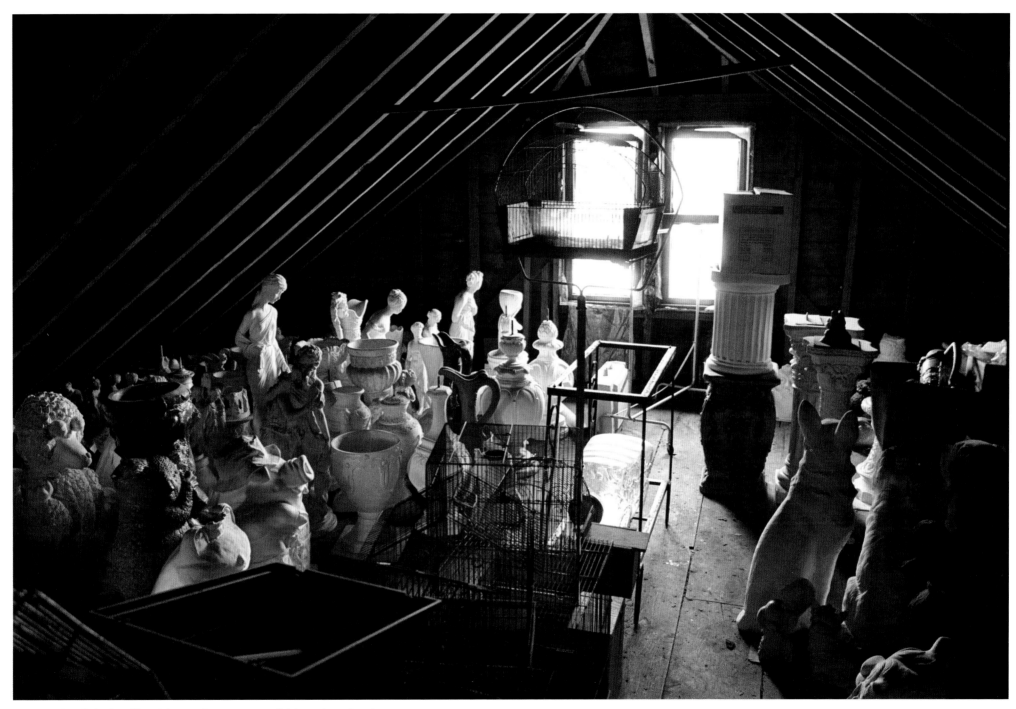

81. Attic of Jim's Gifts, Chene Street, 1989 (Urban Interiors)

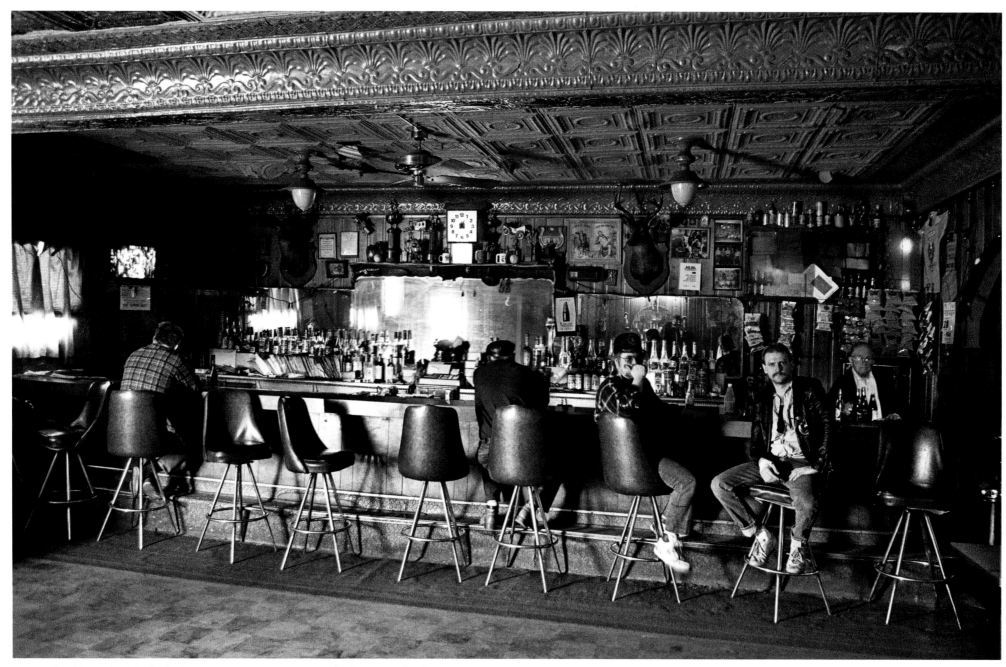

82. Buckhorn Inn, Dubois Street at Ferry Street, 1989 (Urban Interiors)

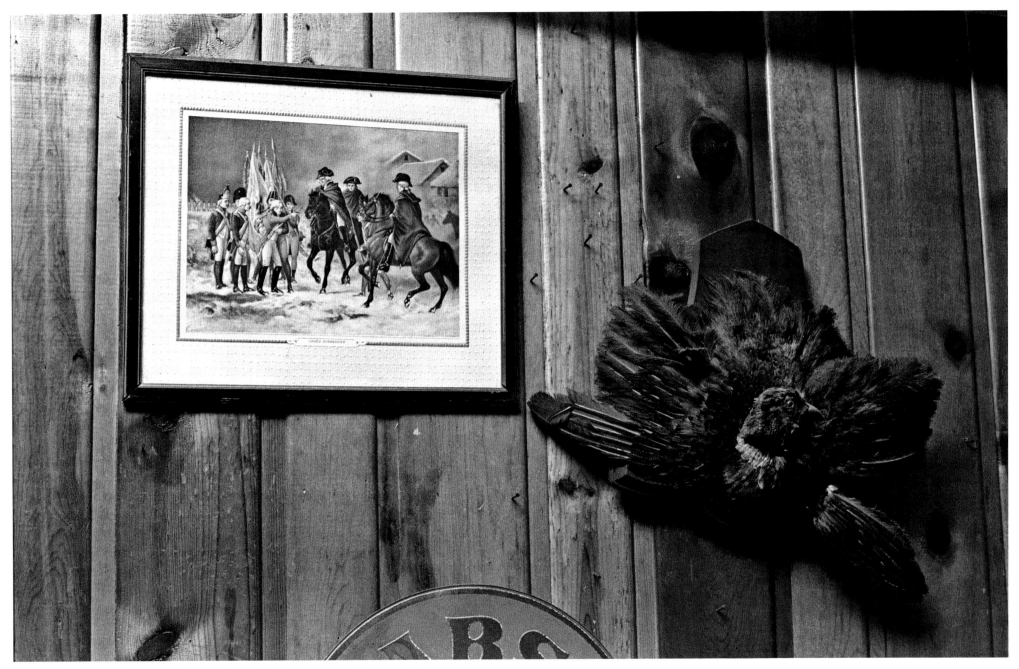

83. Buckhorn Inn, Dubois Street at Ferry Street, 1989 (Urban Interiors)

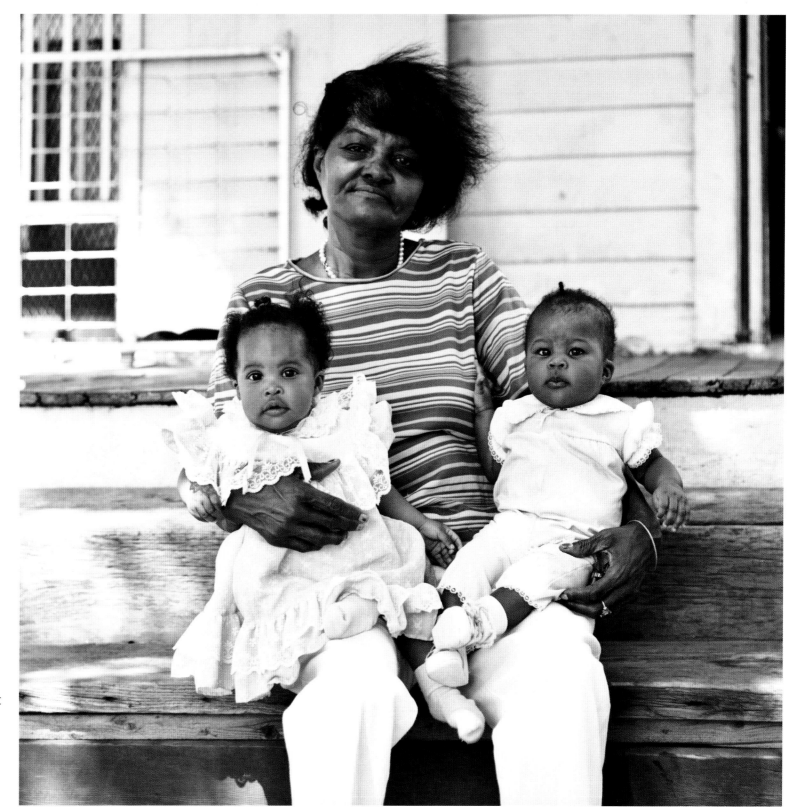

84. (*l*) Buckhorn Inn, Dubois Street at Ferry Street, 1989 (Urban Interiors)

85. (*r*) Bonnie Woods and grand-babies, Moran Street near Forest Avenue, 1988 (Urban Interiors)

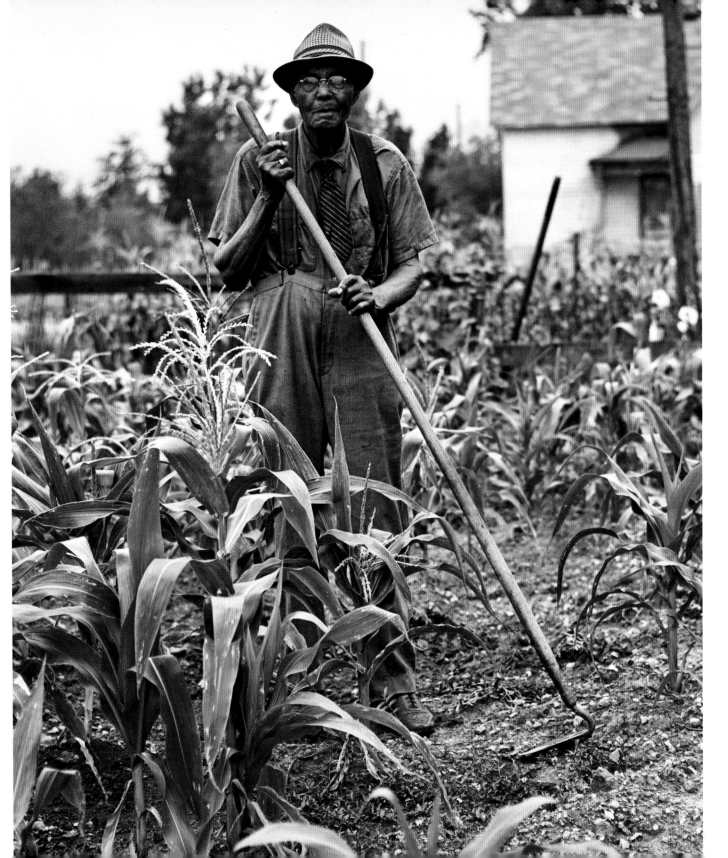

86. (*l*) Cicero Whitlow, St. Aubin Street, 1988 (Urban Interiors)

87. (*r*) Mantel in Cicero Whitlow home, St. Aubin Street, 1988 (Urban Interiors)

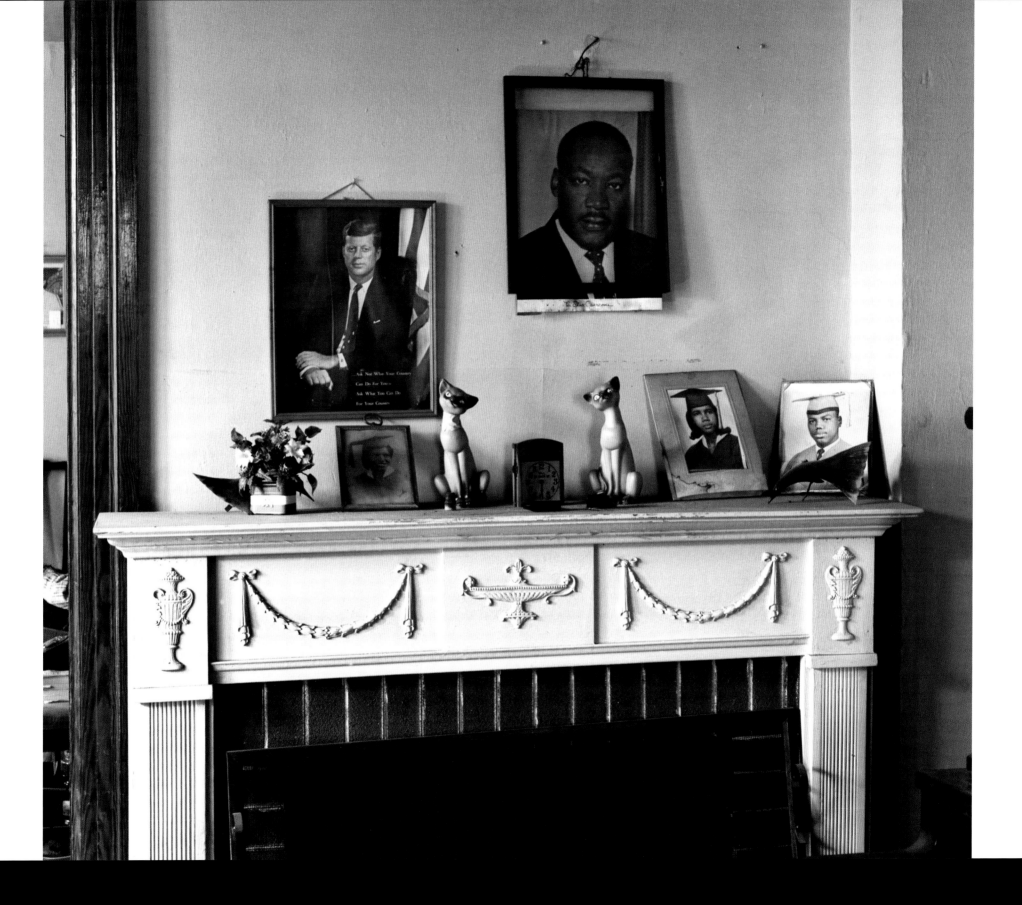

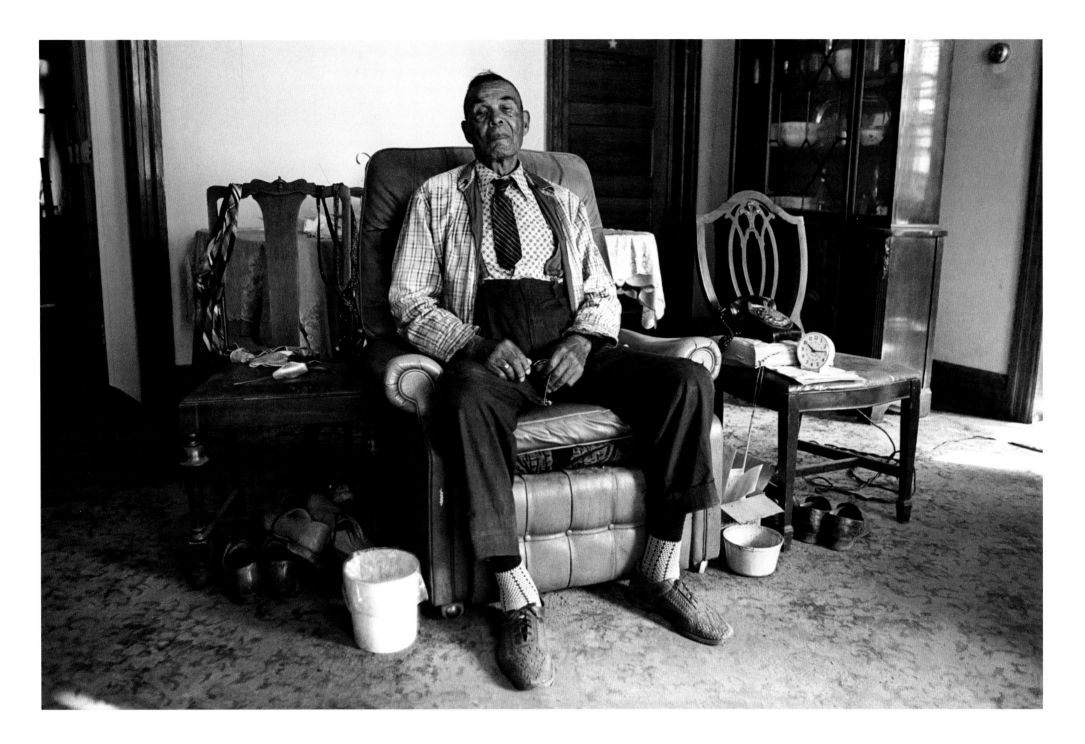

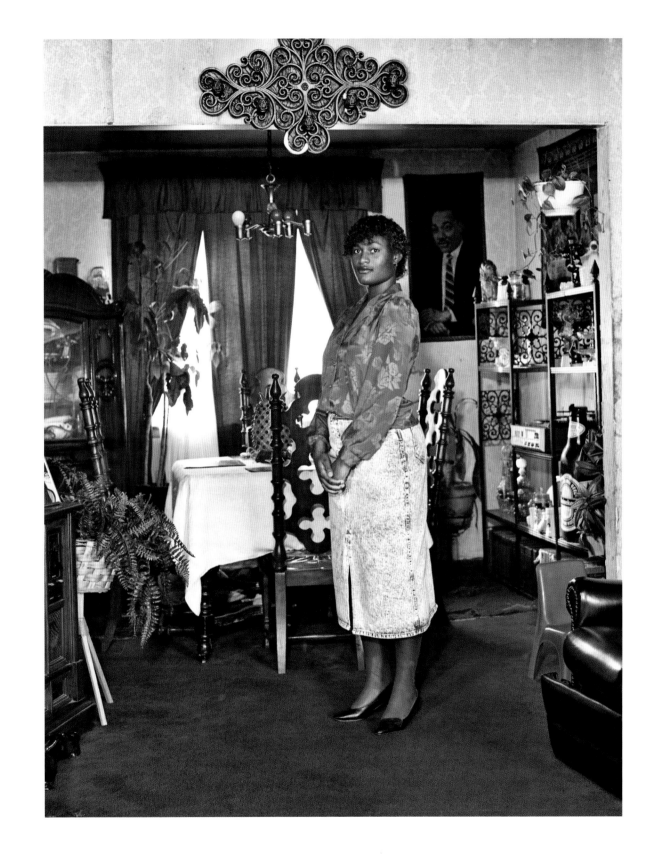

88. (*l*) Cicero Whitlow, St. Aubin Street, 1988 (Urban Interiors)

89. (*r*) Kim Jones, Dubois Street, 1987 (Urban Interiors)

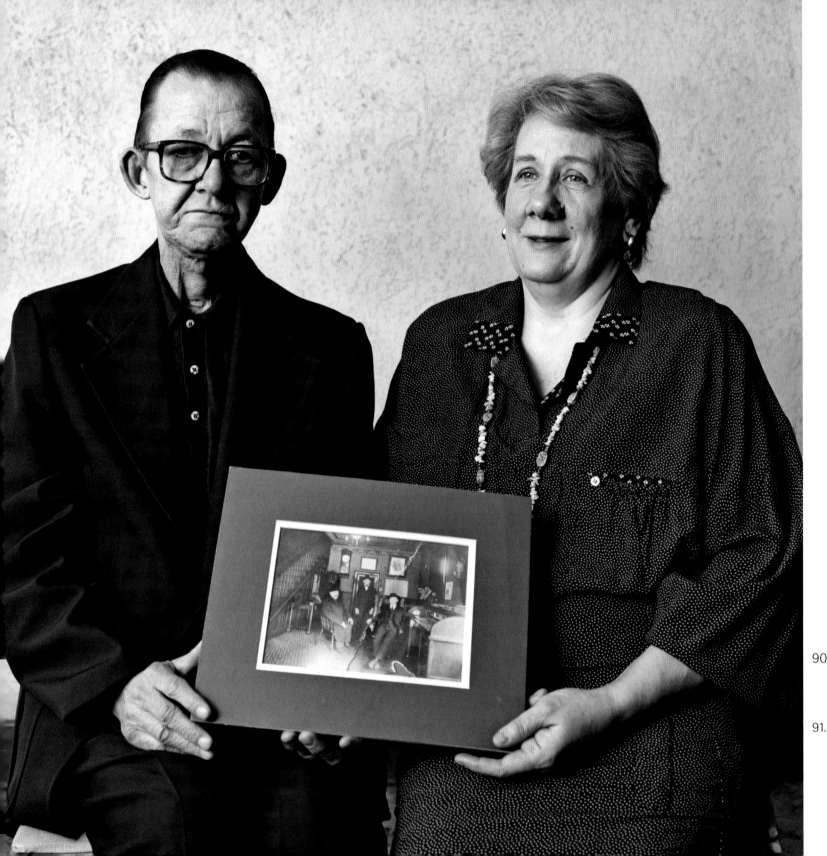

90. (*l*) Joseph and Jeanette Kulwicki, St. Aubin Street, 1989 (Urban Interiors)

91. (*r*) Parlor of Kulwicki Funeral Home, St. Aubin Street, 1988 (Urban Interiors)

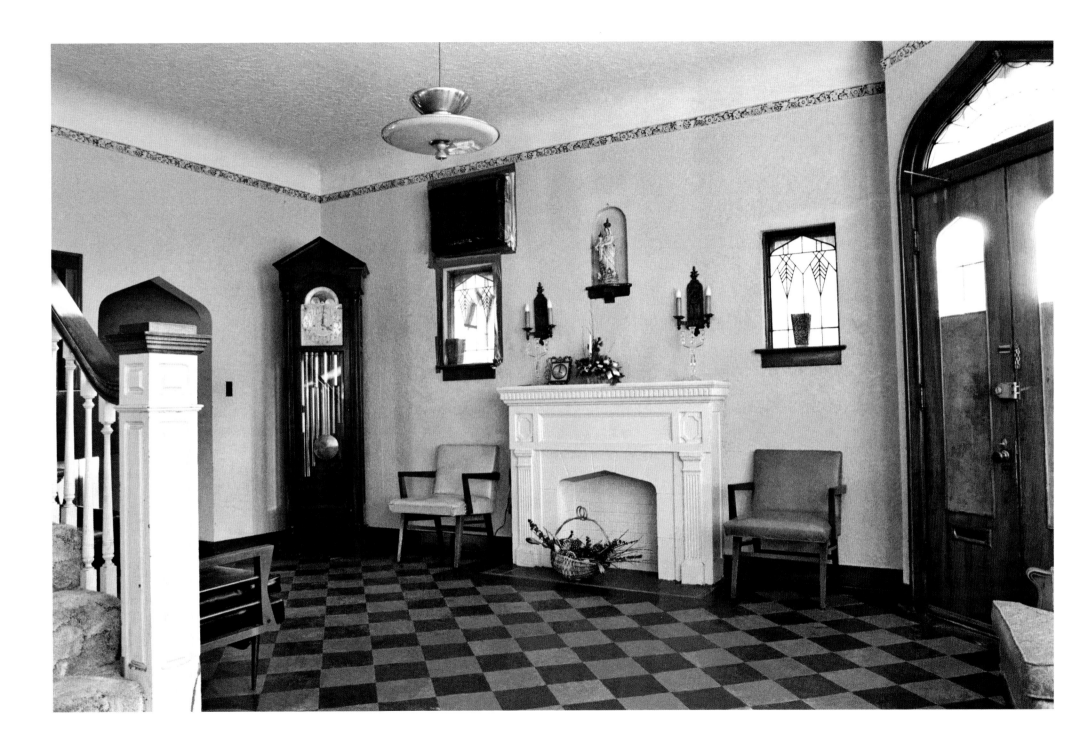

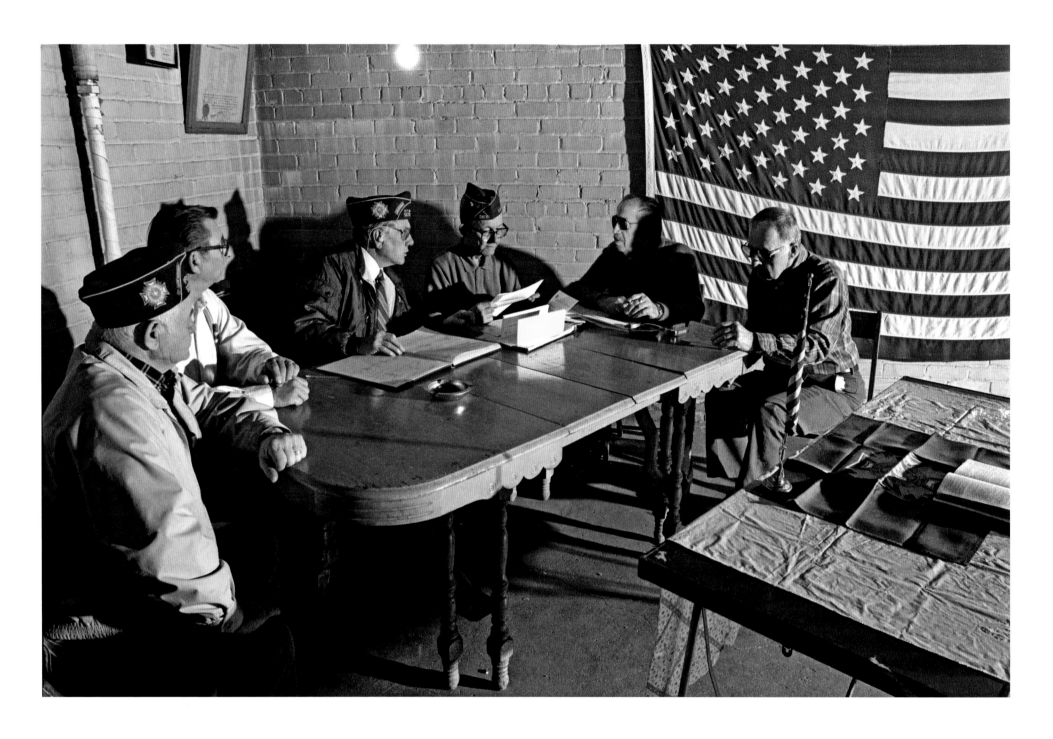

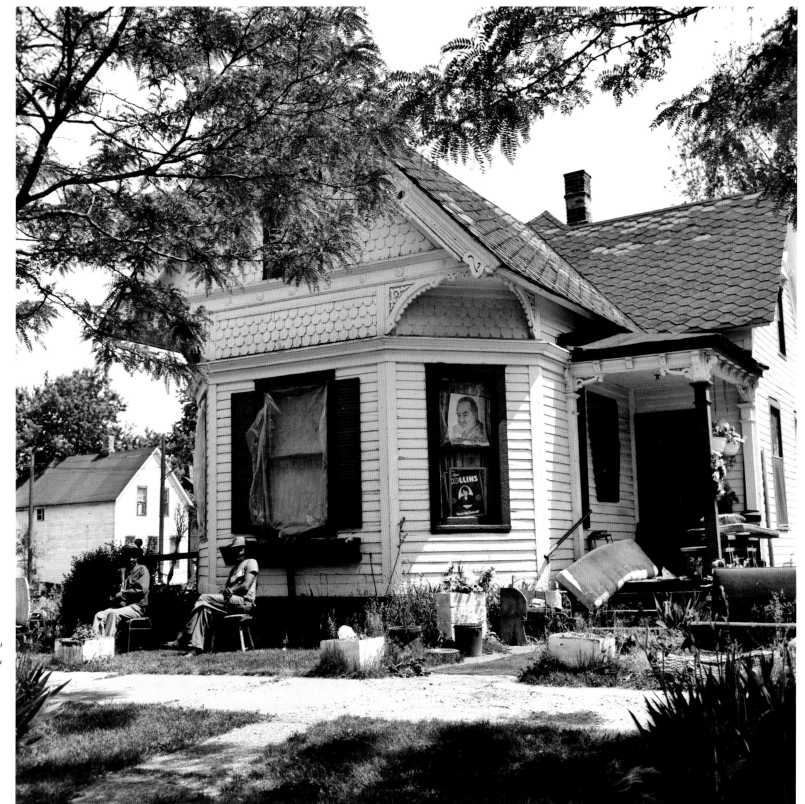

92. (*l*) Meeting of Post 5676 of the Veterans of Foreign Wars, basement of Kulwicki home, St. Aubin Street, 1989 (Urban Interiors)

93. (*r*) Johnny Smith home, Joseph Campau Avenue, 1988 (Urban Interiors)

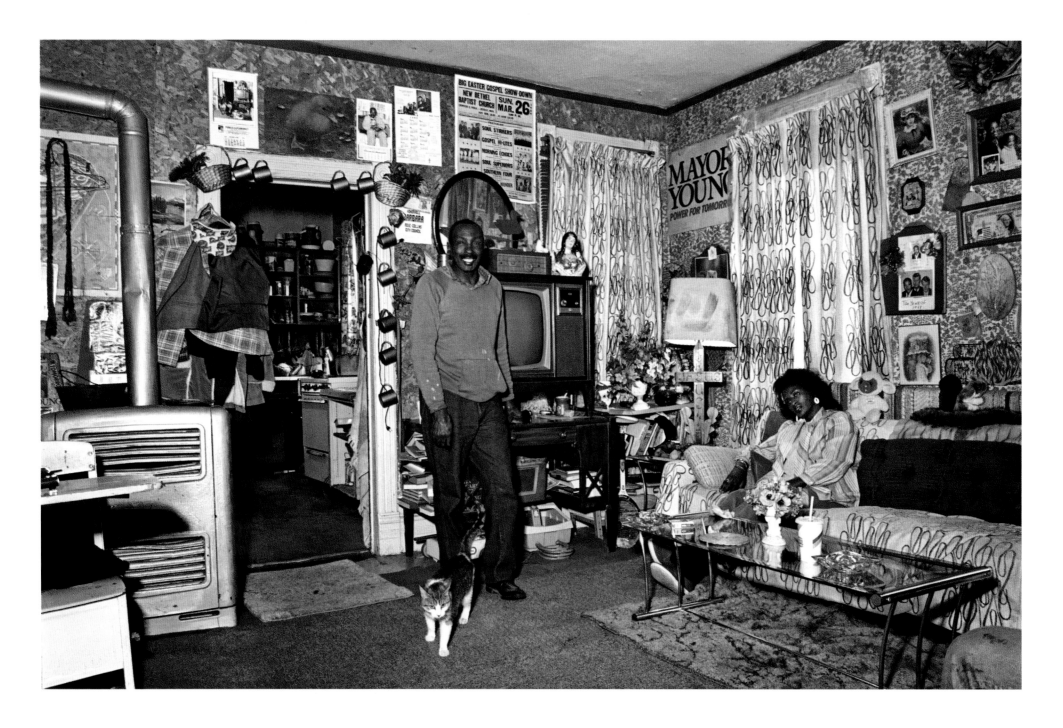

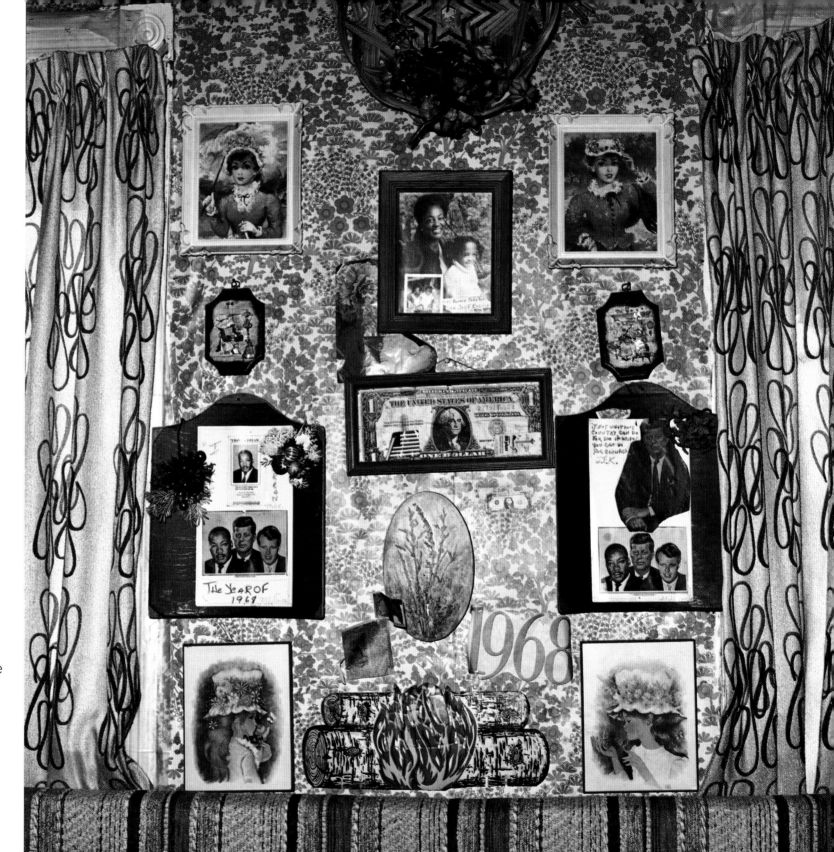

94. (*l*) Johnny Smith and Laverne
 Little, Joseph Campau Ave-
 nue, 1989 (Urban Interiors)

95. (*r*) Wall detail, Johnny Smith
 home, Joseph Campau Ave-
 nue, 1988 (Urban Interiors)

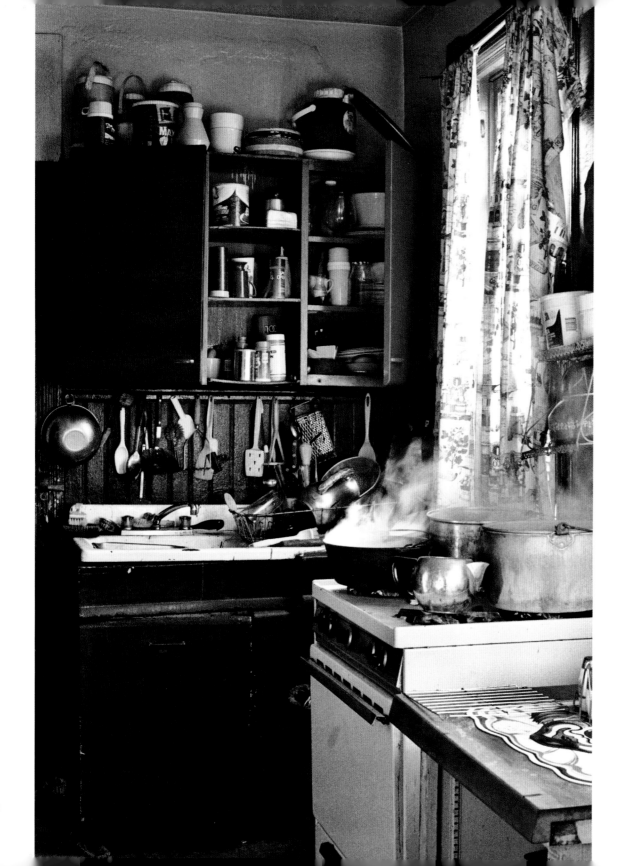

96. (*l*) Kitchen in Johnny Smith home, Joseph Campau Avenue, 1989 (Urban Interiors)

97. (*r*) Mae Cole, Mitchell Street at Mack Avenue, 1988 (Urban Interiors)

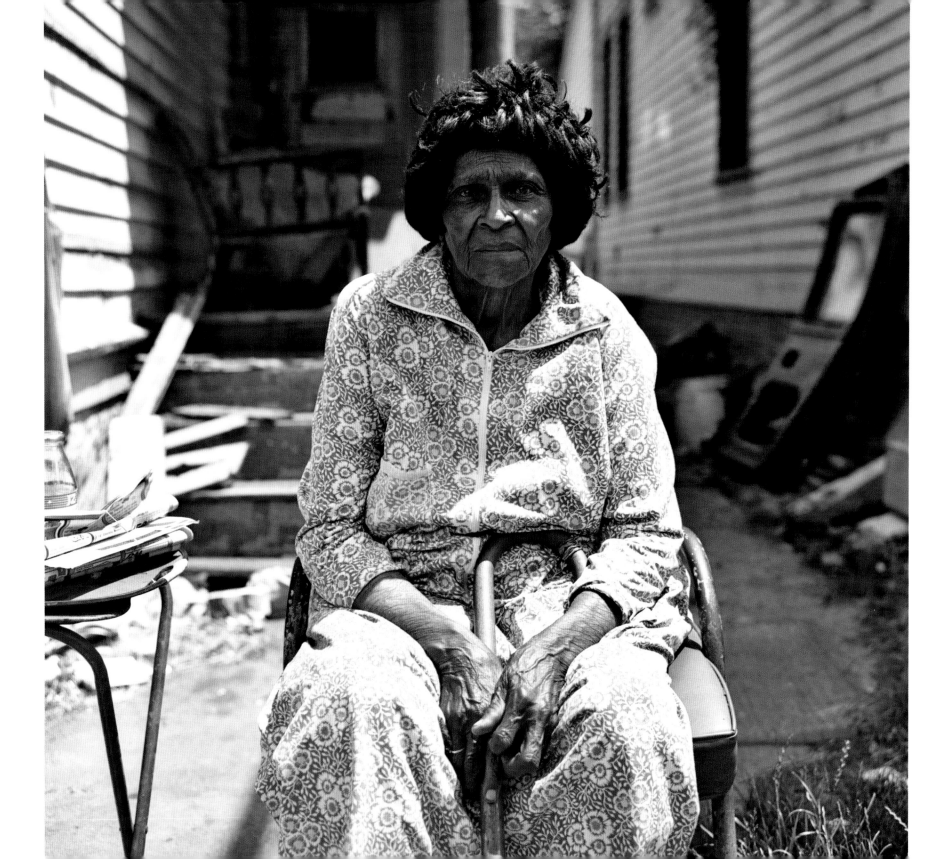

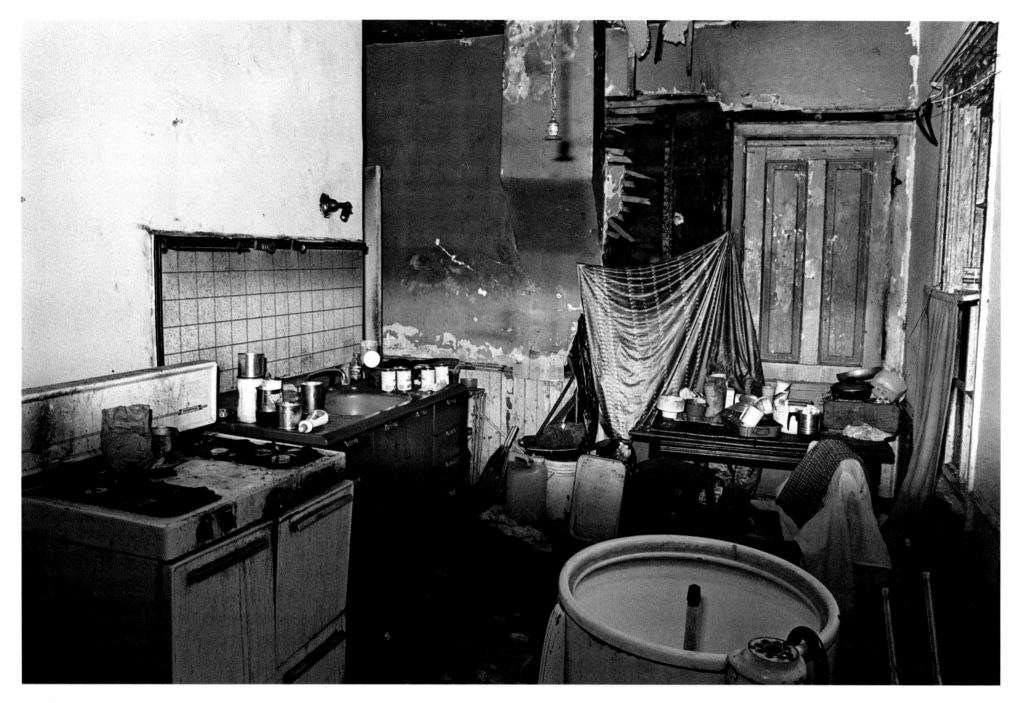

98. Kitchen in Mae Cole home, Mitchell Street at Mack Avenue, 1988 (Urban Interiors)

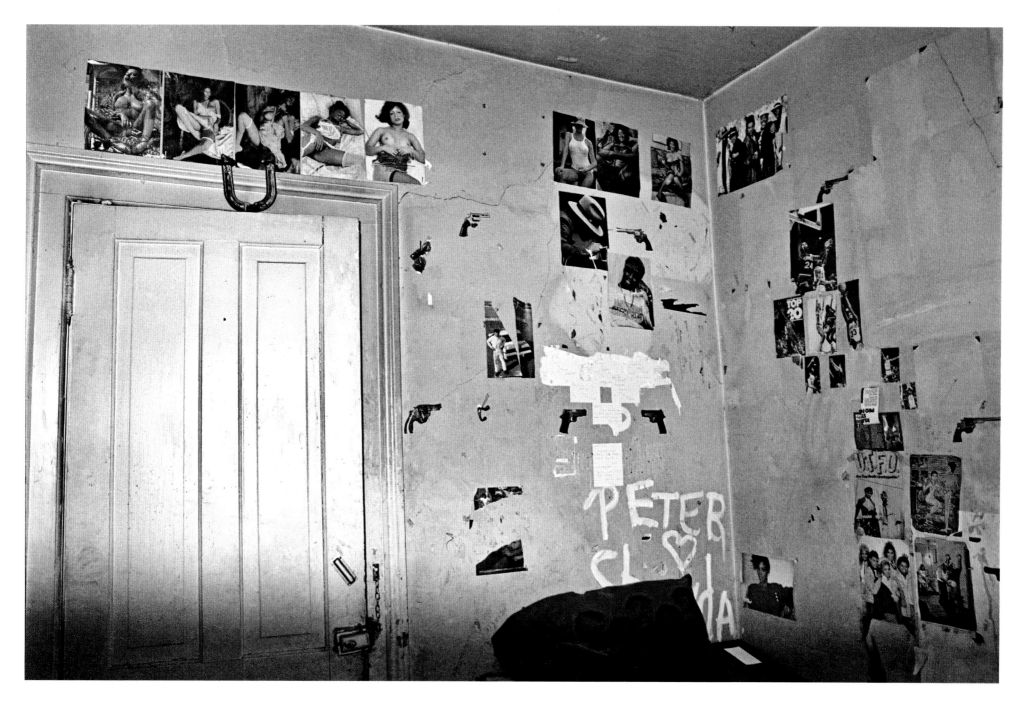

99. Bedroom in Mae Cole home, Mitchell Street at Mack Avenue, 1988 (Urban Interiors)

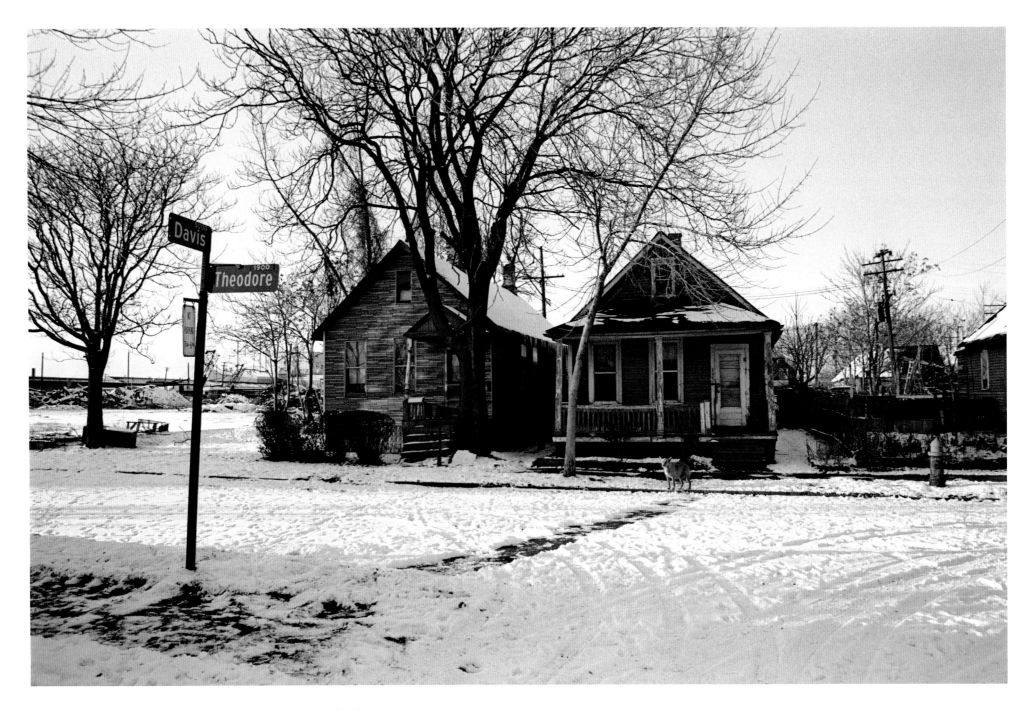

100. Homes on Theodore Street, 1988 (Urban Interiors)

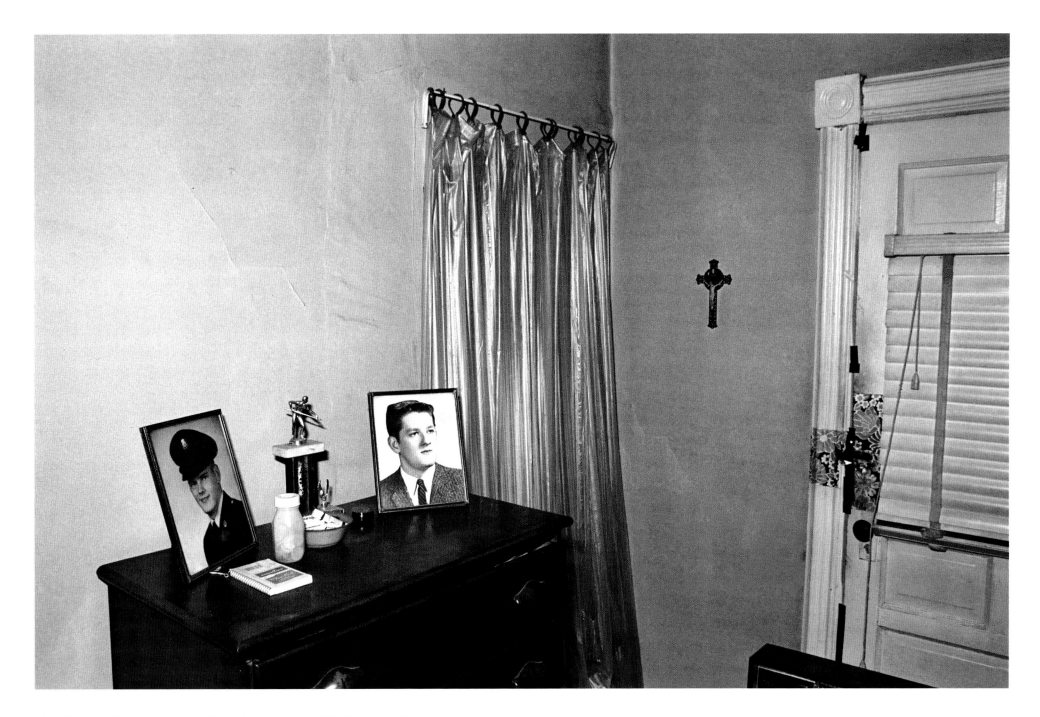

101. Stanley Budnick home, Theodore Street, 1989 (Urban Interiors)

102. Closet in Stanley Budnick home, Theodore Street, 1989 (Urban Interiors)

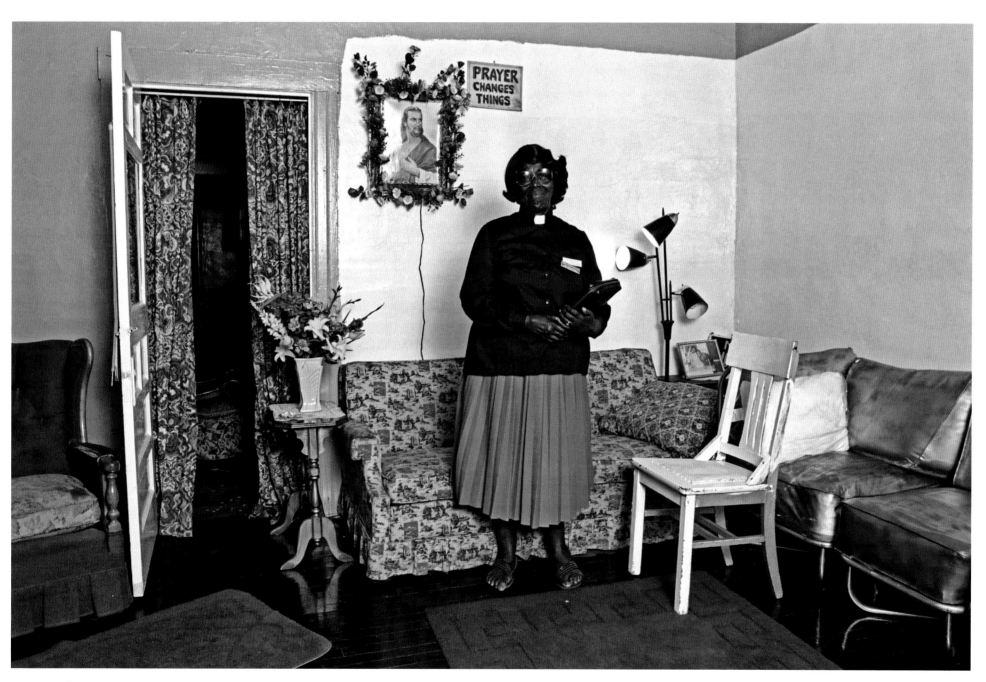

103. Estelle Laster, Moran Street at Farnsworth Street, 1989 (Urban Interiors)

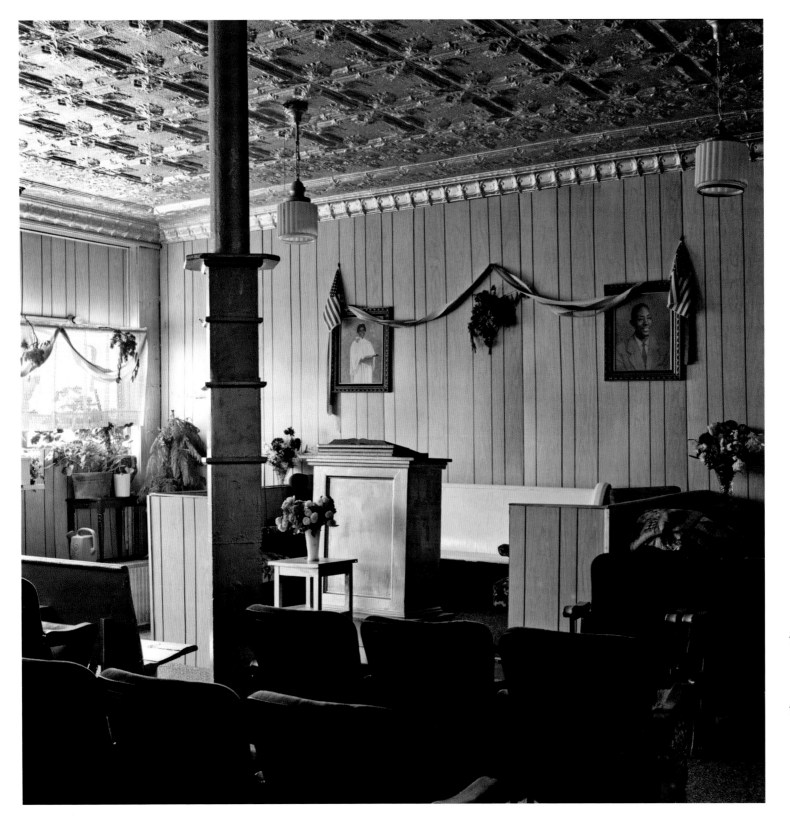

104. (*l*) Chapel, Estelle Laster home, Moran Street at Farnsworth Street, 1989 (Urban Interiors)

105. (*r*) Community room, Estelle Laster home, Moran Street at Farnsworth Street, 1989 (Urban Interiors)

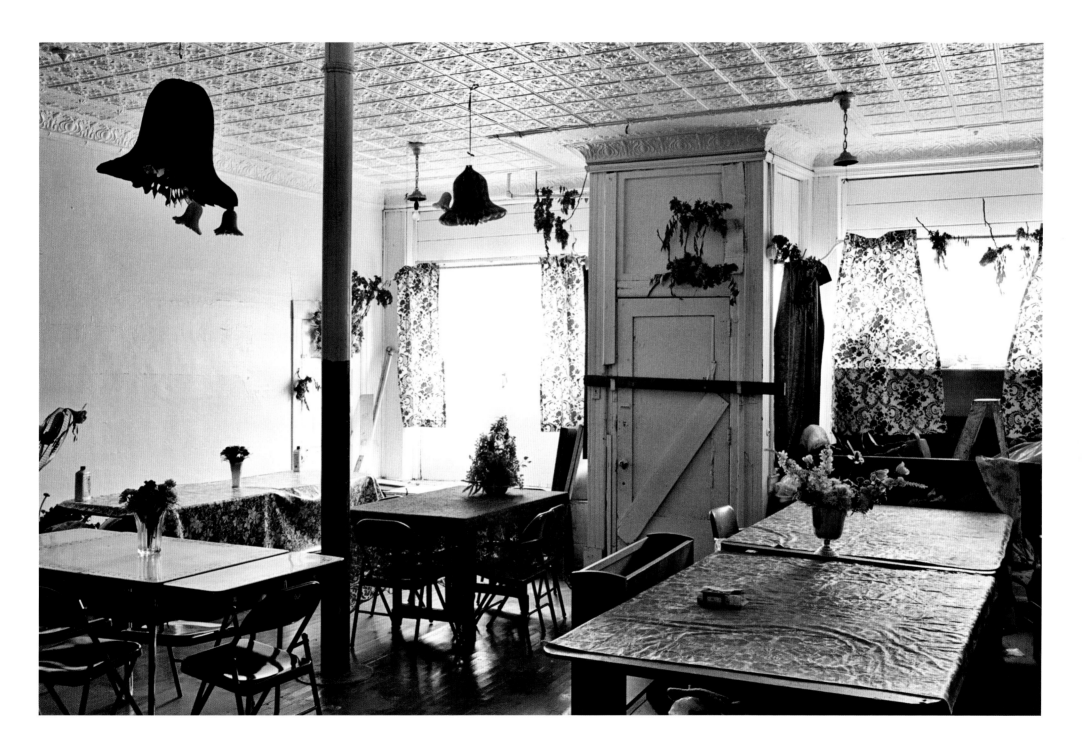

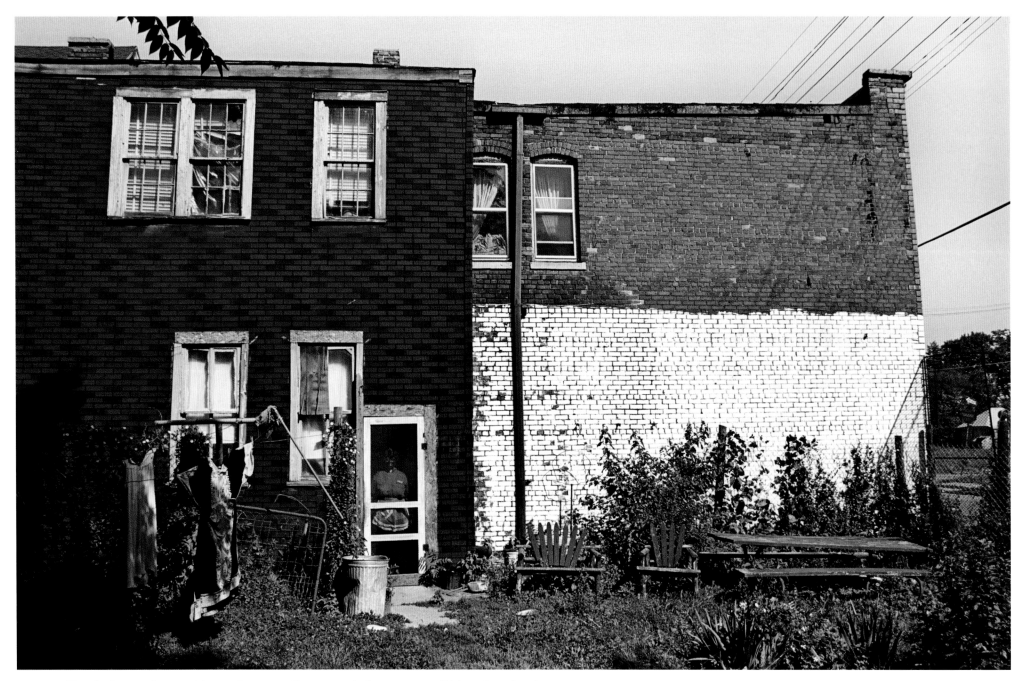

106. Estelle Laster home, Moran Street at Farnsworth Street, 1989 (Urban Interiors)

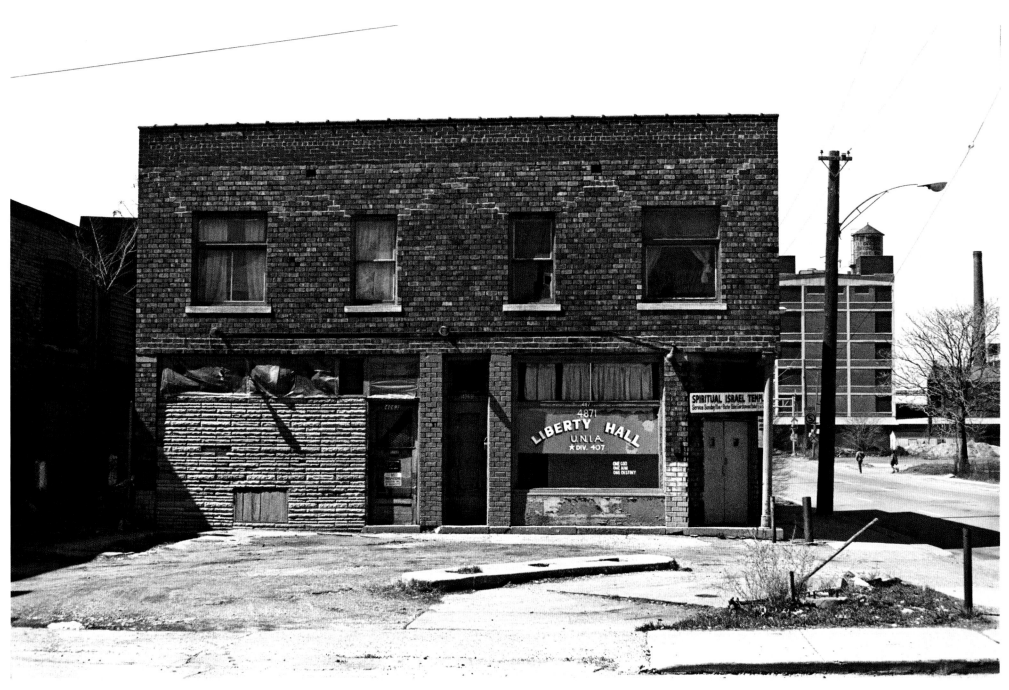

107. Liberty Hall, Universal Negro Improvement Association (UNIA), Division 407, St. Aubin Street at Warren Avenue, 1989 (Urban Interiors)

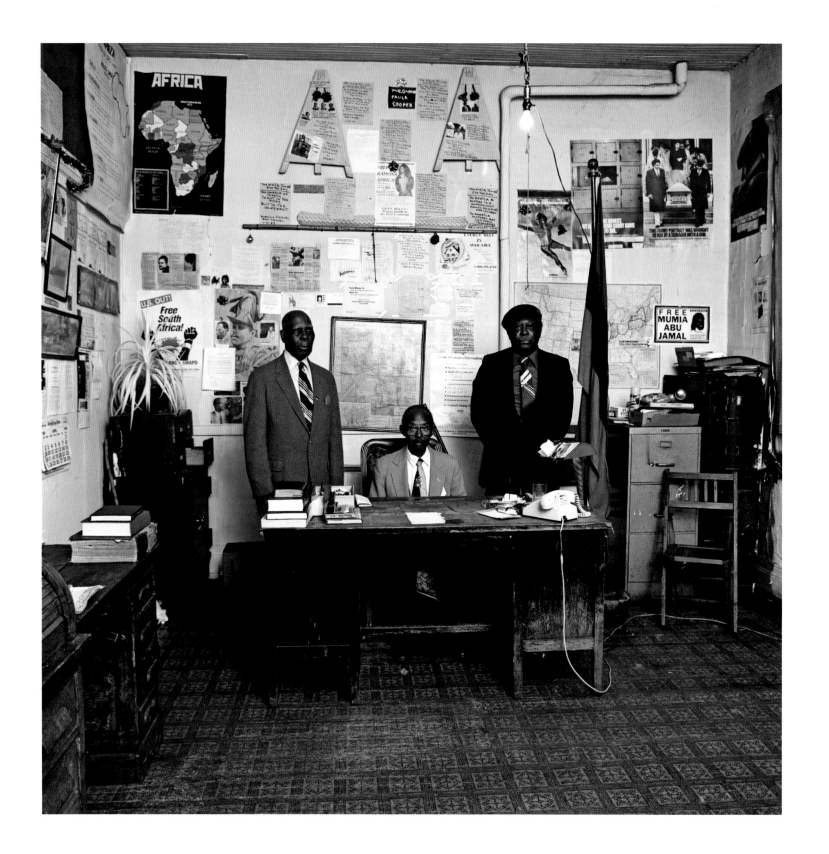

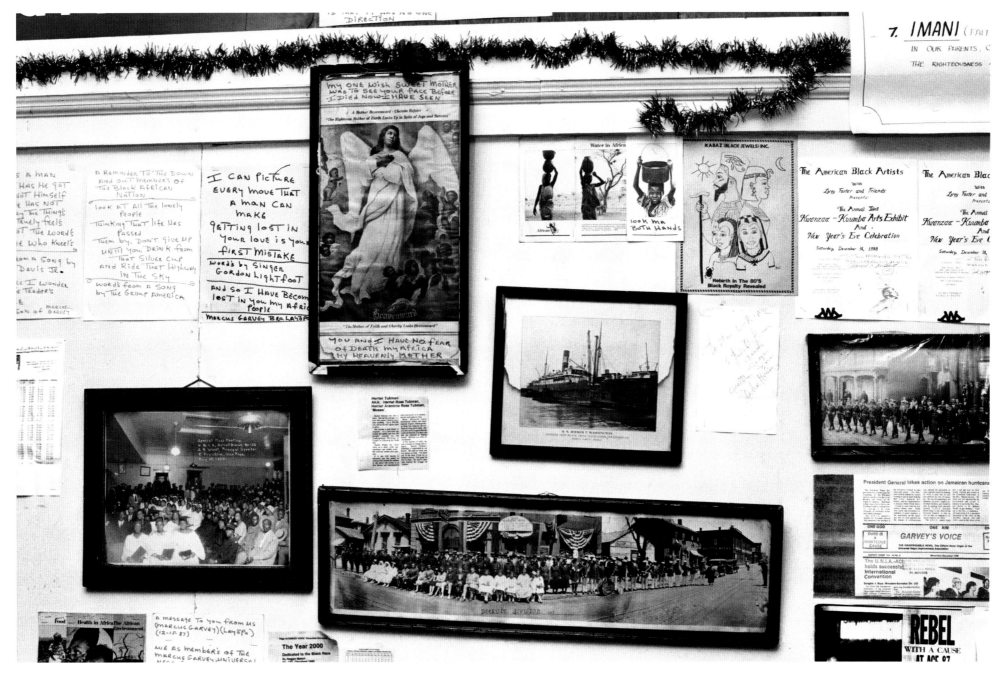

108. (*l*) *From left to right:* Colonel Leroy Jackson, President Arthur Thomas, Captain Hilbert Hanible, UNIA, St. Aubin Street at Warren Avenue, 1989 (Urban Interiors)

109. (*r*) Wall detail, UNIA, St. Aubin Street at Warren Avenue, 1989 (Urban Interiors)

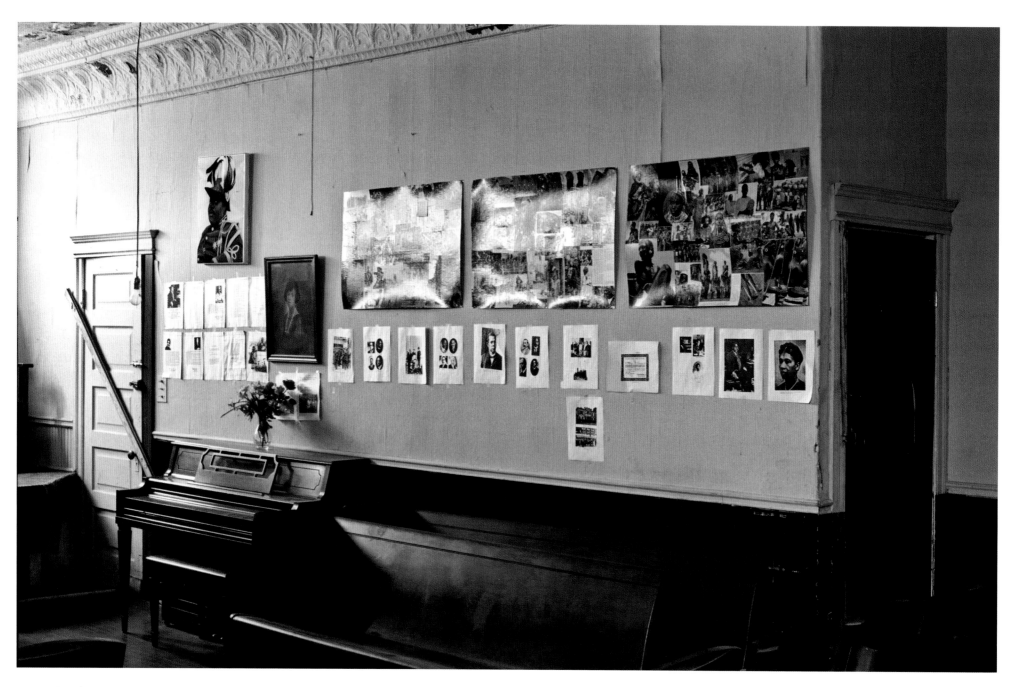

110. Meeting room, UNIA, St. Aubin Street at Warren Avenue, 1989 (Urban Interiors)

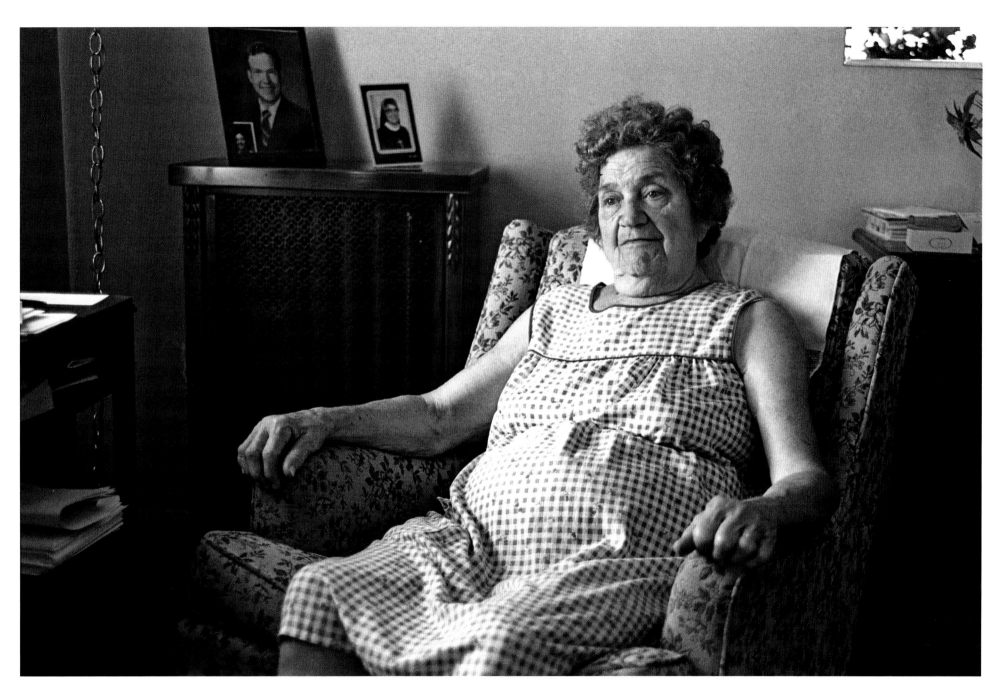

111. Clara Jozwiak, Joseph Campau Avenue, 1988 (Urban Interiors)

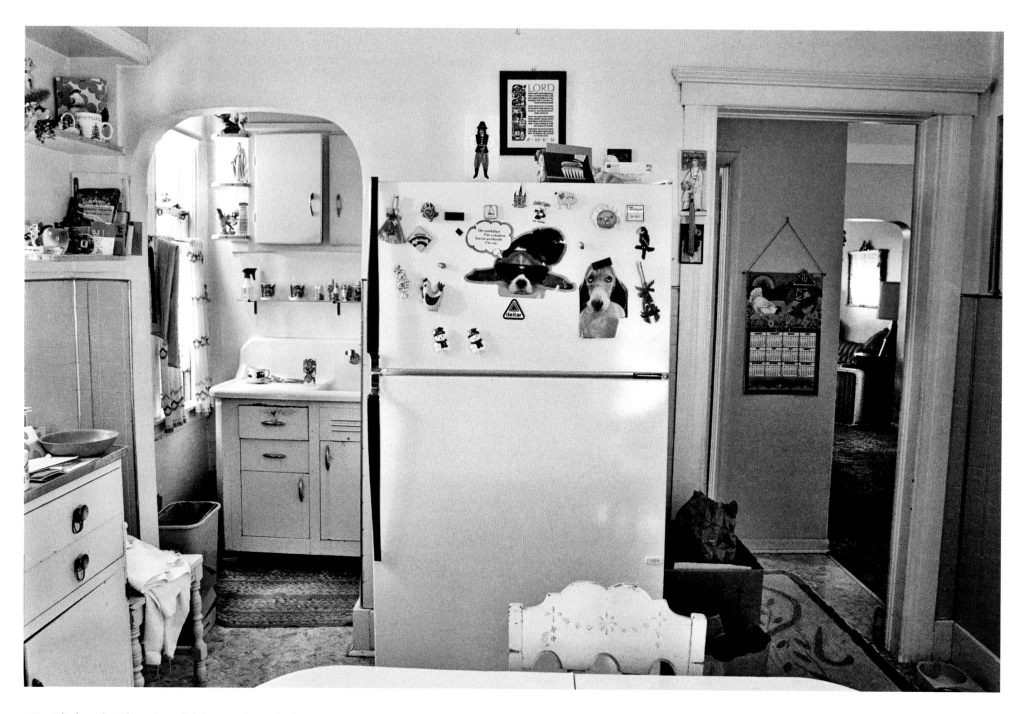

112. Kitchen in Clara Jozwiak home, Joseph Campau Avenue, 1988 (Urban Interiors)

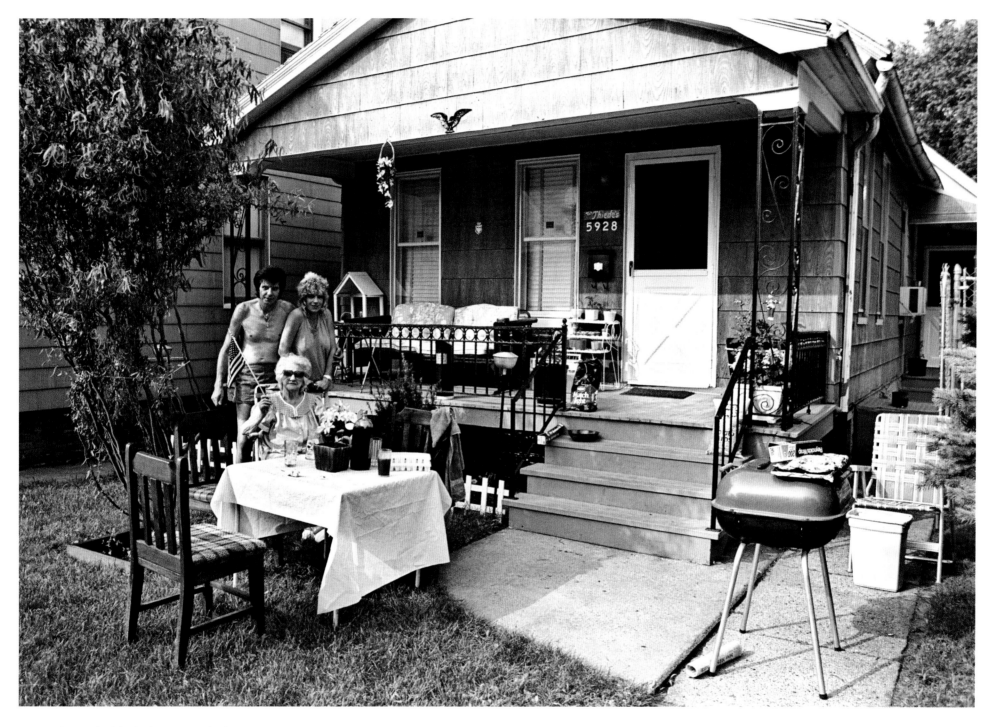

113. Edmund Thiede home, Dubois Street, 1989 (Urban Interiors)

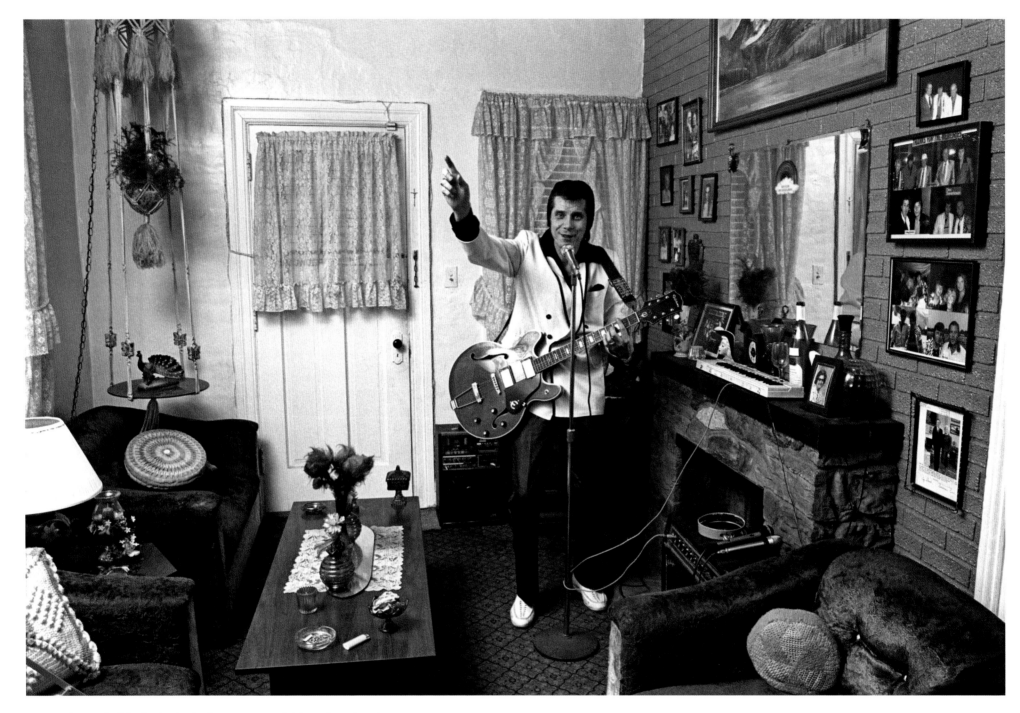

114. Edmund Thiede, Dubois Street, 1989 (Urban Interiors)

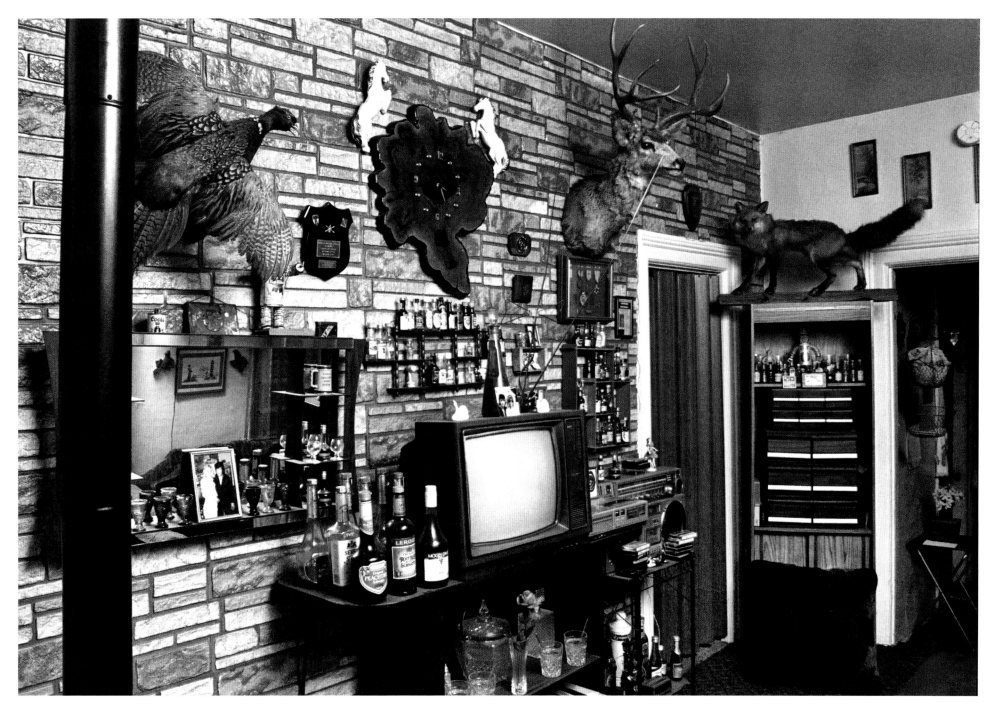

115. Den in Edmund Thiede home, Dubois Street, 1989 (Urban Interiors)

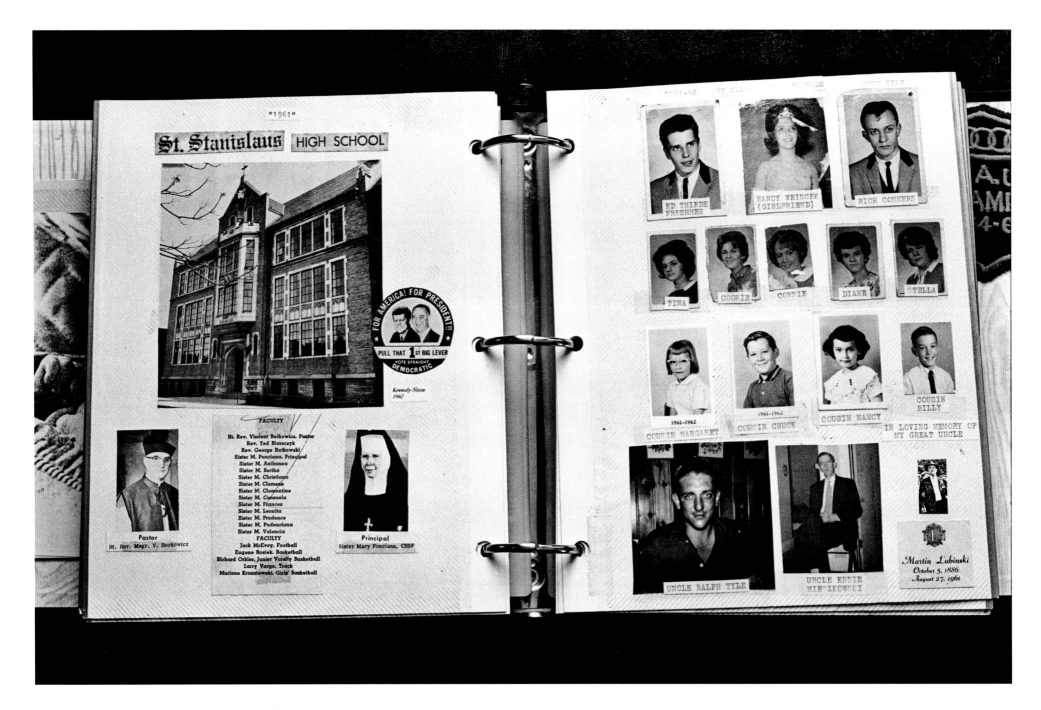

116. Edmund Thiede scrapbook, 1989 (Urban Interiors)

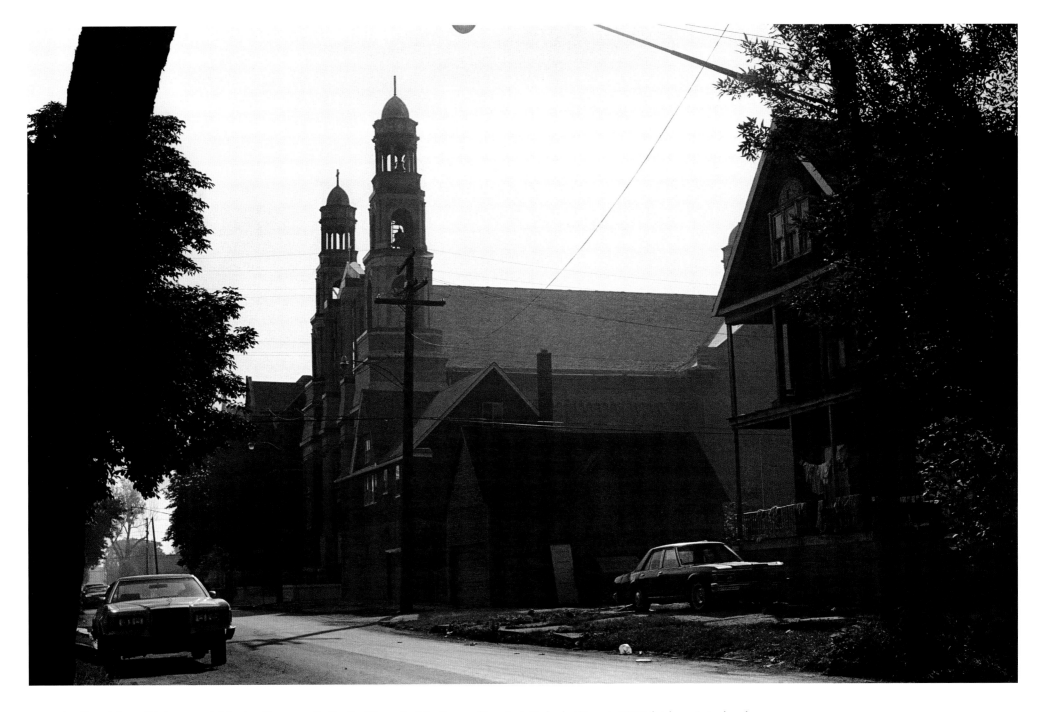

117. St. Stanislaus Bishop and Martyr Roman Catholic Church, Medbury Street at Dubois Street, 1989 (Urban Interiors)

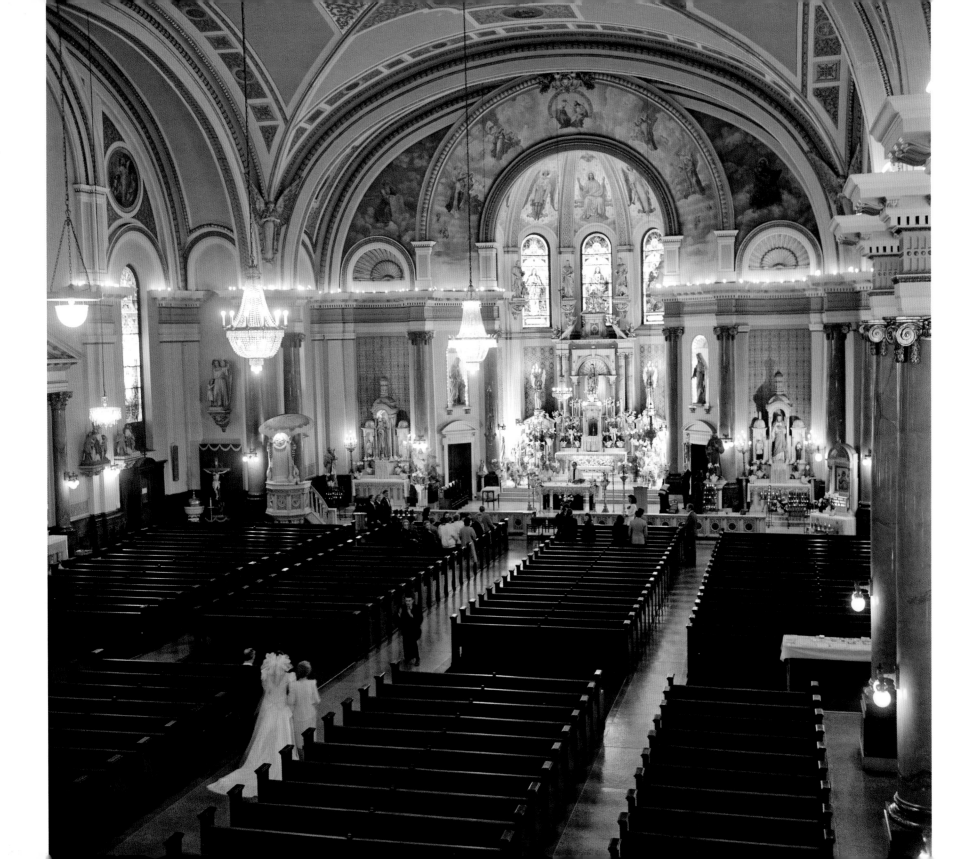

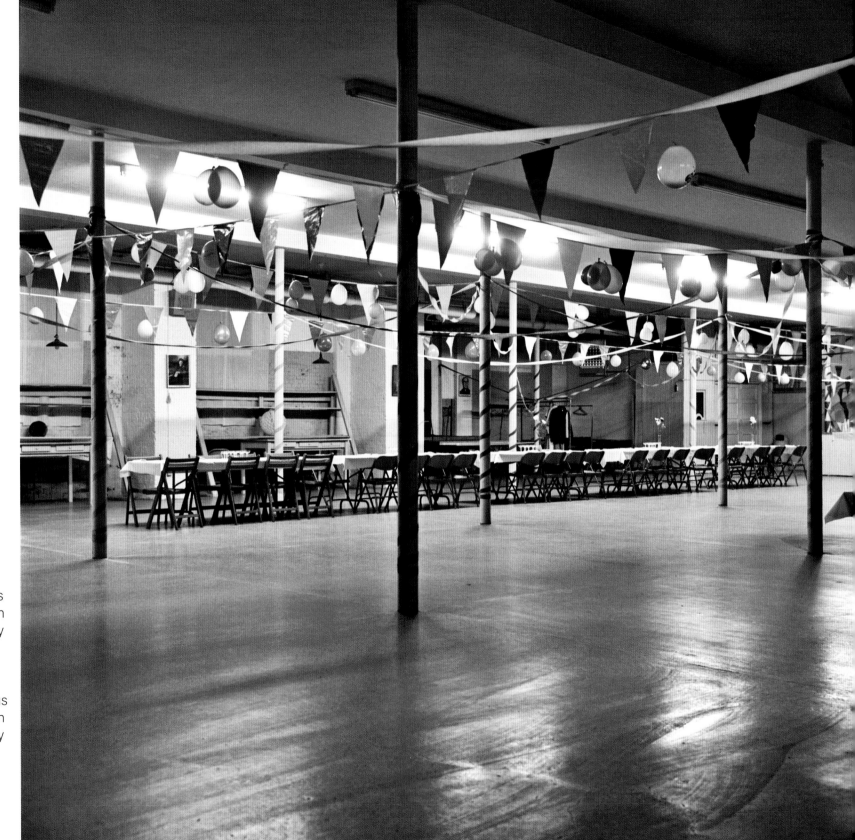

118. (*l*) Wedding, St. Stanislaus Bishop and Martyr Roman Catholic Church, Medbury Street at Dubois Street, 1989 (Urban Interiors)

119. (*r*) Basement, St. Stanislaus Bishop and Martyr Roman Catholic Church, Medbury Street at Dubois Street, 1989 (Urban Interiors)

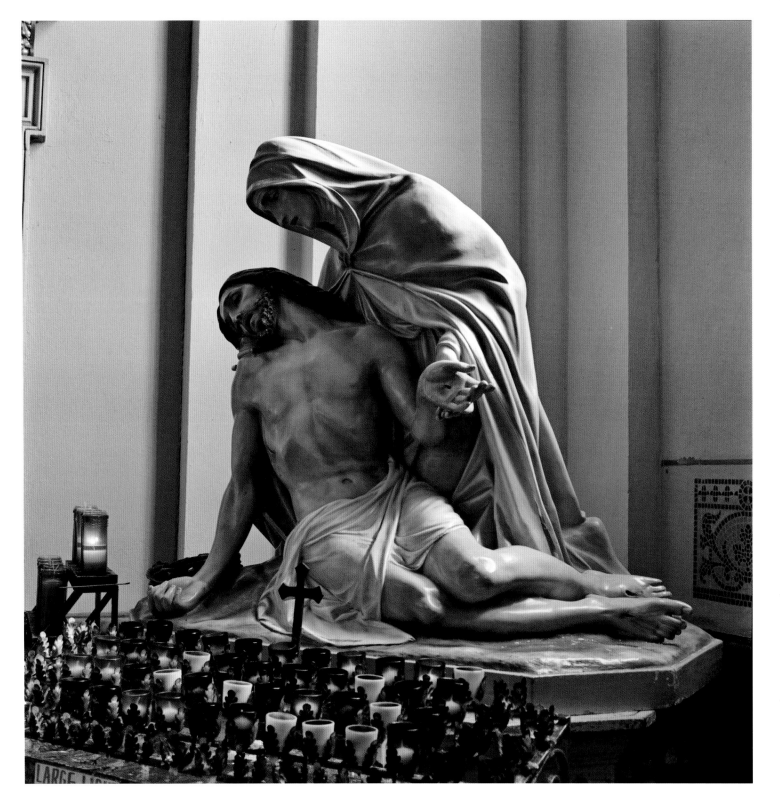

120. (*l*) Pietà, St. Stanislaus Bishop and Martyr Roman Catholic Church, Medbury Street at Dubois Street, 1989 (Urban Interiors)

121. (*r*) Winifred Stankowski, Mc-Dougall Street, 1988 (Urban Interiors)

122. Szymczak family photographs, Kirby Street, 1988 (Urban Interiors)

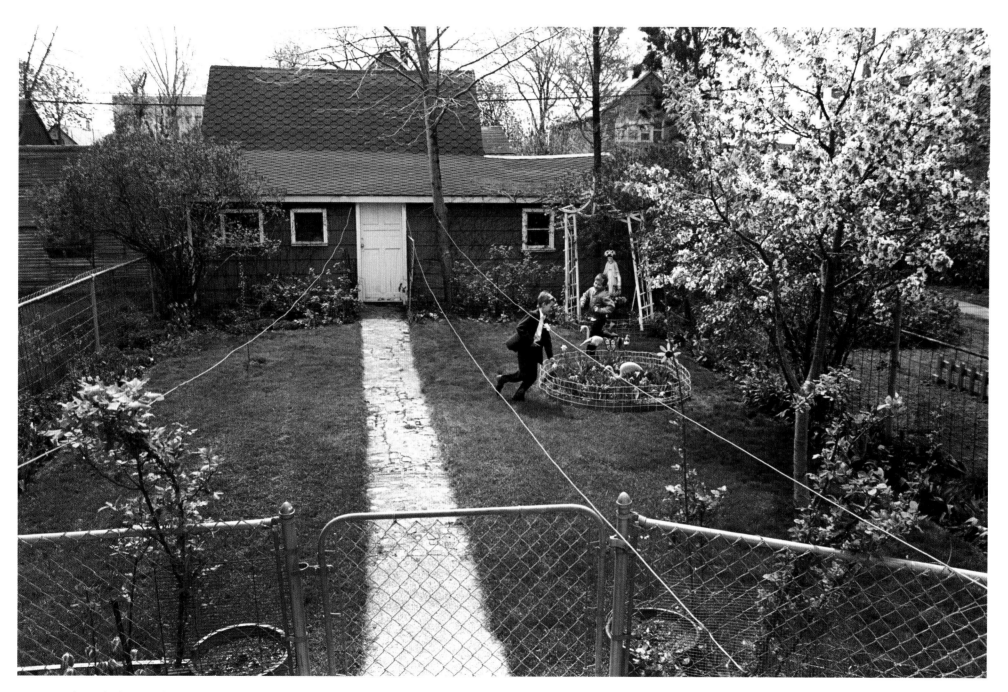

123. Backyard of Antonina Szymczak home, Kirby Street, 1989 (Urban Interiors)

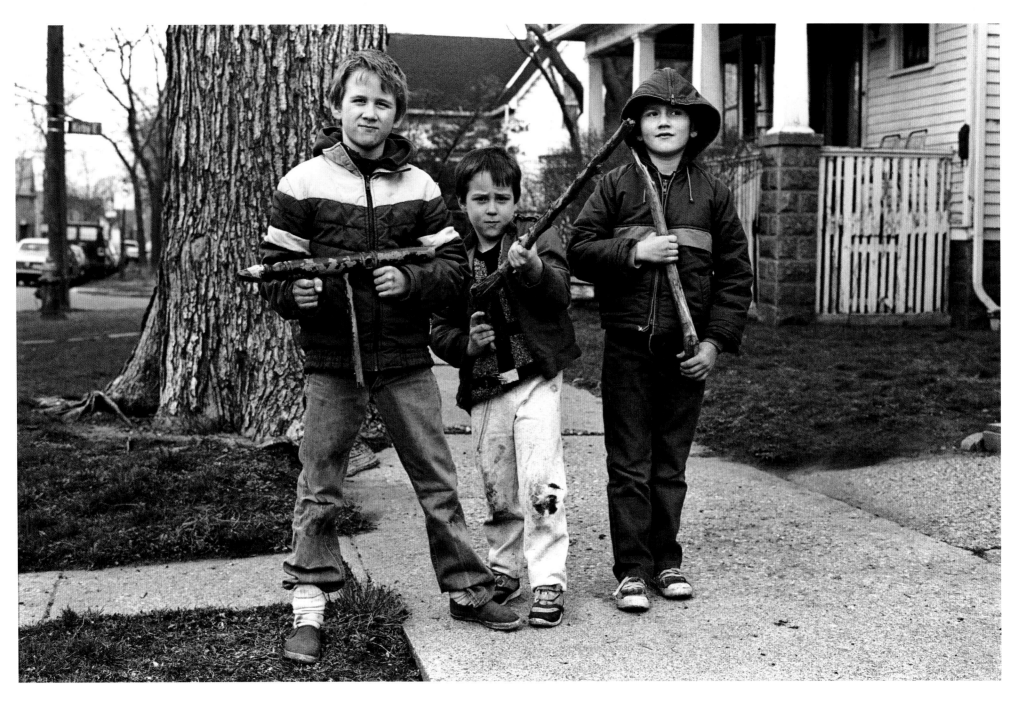

124. Soldier boys, Grandy Street, 1988 (Urban Interiors)

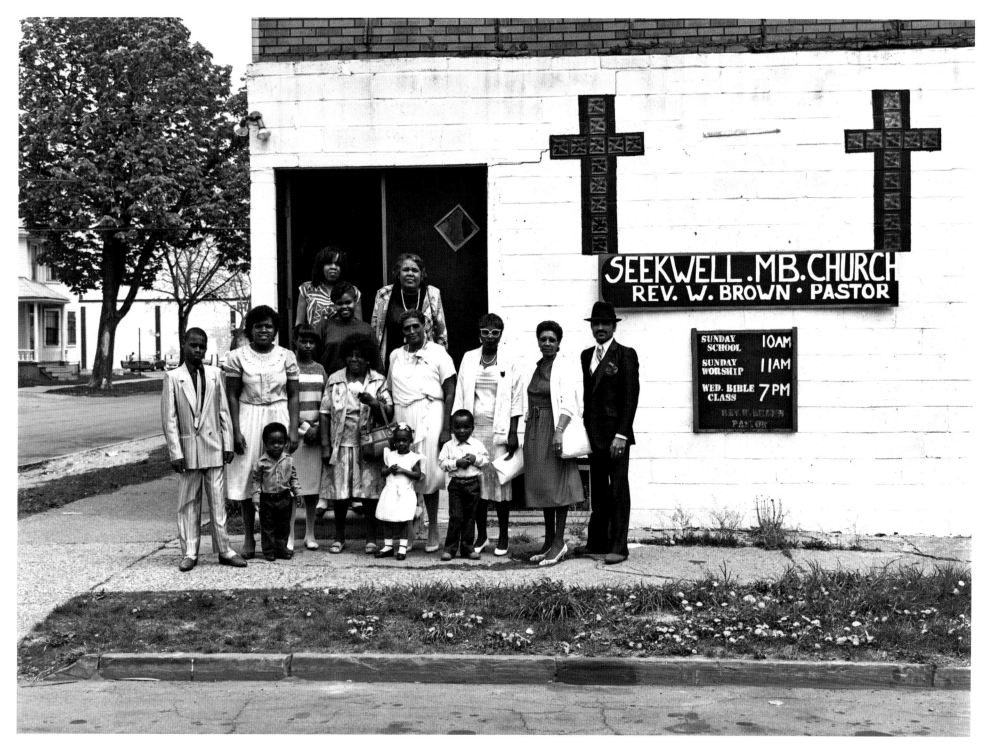

125. Seekwell Missionary Baptist Church, Dubois Street at Palmer Street, 1989 (Urban Interiors)

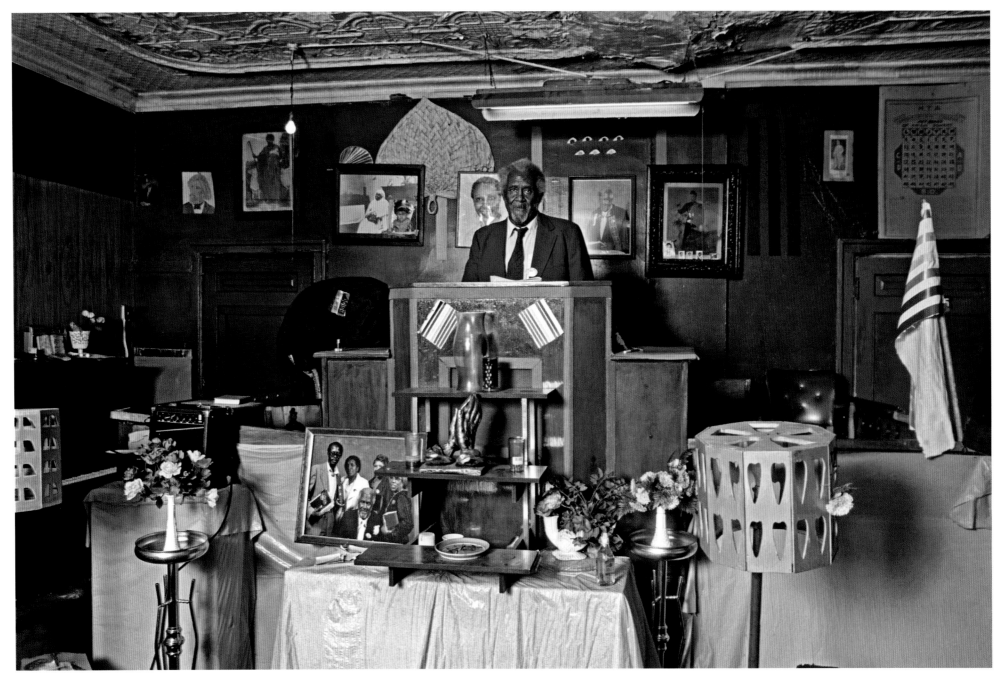

126. Bishop Kendall, of the Almighty Love Kingdom of Our Lord and Savior Jesus Christ, McDougall Street, 1988 (Urban Interiors)

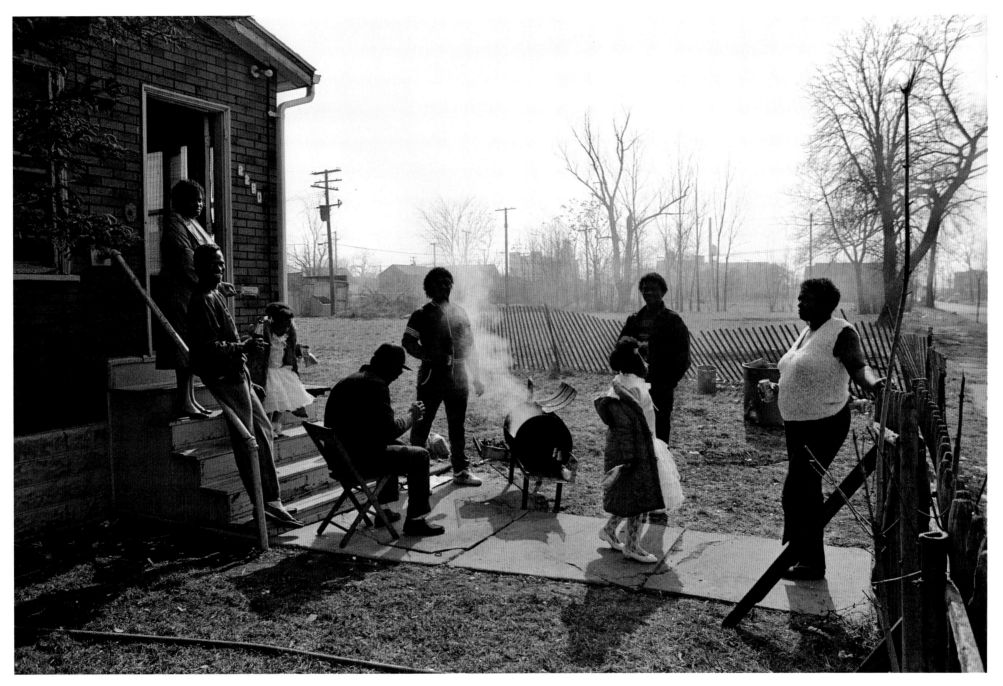

127. Barbeque, Cleo Neal home, Frederick Street, 1989 (Urban Interiors)

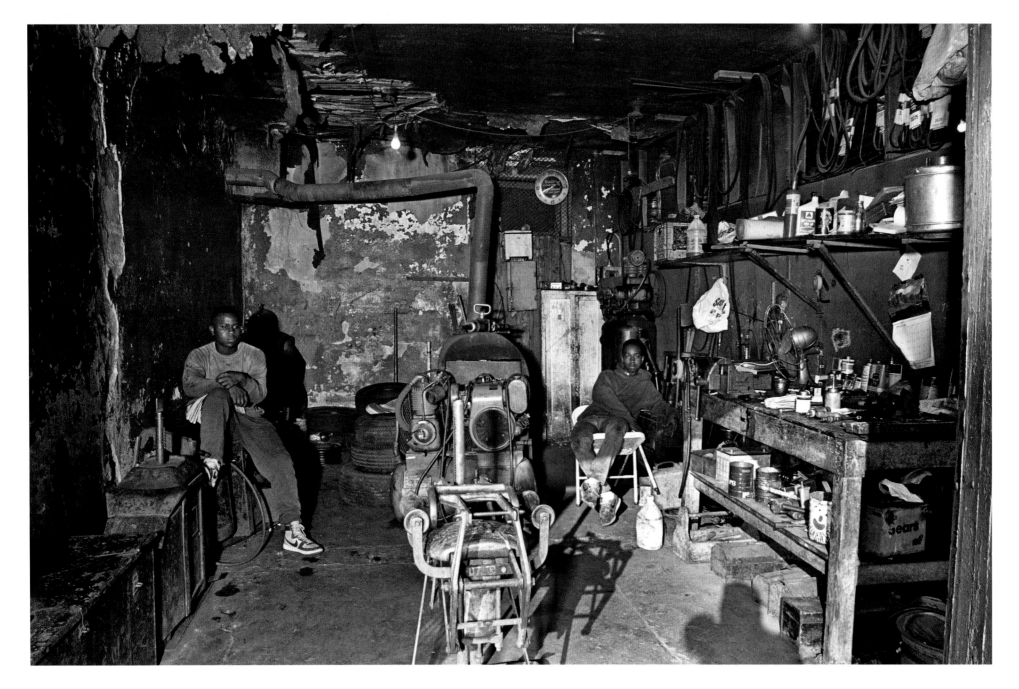

128. (*l*) Russell Tire Service, Dubois Street, 1989 (Urban Interiors)

129. (*r*) East Side Bait Shop, Chene Street, 1990 (Urban Interiors)

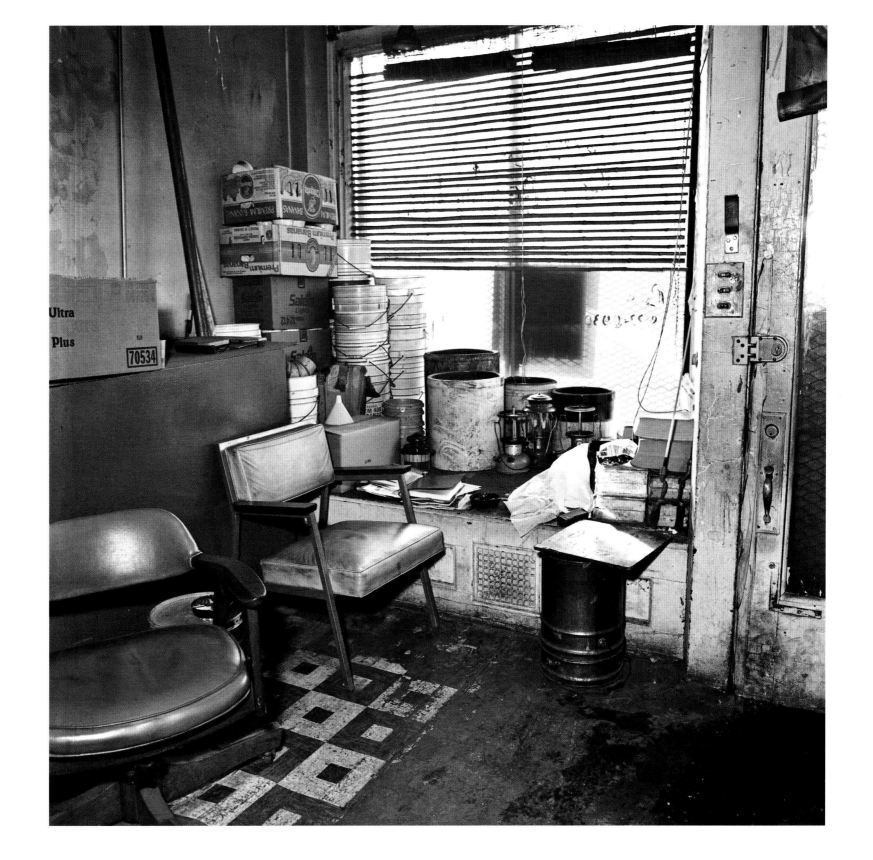

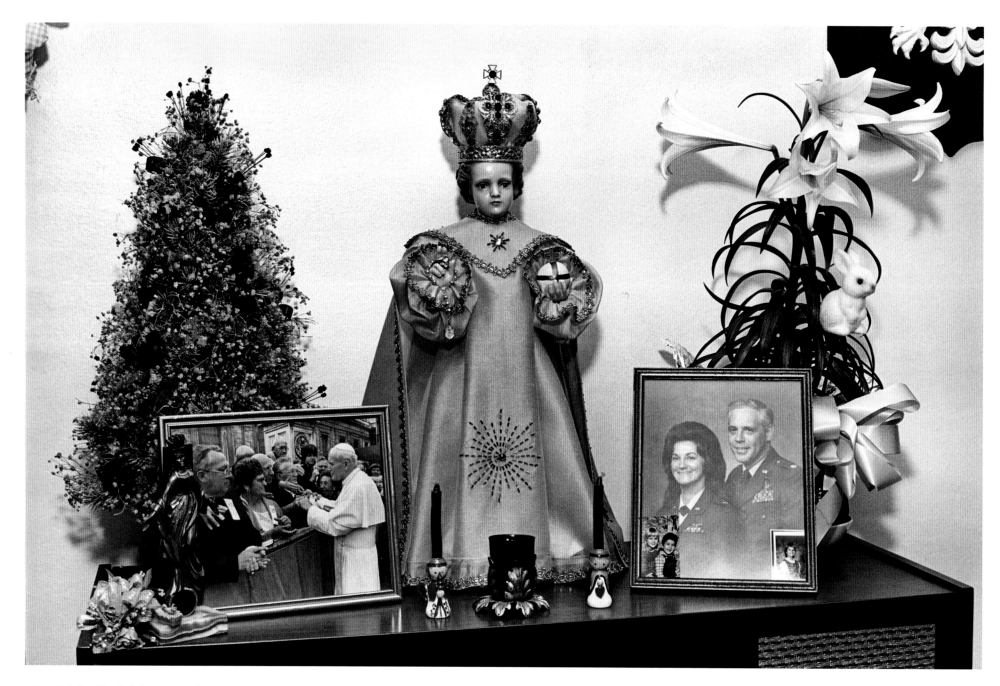

130. Adela Cieslak home, Palmer Street, 1988 (Urban Interiors)

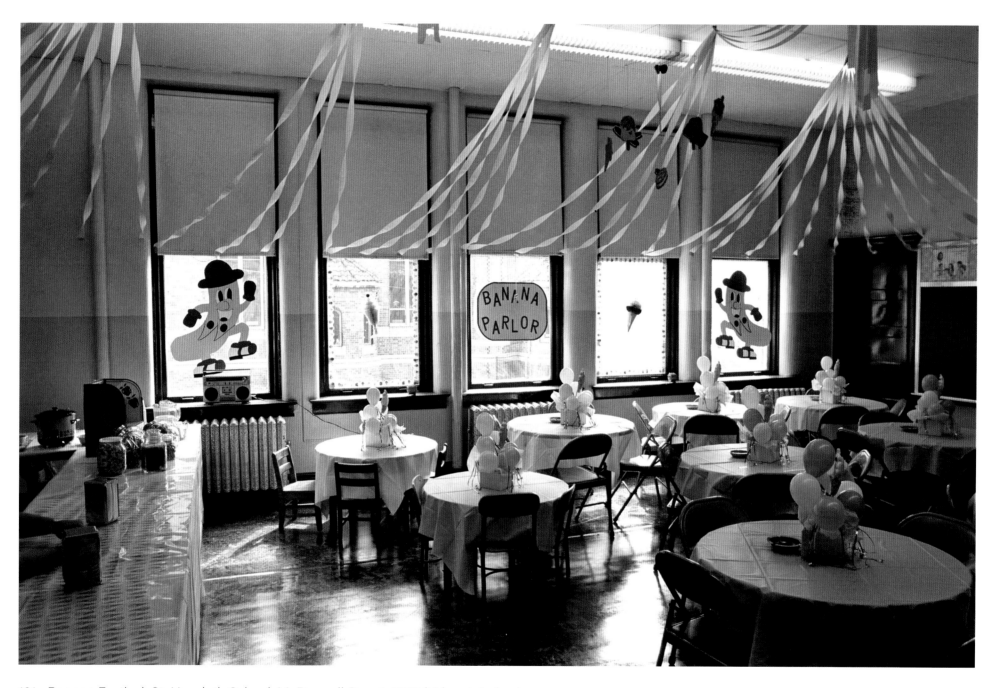

131. Banana Festival, St. Hyacinth School, McDougall Street, 1988 (Urban Interiors)

132. (*l*) St. Patrick Catholic Church, Adelaide Street, Brush Park, ca. 1977

133. (*r*) Horace S. Tarbell house, Adelaide Street at John R Street, Brush Park, ca. 1980

134. Apartment building, John R Street at Adelaide, Brush Park, ca. 1980

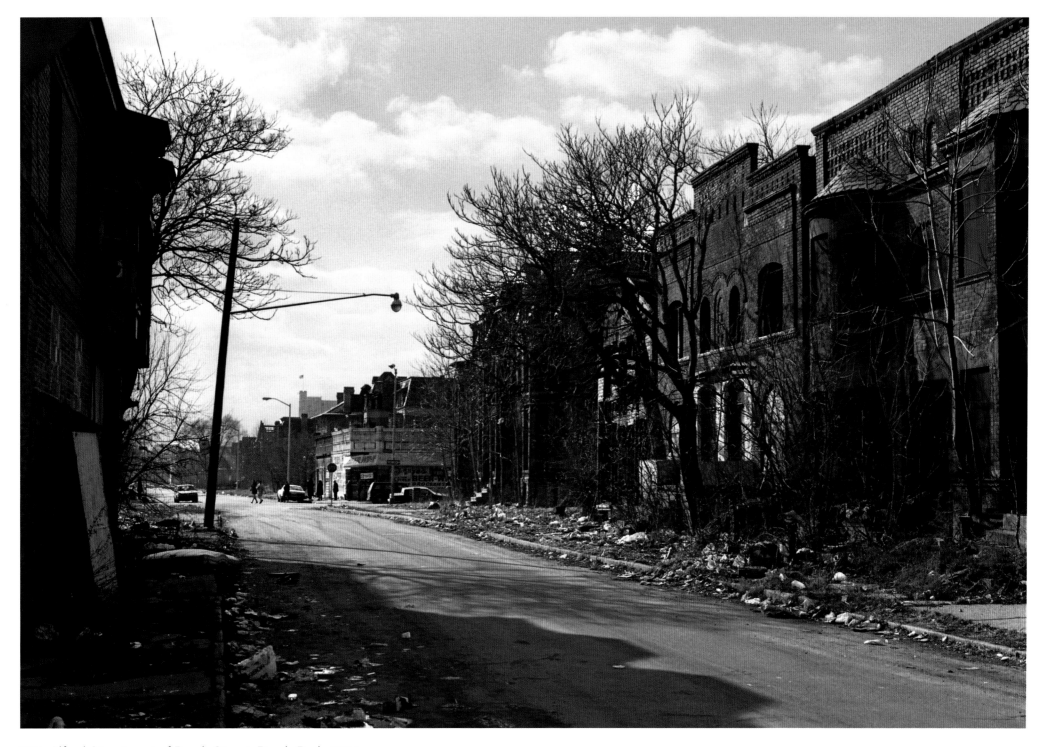

135. Alfred Street east of Brush Street, Brush Park, 1994

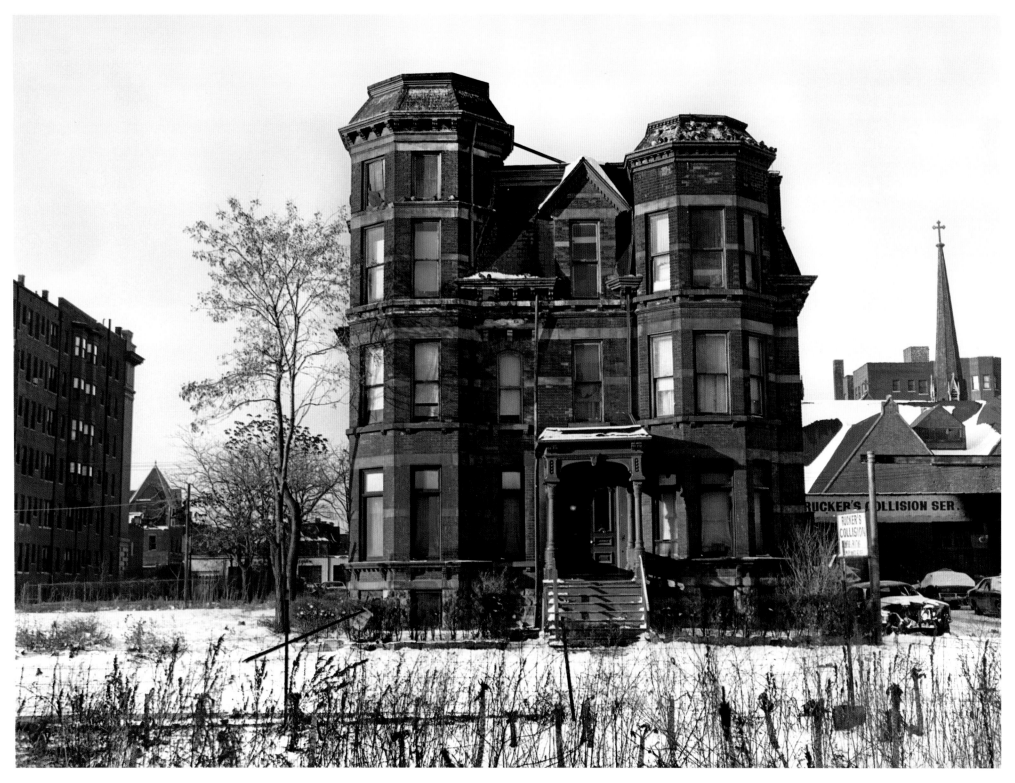

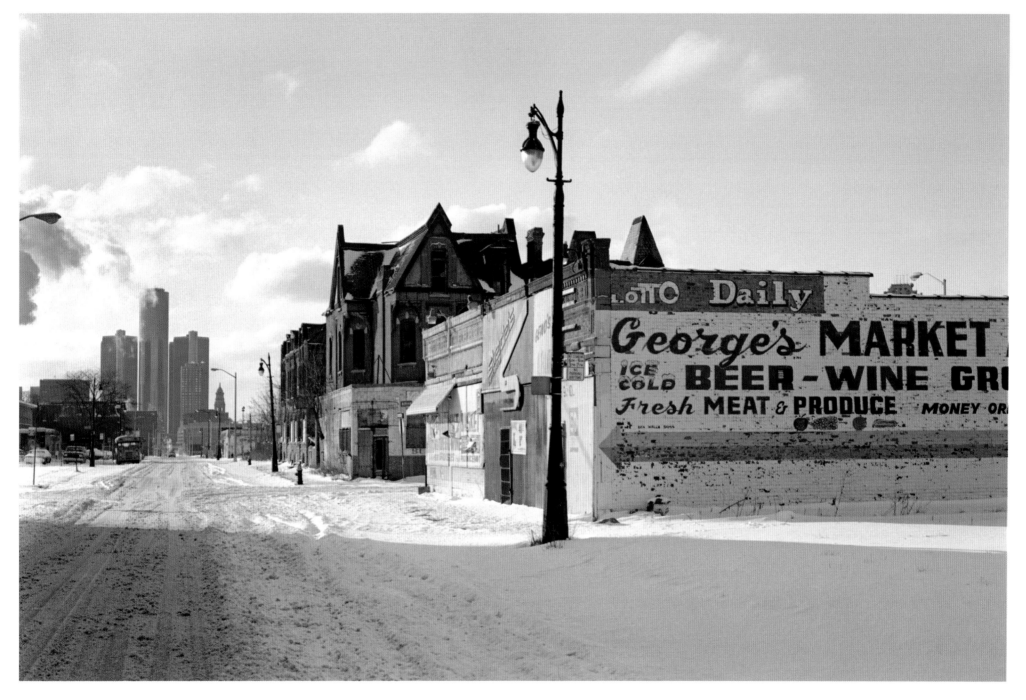

136. (*l*) John Harvey house, Winder Street, Brush Park, ca. 1977

137. (*r*) Brush Street near Alfred Street, Brush Park, 1994

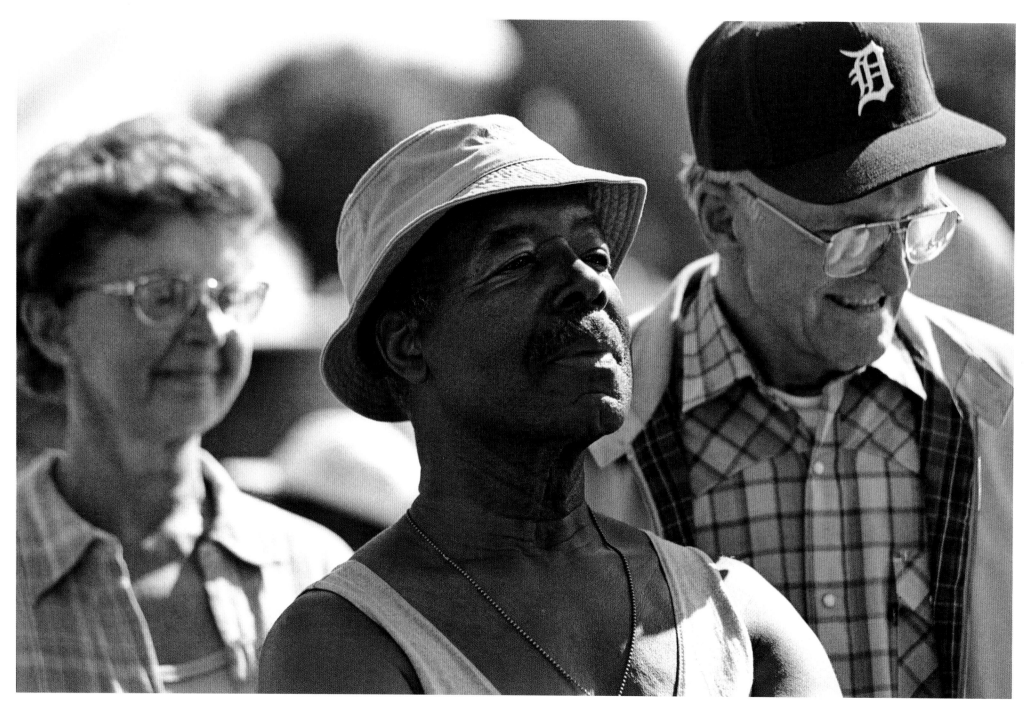

138. Hart Plaza 1, ca. 1985

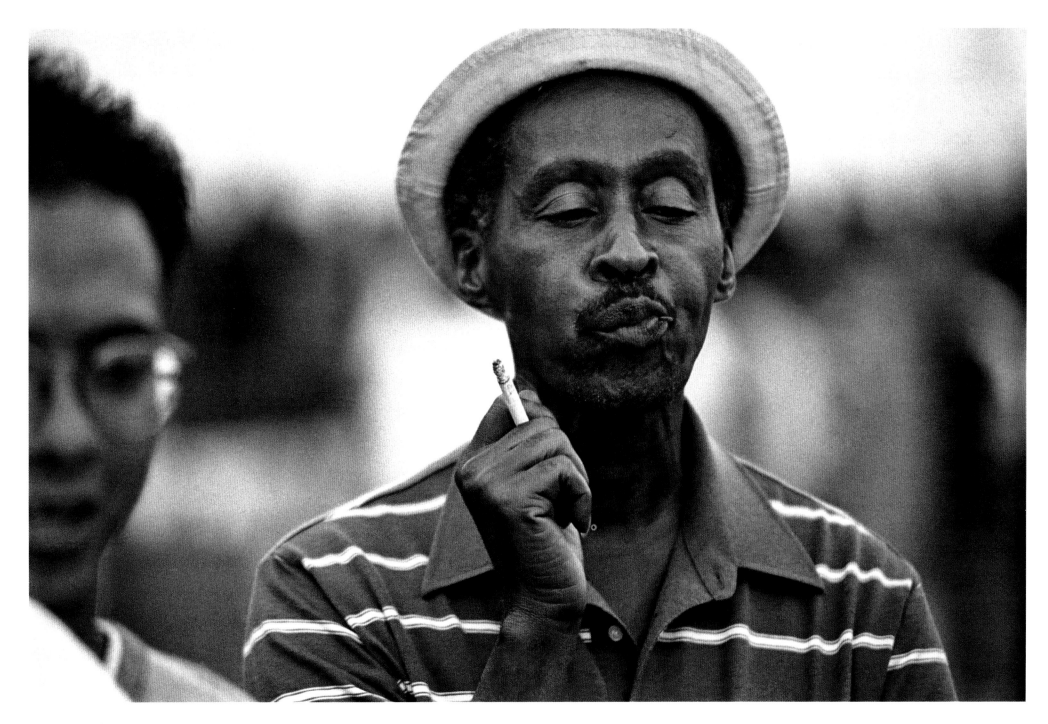

139. Hart Plaza 2, ca. 1985

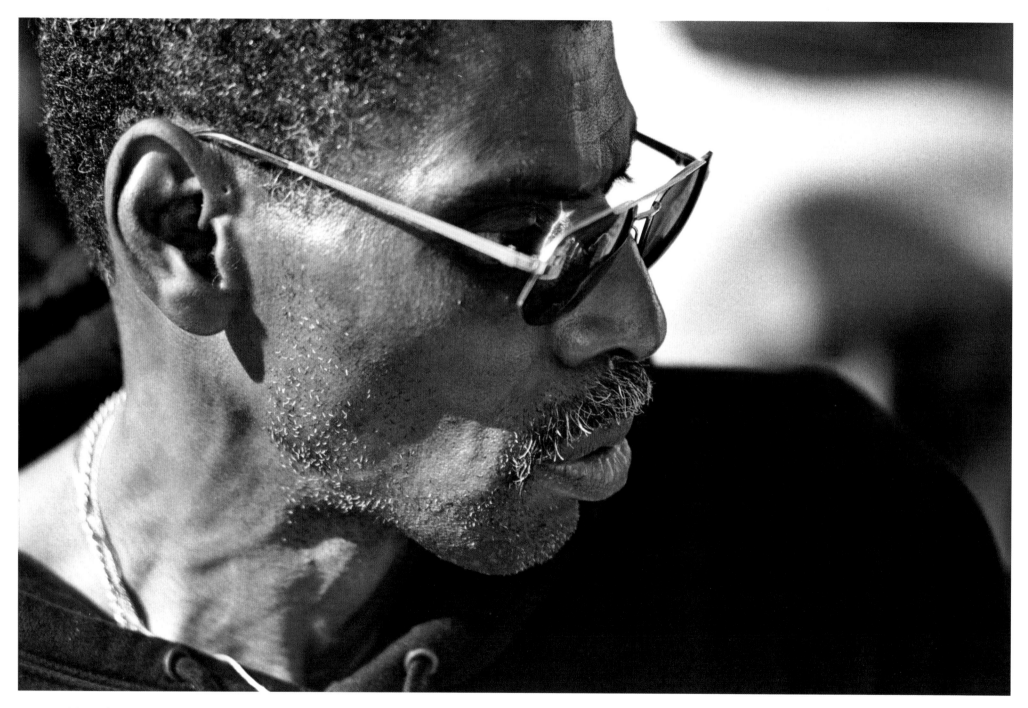

140. Hart Plaza 3, ca. 1985

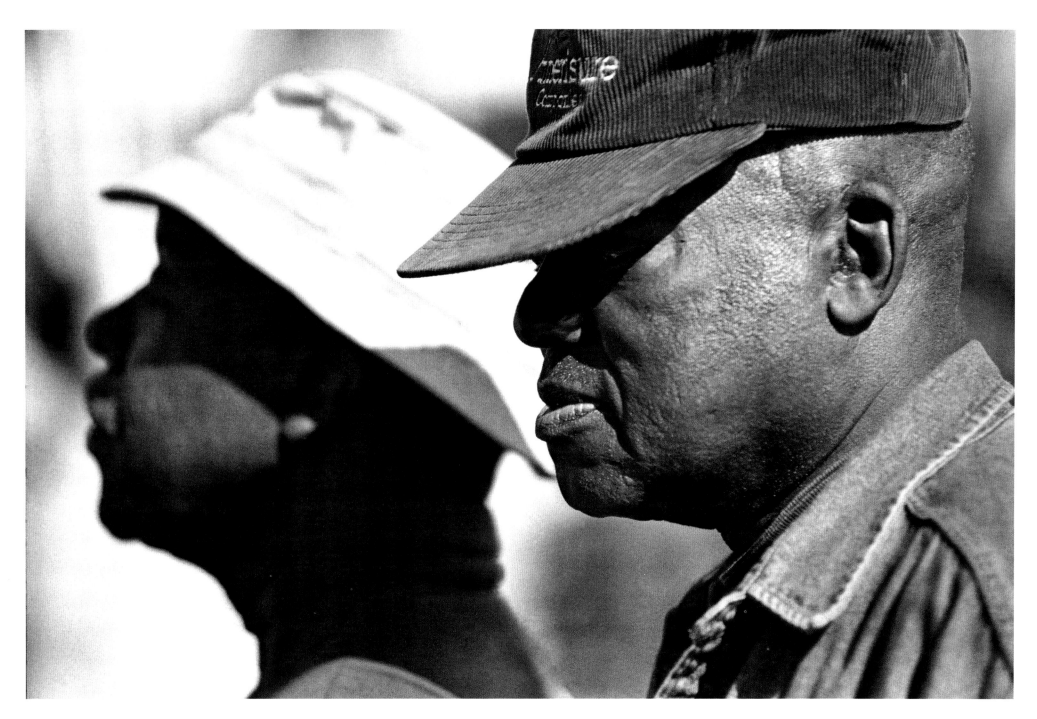

141. Hart Plaza 4, ca. 1985

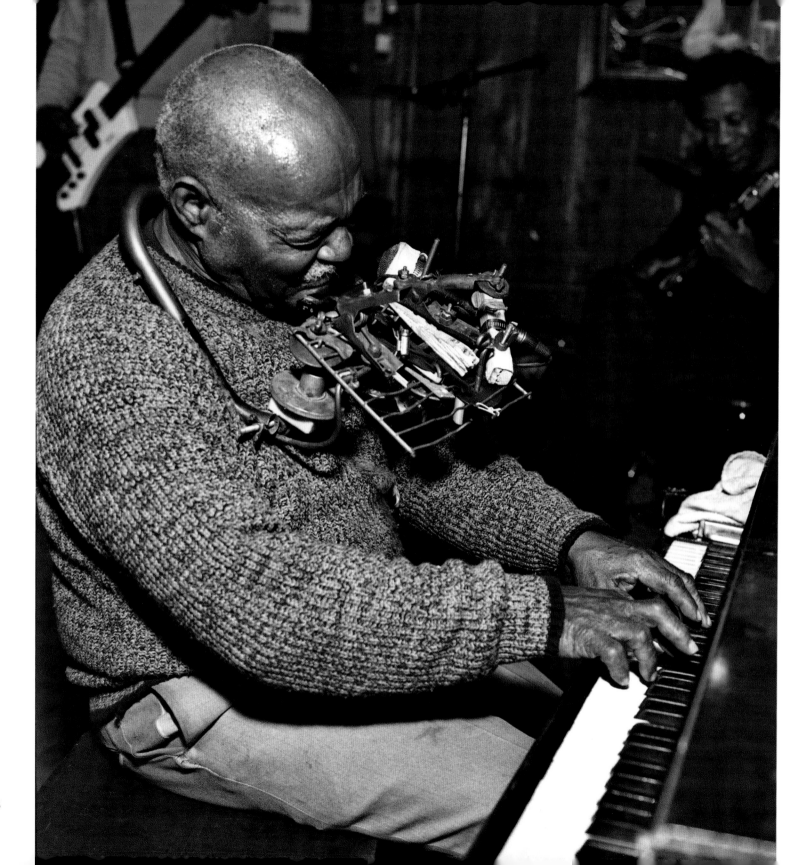

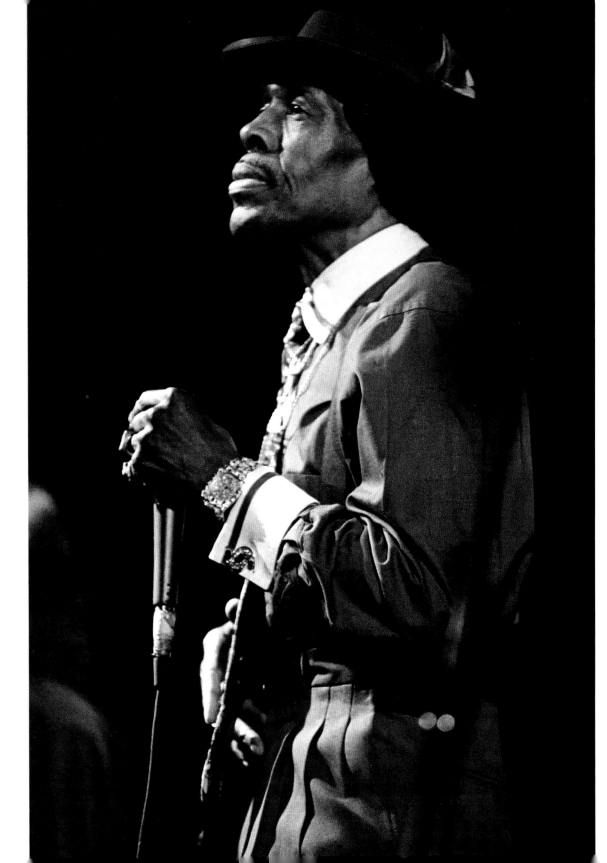

142. (*l*) Uncle Jessie White, Attic Bar, Hamtramck, 1997

143. (*r*) Junior Wells, Magic Bag, Ferndale, 1997

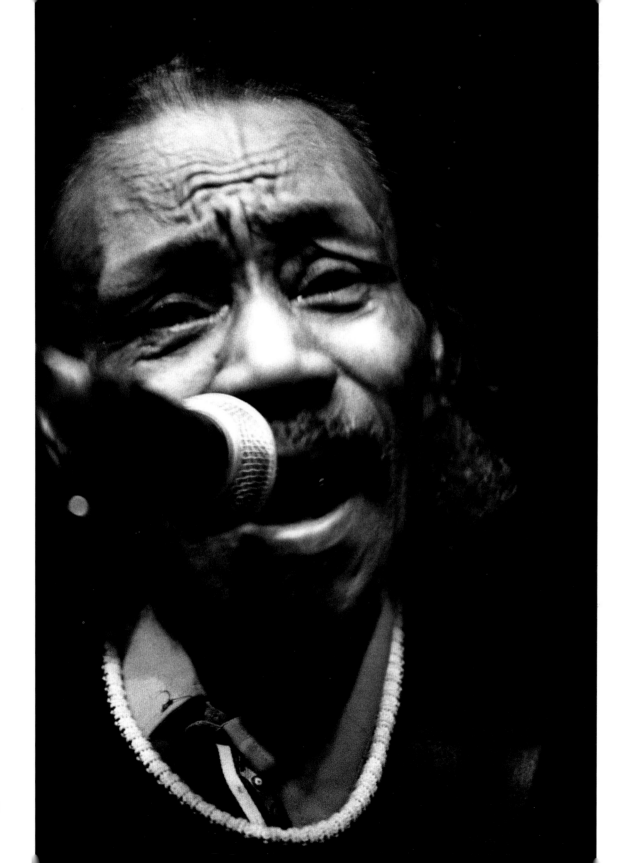

144. (*l*) Willie D. Warren, Soup Kitchen Saloon, Detroit, 1997

145. (*r*) George "Wild Child" Butler, Attic Bar, Hamtramck, 1997

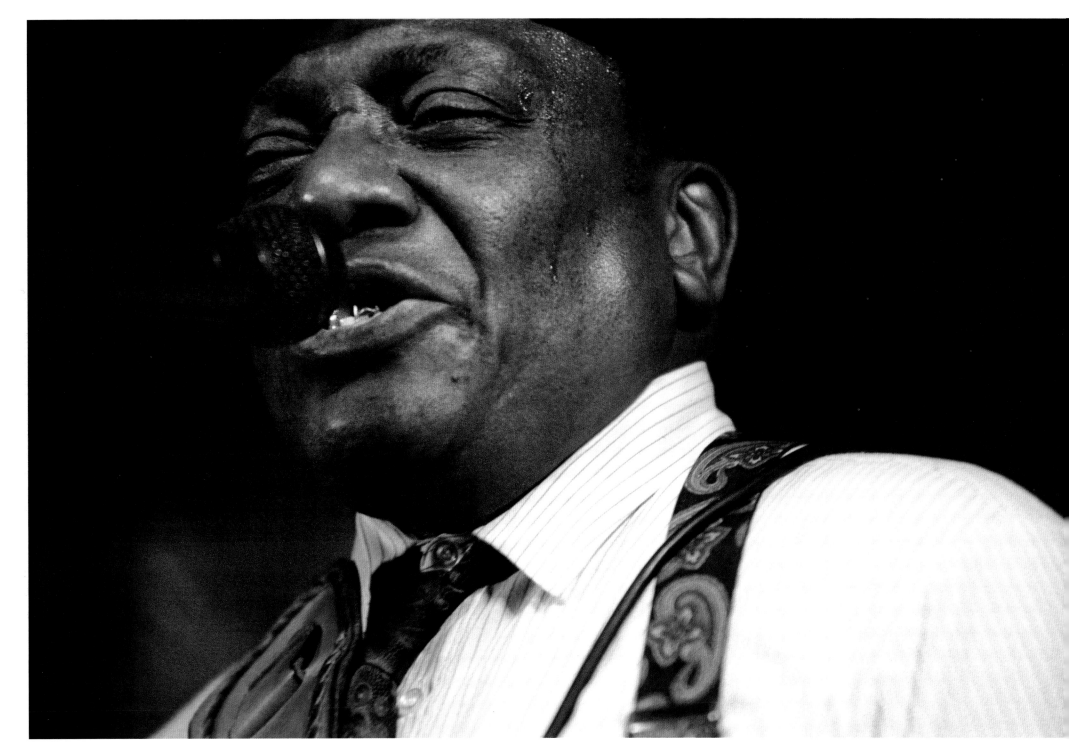

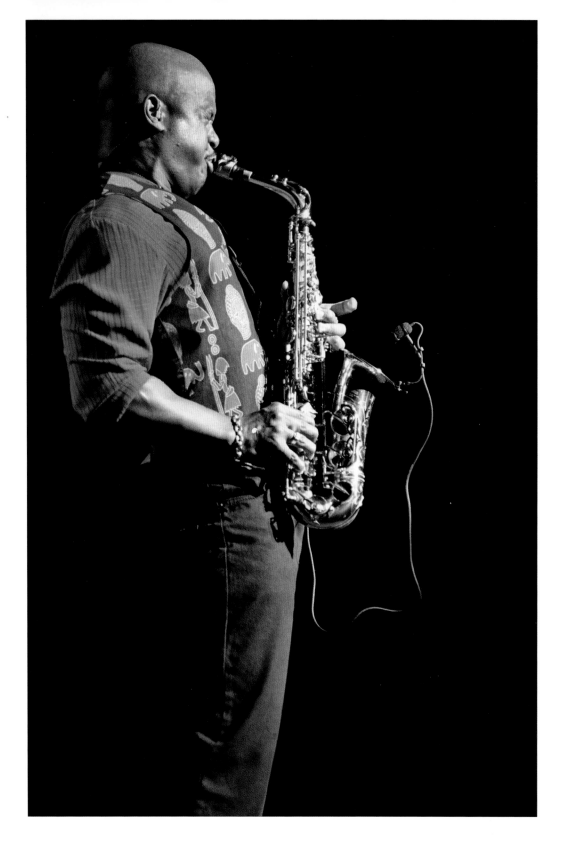

146. Fernando Harkless with War, Concert of Colors, Chene Park, 2001

147. El Vez, Concert of Colors, Chene Park, 1997

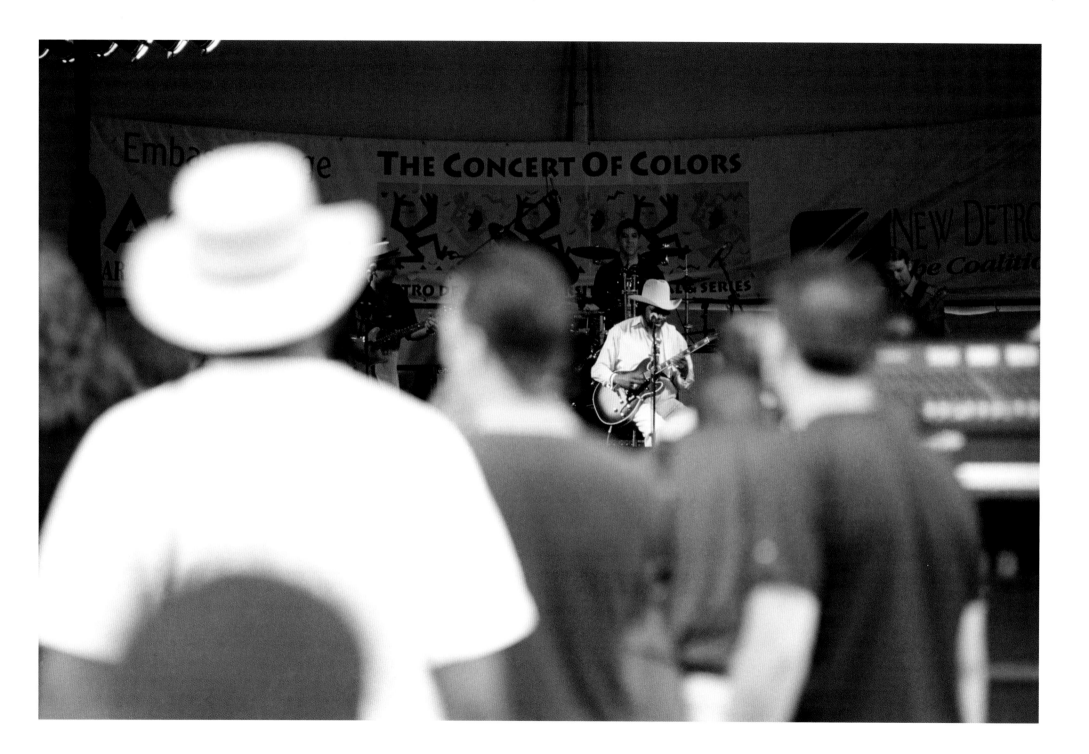

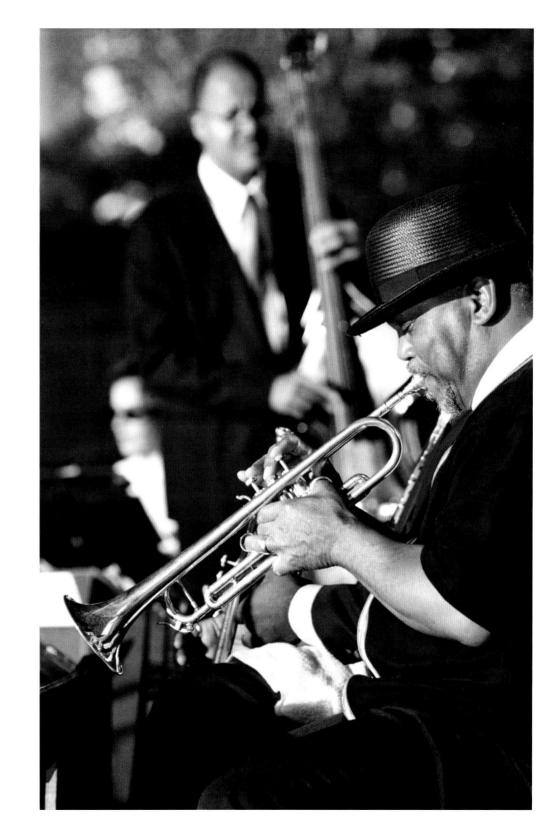

148. (*l*) Son Seals, Concert of Colors, Chene Park, 2001

149. (*r*) Marcus Belgrave, Concert of Colors, Chene Park, 1998

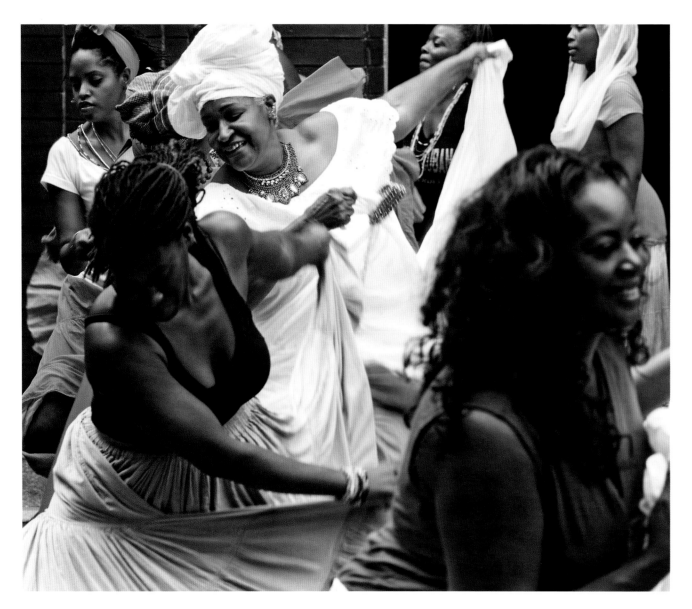

150. (*l*) Iyawo Dance Theatre Folkloric Women's Vocal Ensemble, Concert of Colors, Max M. and Marjorie S. Fisher Music Center, 2016

151. (*r*) Drummer, Concert of Colors, Chene Park, 2000

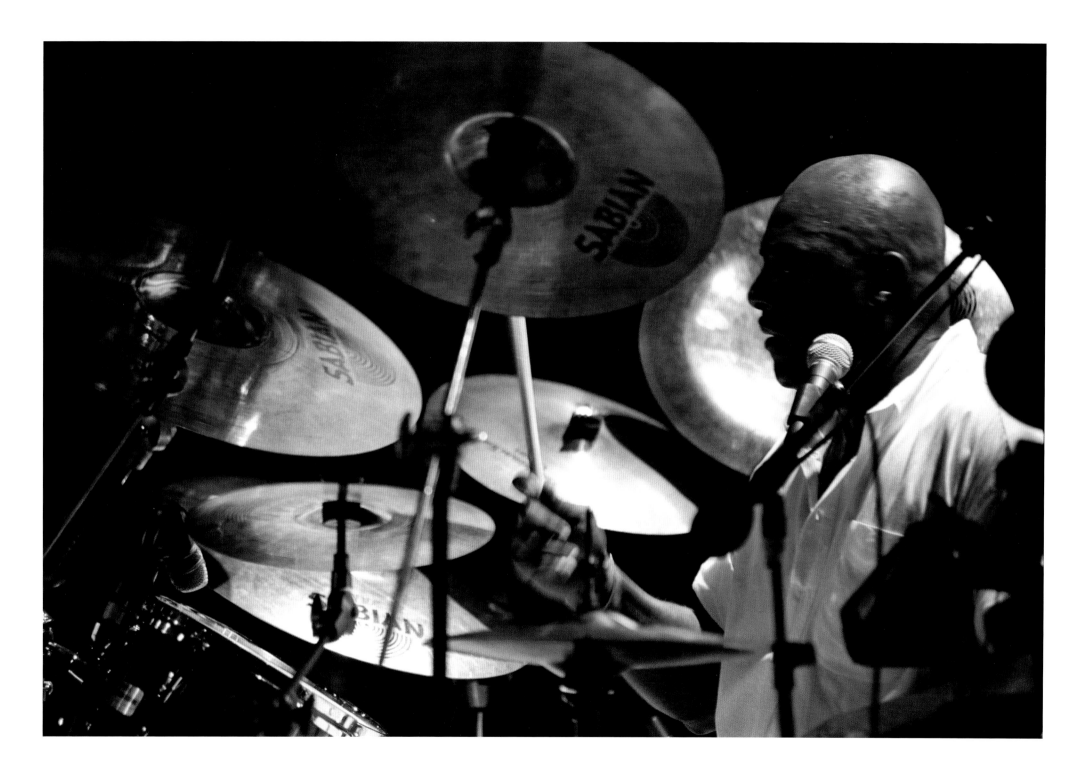

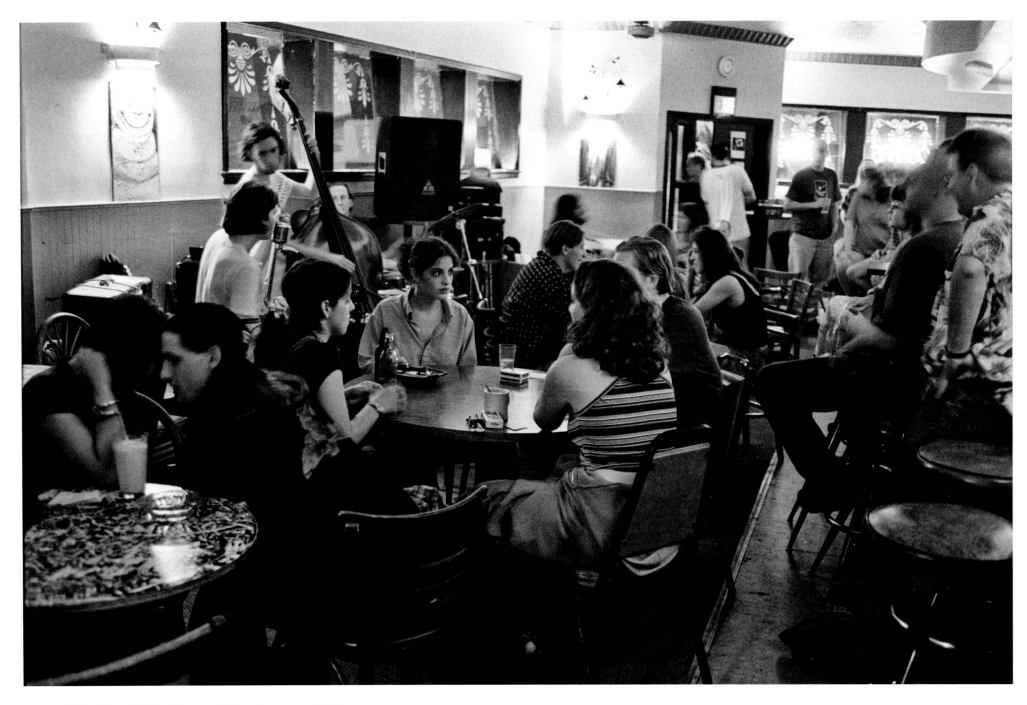

152. The Zone Coffee House 1, Dearborn, ca. 1996

153. The Zone Coffee House 2, Dearborn, ca. 1996

154. The Zone Coffee House 3, Dearborn, ca. 1996

155. The Zone Coffee House 4, Dearborn, ca. 1996

156. The Zone Coffee House 5, Dearborn, ca. 1996

157. The Zone Coffee House 6, Dearborn, ca. 1996

158. The Zone Coffee House 7, Dearborn, ca. 1996

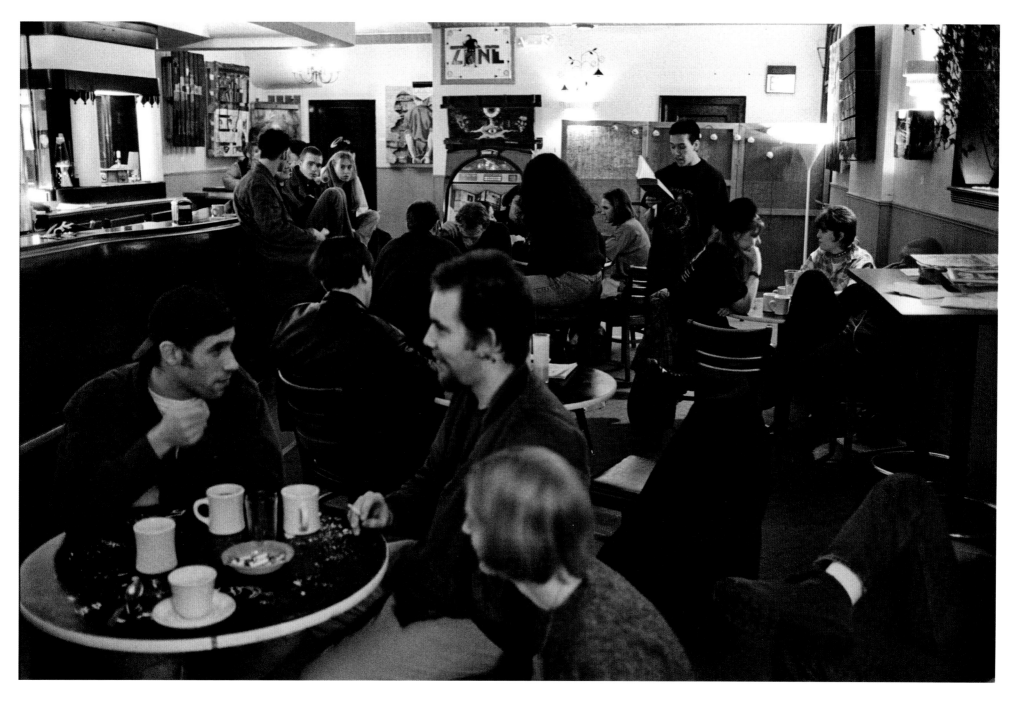

159. The Zone Coffee House 8, Dearborn, ca. 1996

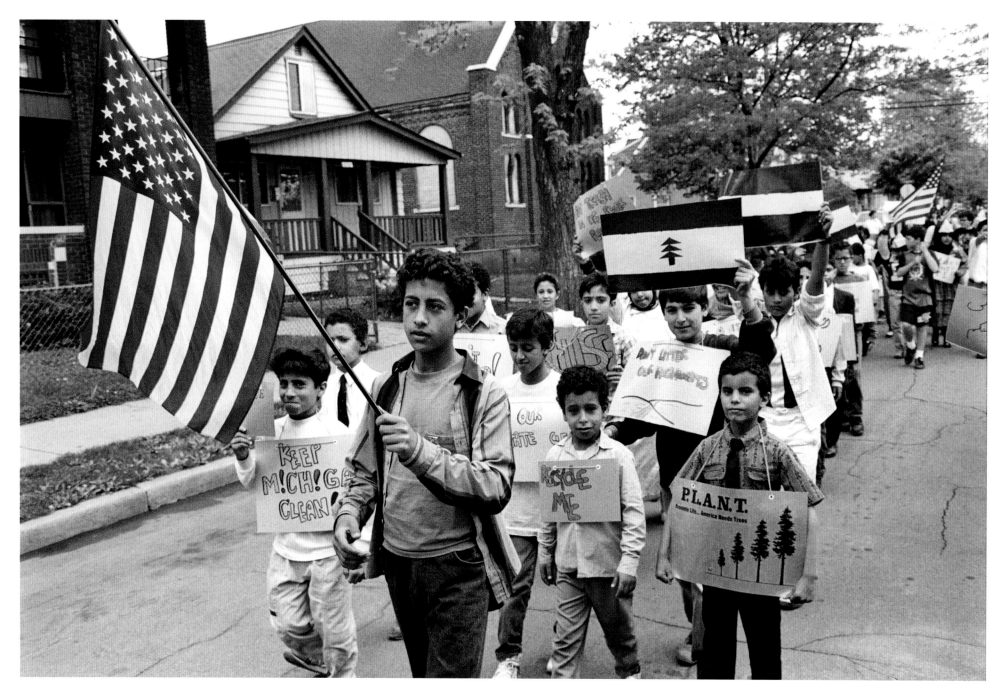

160. Clean-Up Parade, Holly Street, Dearborn, ca. 1992

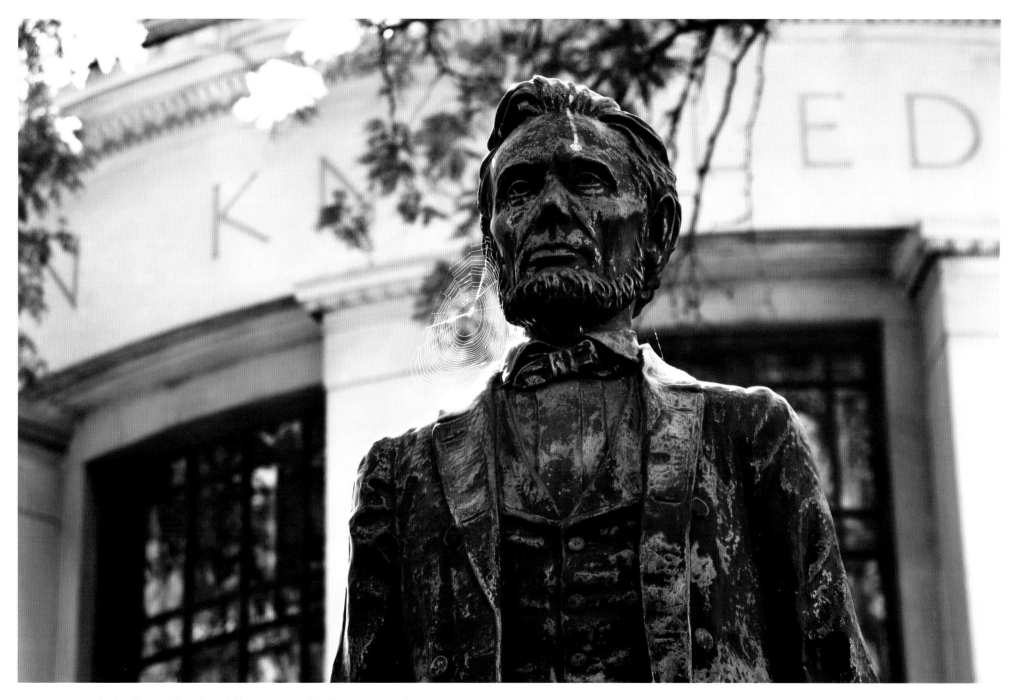

161. Statue of Abraham Lincoln, Skillman Branch Library, Detroit, 2019

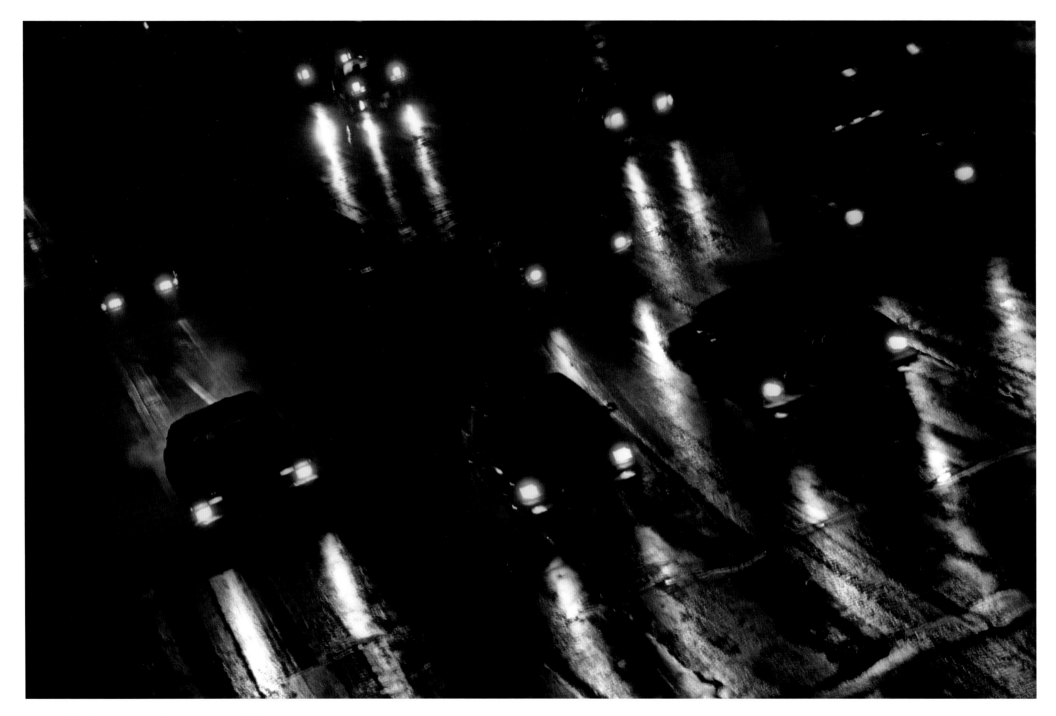

162. Cars at night, Dearborn, 1988

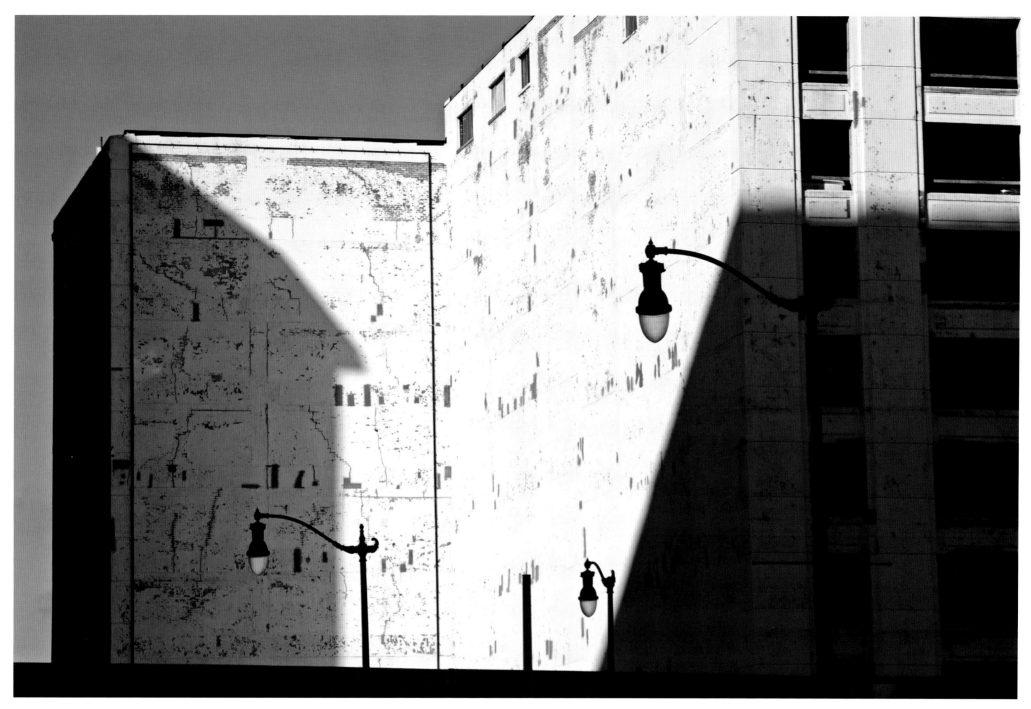

163. Parking garage, Detroit, 2019

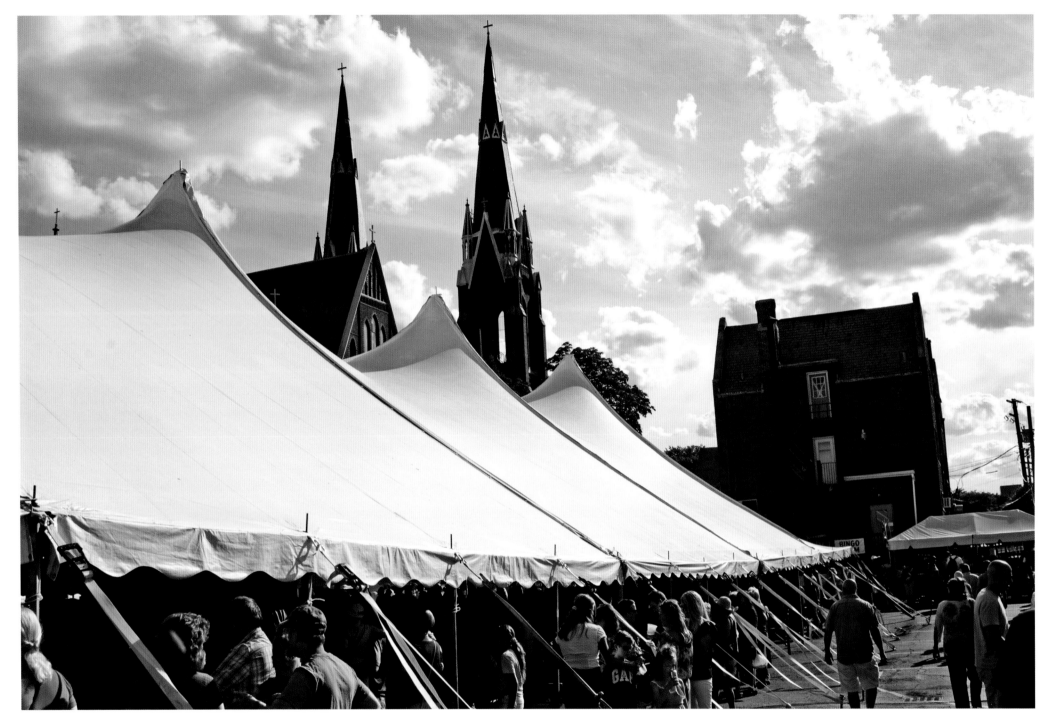

164. Pierogi Festival, Sweetest Heart of Mary Roman Catholic Church, Russell Street, Detroit, 2019

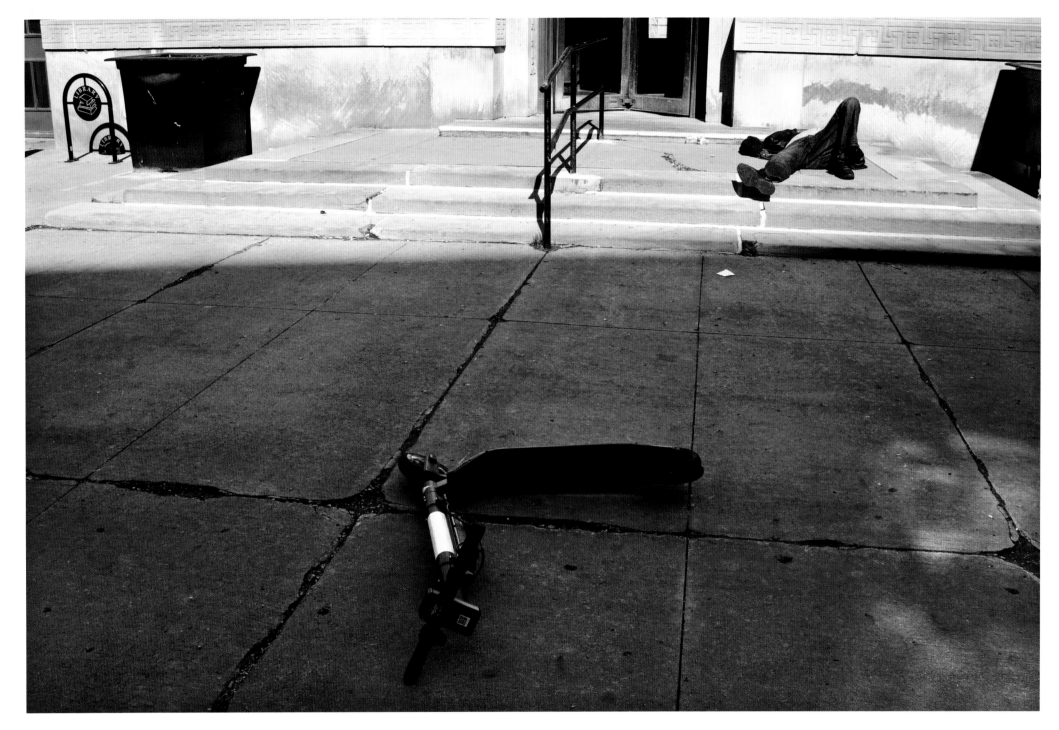

165. Man and electric scooter, Detroit, 2019

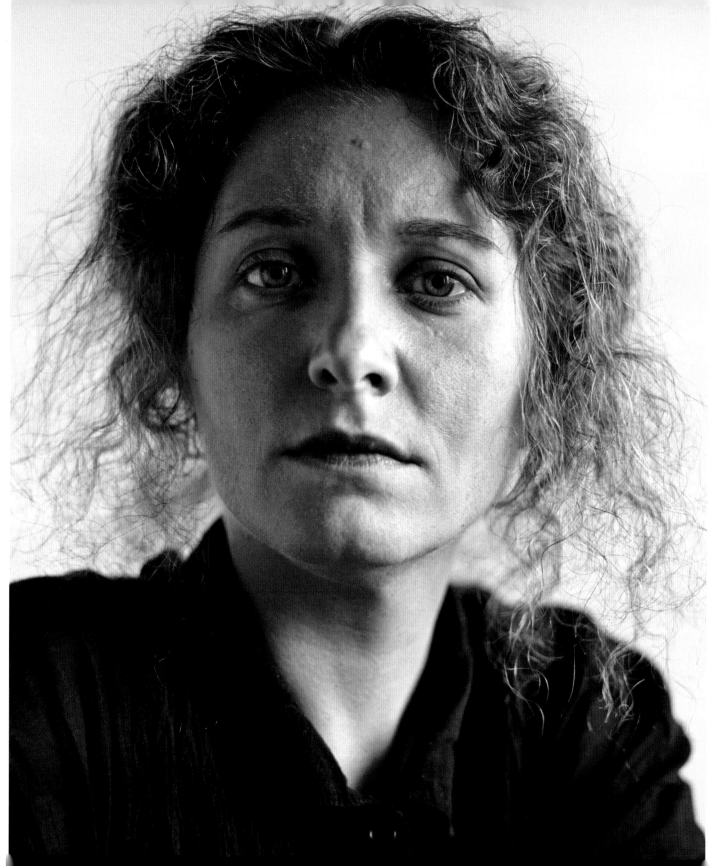

166. Shiree, ca. 1994

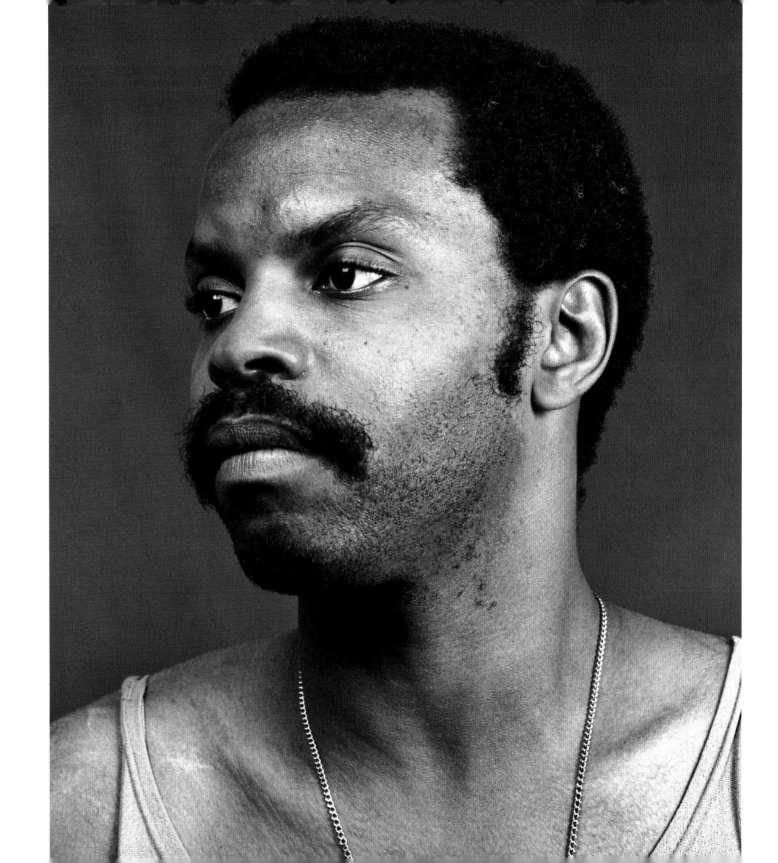

167. John, ca. 1994

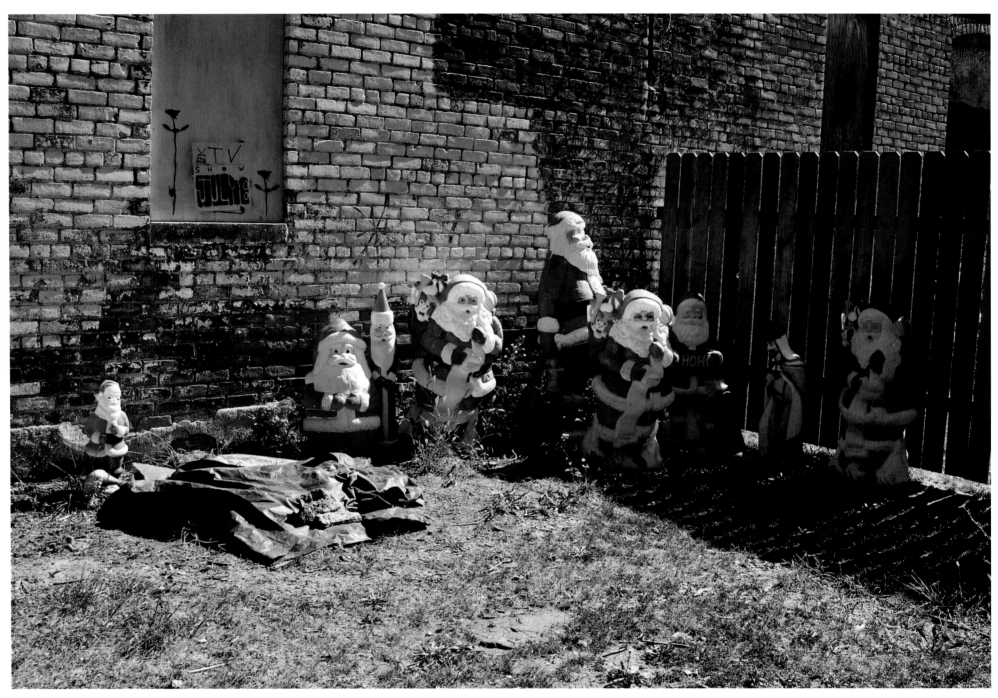

168. Plastic fantastic Santas, Farnsworth Street, 2009

169. Memorial gathering for Russ Gibb, former owner of Detroit's Grande Ballroom, Dearborn, 2019

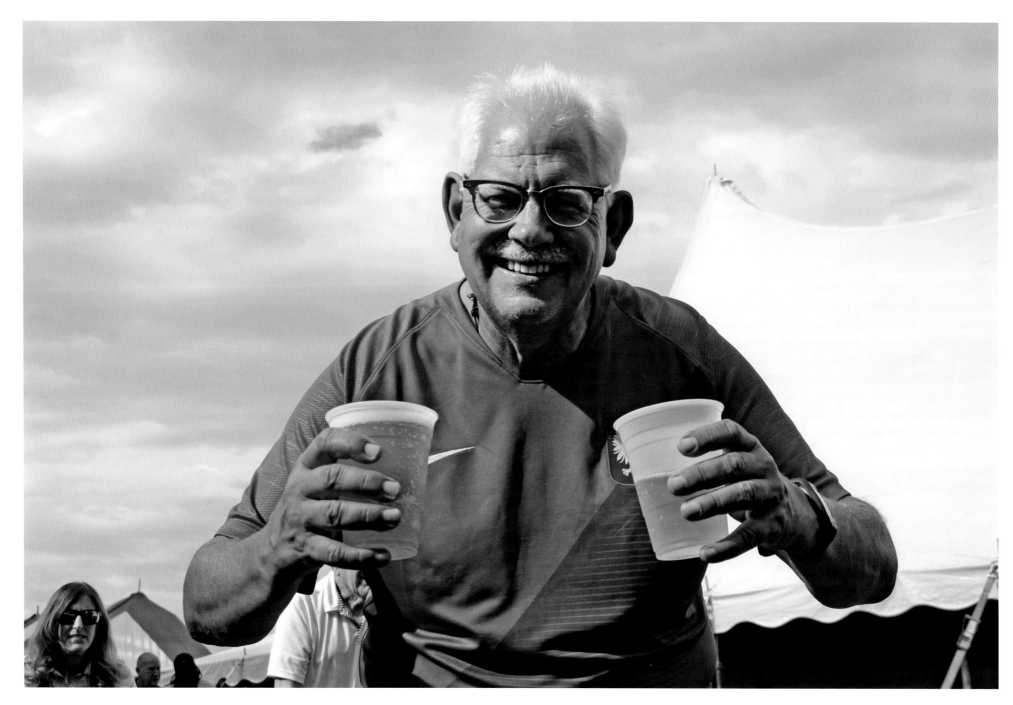

170. Man at Pierogi Festival, Sweetest Heart of Mary Roman Catholic Church, Detroit, 2019

Photographer's Notes

Bruce Harkness

The numbers below refer to the corresponding numbered photographs.

Dedication. Greg Pace lived in the Mitchell Street–Gratiot Avenue area, where I met him in June of 1988. My time with Greg was short. Our paths often crossed while I was walking in that area, and after we became acquainted we drove around in my car a few times. I learned of the Heidelberg Project and saw it for the first time when Greg took me there. Greg was intelligent, engaging, and inquisitive. There was something special about him, and something special about being with him. In early December of 1988, I learned of two fatal shootings on Detroit's near east side. I soon discovered one of the victims was Greg. At the time of his death, Greg was thirty years old, unmarried, and unemployed. He died within minutes of being shot multiple times in front of 3240 McDougall Street at 12:25 a.m. on December 3, 1988.

1. Two girls I encountered while working on an early Center for Creative Studies student project documenting Detroit's ethnic neighborhoods. My assigned area was the neighborhood around the Basilica of Sainte Anne de Detroit, not far from the Ambassador Bridge.

2. A man I encountered near the Center for Creative Studies building while walking from the school to my residence on the Chrysler Freeway Service Drive.

3. A first-year photography assignment: portray loneliness. At the time, one could freely enter and roam the terminals of Detroit Metropolitan Airport.

4. Professor Raymond Hoekstra's aesthetics class convened in the auditorium of the music school once located at the corner of John R and Kirby Streets, near the Center for Creative Studies campus. Those who beheld his class from the rows of seats may recall his delightful and distinctive mannerisms—the mimicked dance, singsong voice, and impish smile. Forty-five years later I remember one lesson only. After presenting a long sequence of philosophical postulates (if this is so, then this must be so, etc.), Professor Hoekstra arrived at one seemingly unshakable conclusion: art cannot be defined.

5. John and Darryl shared an apartment on the top floor of the Renaud Apartments on Selden Street just west of Cass Avenue. I met John in 1979 when we worked as waiters at Union Street restaurant on Woodward Avenue. We remained friends until his death at Mount Saviour Monastery, his long-sought home, near Corning, New York, in April 2018. (See photo 167.)

6. Taken in shed three at the Eastern Market while I was a student at the Center for Creative Studies.

7. Detail from a sign on the front of the Eastern Market Lounge, a small breakfast and lunch café, closed years ago. This location is now the northeast corner of the much larger Eastern Market Cold Storage Company.

8. Two women I encountered while walking in the area around Buchanan and Fifteenth Streets. This neighborhood was a fairly short walk from Commonwealth Street at Warren Avenue, where I lived at the time.

9. Man encountered near Buchanan and Fifteenth Streets.

10. Taken from Lysander Street, looking southeast to Lincoln Street and the Jeffries Housing Project. I often took this path when walking from my residence in the Woodbridge district to the Cass Corridor. A housing complex now occupies this area between Trumbull Avenue and the Lodge Freeway.

11. Taken while walking east along Grand River Avenue with my Speed Graphic camera and tripod. On the left is Carl's Chop House and beyond is Cass Technical High School (not visible). The Wonder Bread factory and other buildings on the right were supplanted by the MotorCity Casino.

12 and 14. The path of a circa 1980 early-morning walk through the Cass Corridor is preserved in fifteen sequential images on the original film, which I still possess. From Brainard Street I went east to Second Avenue, then turned south and walked along Second toward Cass Park and the Masonic Temple (photo 14). At Temple Street (Cass Park), I turned east toward Cass Avenue, then south again on Cass to Clifford and Sibley Streets, where I reversed direction, found an abandoned building on Cass Avenue, ascended to its upper floor, and took a photograph of the Detroit skyline (photo 12). Exiting the building, I walked north on Cass Avenue to Peterboro Street, where I photographed the shell of the James Scott Mansion and buildings along Cass Avenue, including the front of the Gold Dollar Show Bar. This perambulation typified my method of operation.

13. During one of my first forays down Third Avenue, I encountered this man, on the ground, being kicked repeatedly by another man. Someone intervened and stopped the beating. The police arrived and I remember one officer commented dryly: "Another day in the Corridor."

15. The Niagara Apartments, built around 1916, stood on the east side of Third Avenue between Peterboro and Charlotte Streets. The majority of the Niagara's thirty or so subsidized hundred-dollar-a-month rooms were occupied by near-destitute alcoholics. The building's dingy interior showed years of neglect, and its small apartments offered barely subsistence-level amenities. I visited and photographed inside the Niagara from 1976 to 1978. In the summer of 1978, I interviewed several Niagara residents, and excerpts from these interviews, along with a selection of my photographs, were published in the November 1978 issue of *Detroit* magazine, the Sunday supplement of the *Detroit Free Press*.

16–17. I first visited with Mary Caffery in her apartment in 1976. These visits continued until the fall of 1978. Born in 1926, Mary grew up on Detroit's Muster Street. She married young and by age twenty-three had moved to Alabama, where she bore three children. She returned alone to Detroit in 1969 and moved to the Niagara Apartments in 1974. Mary's apartment, No. 106, consisted of a main room, kitchenette, bedroom, and bathroom. The main room contained a small table, two chairs, and a refrigerator. "Sure I'm lonely. I miss my kids. It's been rough. Every night I get cockroaches crawling on me. You can feel them. I got no blankets. I even went to bed with my winter coat on, my good winter coat. Before my dog died he used to keep me warm."

18. Rosie's apartment was opposite Mary's on the first floor.

19. Born in Lone Mountain, Tennessee, Don Mason joined the air force at age nineteen and served as a waist gunner aboard a B-17 bomber in World War II. Marilyn Tribble, from Mayfield,

Kentucky, had two children by age sixteen. She was a transient and stayed with Don while at the Niagara. "I've been running around, staying with different people, doing housework for room and board."

20–21. Lawrence Godfrey would always ask for a cigarette. "I'm dying for a cigarette. Can you get me a cigarette?" Beyond this, Lawrence made little sense. He wandered the building, staying in any unoccupied and unlocked apartment. A Niagara resident heard he used to drive a cab in Detroit. When given food, he often threw most of it out the window. He said he had to feed his "doggies."

22–23. The first time I saw Norman Brandenburg, he was in his wheelchair at the far end of the dark basement hallway. He often wheeled himself to that hallway spot, just outside his apartment, and waited for someone to appear and ask if they could get him tobacco or beer or food at the Publix Super Market across the street. Other times I found him, his back to me as I entered his room, at his small table, drinking beer and smoking his self-rolled Bugler cigarettes. Norman was arthritic and unable to walk unassisted. He had few visitors, and I never saw him outside the confines of the Niagara basement. I remember he had a pleasant disposition and easy smile. Norman Brandenburg and Lawrence Godfrey both died alone in their rooms in March of 1978.

24–27. The Niagara's owner abandoned the building in the fall of 1978. The utilities were turned off and the nights turned cold. The residents struggled to relocate, and in most cases they moved to nearby buildings much like the Niagara. I entered the uninhabited Niagara for the last time in December 1978 and made my way from floor to floor, pointing my camera at the debris, as I found it, that remained in the abandoned rooms.

28–29. On Cass Avenue, two blocks east of the Niagara Apartments, I found the Gold Dollar Show Bar, a bawdy drag bar where a small troupe of female impersonators (as advertised on the building's facade) mounted the stage and lip-synched to a collection of 1950s and '60s nightclub standards, one being a crowd-pleasing version of Eartha Kitt's "My Champagne Taste and Your Beer Bottle Pockets." Between sets Diane and Lisette, Dee Dee and Jackie, and Jack and Ron tended bar, prepped for their next stage appearance, or mingled with the curious mix of Cass Corridor denizens and suburban patrons.

30–31. Art performed on the Gold Dollar stage both in drag and out, with Ron, his partner, always stage-side. At the time they lived, as did several others from the Gold Dollar, at Spaulding Court, a building consisting of small apartments on Rosa Parks Boulevard.

32. The after-hours spot for the Gold Dollar queens was Verdi Bar on Sibley Street just west of Woodward Avenue. The plot of land where Verdi Bar once stood is now a small section of the Little Caesars Arena complex.

33. Third Avenue was the most direct route from my apartment near Wayne State University to the Niagara Apartments. I walked this path many times in the mid to late 1970s carrying either a small 35 mm or a larger twin-lens reflex camera. When I had more equipment to transport to the Niagara, for safety's sake I carried it in a paper grocery bag.

34. I met this man in the backyard of an abandoned Fourth Street house. He told me his life was difficult and wanted to show me where he had slept the previous night: on an overturned piano inside the empty house.

35. As I approached, this young girl and several adults happened to exit this home. The adults descended the porch steps, entered a car parked in front, and drove away, leaving this girl standing alone on the porch.

36–65. In 1980, General Motors (GM) needed land for a new assembly plant. The cities of Detroit and Hamtramck, Michigan, offered adjoining parcels that, combined, totaled about 465 acres, and GM accepted. This land lay roughly within the perimeter of the Edsel Ford Freeway on the south, Denton Street on the north, St. Aubin Street on the east, and Mt. Elliott Street on the west. But the land was not vacant. Some 3,500 people owned or rented homes or apartments in the area. These residents, some lifelong, also attended neighborhood schools and churches and worked in and patronized the large variety of businesses and walked the sidewalks and drove the streets and tended the lawns and gardens of the area. The massive Dodge Main automobile plant, closed in 1980, occupied most of the Hamtramck section on the north. I began photographing in the area in February 1981. I recorded street scenes, intersections, panoramic views, homes, businesses, churches, and people. I watched as over the course of ten months and ninety visits and six hundred photographs it all disappeared forever. Most of my pictures were taken with a 4 × 5 Graflex Super Speed Graphic camera with one lens. When I took a picture, a dark cloth covered my head and camera. I usually made only one photograph of a particular subject.

36. Looking west along Milwaukee Avenue to Dubois Street. The home at right belonged to Andrew and Ann Giannini. Andrew owned Hupp Billiards on Chene Street (photo 46), and Ann was an active and vocal dissident of the GM project.

37. By mid-May, many of the homes along the east side of Joseph Campau Avenue between Trombly and Milwaukee had been demolished.

38–39. I climbed to the roof of the vacant eight-floor Greylawn Apartments building (built ca. 1923), at East Grand Boulevard and Chene Street, four times in 1981: twice in March and once each in May and October. I made about twenty photographs in all, looking in all directions. By October what I saw from the roof of the Greylawn was mostly patches of cleared and graded land.

40. The Milwaukee Junction area, taken from the East Grand Boulevard bridge over the Grand Trunk rail lines. In the distance, out of view, is an offshoot of these tracks that fed the Dodge Main plant. On the horizon, in the center and barely visible, is the steeple of St. Florian Church in Hamtramck, and on the right is the tower of the ACME Paint Company, formerly ACME White Lead and Color Works, founded circa 1906. The two distant smokestacks at left rise from the Chevrolet Gear and Axle plant.

41. An afternoon view west along Adele Street. Children often enjoyed becoming part of the picture, and I soon became known as "the picture man."

42. I encountered this family in the early spring while walking in the area near Dane and Elmwood Streets. Soon to vacate their home, they were loading household possessions into a U-Haul truck.

43. I was invited to an upper floor of the Dubois Apartments on East Grand Boulevard near Dubois Street to photograph this child's first birthday party. Regrettably, I could not later locate the family to give them copies of the photographs, my usual practice with many of the subjects I photographed.

44–45. Photo 44 looks west along Horton Street to Dubois Street. Photo 45 looks east from Dubois Street back along what was, a month earlier, Horton Street.

46. Hupp Billiards was a basement pool hall located on the west side of Chene Street between East Grand Boulevard and Milwaukee Avenue. It had been owned and operated by Andrew Giannini since 1954. The Giannini family home was close by on Milwaukee Avenue (photo 36).

47. For about thirty-five years, the Famous Restaurant and Bar-B-Q, owned by Carl Fisher, had been a popular stop for those living and working in Poletown. It was located on Chene Street, just north of the entrance to Hupp Billiards.

54. The long dead of Beth Olem Cemetery were spared the indignity—and desecration—of forced relocation. They lie today where they have lain for over 130 years, within the brick-wall perimeter of Beth Olem, a two-acre green-and-gray island afloat in the vast grounds of the GM Detroit-Hamtramck plant. From 1985 to 2020 the plant manufactured several types of GM vehicle, including the Cadillac Eldorado, Chevy Volt, and Chevy Impala. The plant was idled in 2020 to retool for the production of all-electric vehicles scheduled for late 2021.

55. Adele Street ran from Chene Street to St. Aubin Street on the south end of the Poletown district. The homes on the left fronted the Edsel Ford Service Drive (photo 58). At right, and barely visible, is the Dubois Street Bridge (later removed) over the freeway. On the opposite side of the freeway stands the Grand Trunk Warehouse and Cold Storage building, at East Ferry and St. Aubin Streets.

56. This was one of a diminishing number of families still living in Poletown in August 1981.

58. One of the last homes along the Edsel Ford Service Drive, west of Chene Street.

63. The two distant buildings in the center of this photograph, St. Joseph Mercy Hospital on the left and the St. Joseph Health Center and nurses' dormitory on the right, straddled East Grand Boulevard.

65. In the late fall and early winter of 1981, little remained in Poletown, so I visited the area sporadically. These six homes on the south side of Trombly Street were among the final few still standing in November. To the right of these homes is St. Stanislaus Church and the parish school, located on Medbury Street at Dubois, south of the Edsel Ford Freeway.

66. Taken from the upper floor of a parking structure, looking down to storefronts along the west side of Broadway Avenue.

Closed in 1985, the Grand Circus Theater, at right, advertised *Beatlemania* on the marquee. About five years after I took this photograph, the elevated track of the Detroit People Mover was installed here, along the center of Broadway Avenue.

68–69. These two photographs were made a few blocks west of the Warren Avenue–Commonwealth Street area, where I lived at the time. In this neighborhood, as in others I explored south of Grand River Avenue in 1982, curiosity about my camera connected me with strangers.

70–71. On the evening the Detroit Tigers won the World Series, a few friends and I walked from the Woodbridge district to Tiger Stadium via Trumbull Avenue. The initial joyous celebration somehow devolved into a violent street fight between those gathered outside the stadium and the Detroit police. Photo 71 shows an overturned Checker cab burning in the middle of Michigan Avenue.

Plate 1. On October 20, 1984, six days after the Detroit Tigers won the World Series and just over two weeks before Ronald Reagan won a decisive victory over Walter Mondale for a second term as president of the United States, over five thousand participants stood almost shoulder to shoulder along a six-mile stretch of Eight Mile Road to protest nuclear proliferation and US military policy in Central America. Organized by the Detroit Area Nuclear Weapons Freeze, the event was tagged the "Survival Line." Having chosen a spot on Eight Mile Road near Coolidge Highway, I walked west along the line and snapped thirty-six pictures (one roll of film), each taken about twenty feet apart, of whoever happened to be facing me when I stopped. I later made an 8 × 10 print of each frame, which I sequenced side by side to fashion a photographic eight-inch-high, thirty-foot-long re-creation of the Survival Line. Reproduced here are eight of those thirty-six photographs. The work was shown only once, at a Detroit Institute of Arts workshop conducted by the venerable photographer Roy DeCarava.

72–131. The Urban Interiors Project was staged on the near east side of Detroit, within the area bounded by Mack Avenue, Mt. Elliott Street, the Edsel Ford Freeway (I-94 E.), and St. Aubin Street. From October of 1987 to early 1990, I photographed individuals met through community contacts and chance meetings. John Bukowczyk and I also conducted sixty hours of oral history interviews with fifty-one residents in thirty-six households and businesses.

72–73. I met these two young men while working on the Urban Interiors Project. I spent many hours walking around the project area and subsequently met many residents. The accompanying street view shows the many small east side businesses still open along Chene Street in the late 1980s. For the first half of the twentieth century, this section of Chene Street, and beyond, was a vital Polish business district.

74. In 1981, Lillian Guyton, her seven-year-old son Andre, and her sister Nita shared this small second-floor apartment on Willis Street. Although Nita moved out in 1982, Lillian, Andre, and a new baby girl, Carllitta, stayed. The old wood-frame building had a steep, narrow stairway that led from the Willis Street entrance to the Guytons' warm, welcoming, light-suffused living room, adorned with family pictures and Lillian's "whatnots" collection. "I try to make it look like something on the inside. I go out and get little things I think I'm going to like; just things in general that make it look decent." Twenty-seven years after my visit, in 2015, Carllitta contacted me after finding her mother's name, and mine, in an online reference to the Urban Interiors Project. She told me her mother had died in 2001 and that the set of photographs I gave to Lillian had gone to relatives years ago. I gave Carllitta a duplicate set of all the pictures, and she declared me an honorary member of the Guyton family.

75–77. The Sherman-Guyton family rented a house on Weitzel Court, just off Mt. Elliott Street. In 1988, Clarence Sherman and Nita Guyton (sister to Lillian Guyton, photo 74) had

been together for seven years and parented four children. Their children attended nearby Ferry Elementary School, and Nita was working on a general education degree. Clarence had worked for the Mammoth Life and Accident Insurance Company from 1965 to 1983. His debit area included a section of Poletown that was razed for the GM plant. "Where that plant sitting right now there used to be a street named Dane, Trombly, Griffin, and Sargent. It took away all my good-paying clients and dispersed them throughout the city. GM sits on 368 acres of prime—used to be prime—debit territory that belonged to me. I figure when they paid off everybody around there the president of GM forgot me. He should have gave me some money." In 1988, Clarence was looking for work, but not as an insurance agent. "I don't want to go back in the insurance business. I had my fill of it. I want a nine-to-five job. Punch the clock, come home, sit down, relax, and go to work the next day."

78. Emery Meade, born in 1922 in West Virginia, and Helen Meade, born in 1923 in Detroit, met in 1945 while working in a plant that produced military aircraft. "Emery used to come and sit with me for lunch. I worked with him on the line, and I kept right up with him. That was a dirty, smoky place, I swear." They went to a bar on their first date. "I was buying the drinks, trying to get her drunk, and she was pouring them in a spittoon can." They married in 1947 and lived in four locations over the next forty-one years, the last (where I met them) a hundred-dollar-a-month rental home on Dubois Street. Helen worked in a chemical-processing plant from 1968 to 1985, and Emery at Dodge Main as a water sander. When I met them in 1988, Helen was working three hours a day at a bakery on Chene Street. She was diagnosed with colon cancer in the spring of 1988 and died four months later. After his wife's death, Emery moved to a boarding house in Hamtramck.

79–81. Three elements made up Jim's Gifts: the original residence; the store (added to the front of the residence); and the studio

behind the residence, where the plaster statues were poured and painted. Born in 1949, Jim Wilmoth married at eighteen, raised seven children, and then divorced. Jim made his first statue in 1972. "A friend of mine had showed me a cobra snake statue and I thought it was 'it.' I guess because I was a kid." He purchased the Chene Street property in 1973 for $2,500 and began producing statues and selling them in what he called his storefront boutique. "I used to sell pipes, papers, bamboo curtains, chimes, all that kind of stuff. First year I made $1,700. Don't ask me how I made ends meet, seven kids, making statues." In 1989, Jim lived with his girlfriend Janine Werts and his son Eric in the home behind the store. He stopped making statues in 1999, sold his Chene Street buildings, and purchased a house a block away on Hendrie Street. The Jim's Gifts buildings burned down around 2013.

82–84. The Buckhorn Inn had no exterior sign, so I did not know it was a bar until, one warm summer day, I peered through the propped-open front door. Behind the bar, amid the mounted deer heads, framed pictures, and odds and ends he had been collecting for decades, stood Walter Miller (b. 1913, Detroit), the bar's proprietor for the past forty years. During World War II, Walter parachuted over the Rhine River and fought in the Battle of the Bulge. After the war he returned to Detroit and started working at the Buckhorn, then owned by his stepfather. Located near the bustling east side Chene Street business district, the bar thrived throughout the 1950s, but business slowed in the 1960s and '70s as the neighborhood changed. "I used to have the guys from the Farm Crest Bakery [on Russell Street] come over for hamburgers, about thirty or forty at a time. In those days we had all those older people here and the neighborhood was going good because of all the shops. Finally the shops started moving away. Then the expressway [Edsel Ford Freeway] came in and that messed everything up." When I visited the Buckhorn in the late 1980s, there were usually four or five regulars at the bar, talking or watching television. "Well for me it's just something to do, instead of sitting at home and looking out the window, so might as well stay here."

The Buckhorn closed in the early 1990s, and the building burned down soon after.

85. Bonnie Woods, her six grandchildren, and her three great-grandchildren lived in a large, old, farmhouse-style clapboard home on Moran Street, just south of Forest Avenue. Bonnie's only son, Tommy Lee, was the grandchildren's father. "They [Tommy Lee and his wife] lived with me until they separated. Then she went off and left the kids." When Tommy Lee died in 1987, Bonnie raised the children. Bonnie was born in Dardanelle, Arkansas, in 1930. Her mother was a sharecropper, and Bonnie helped in the fields, along with her brothers and sister. "When we come home from school we hit the door. We didn't have a chance to study. We had to go to the field, pick cotton, chop cotton. That was hard work." By seventeen Bonnie had married, separated, moved to Detroit, and had a son. "I been in this area ten years and ain't never had a minute's problem, so I must be doing something right. I hope to live to see all my kids grow up with a job. I want to see what they doing with what I taught them."

86–88. I first saw Cicero Whitlow from my car as I drove past his St. Aubin Street home in April 1988. He was in his garden cutting furrows with a hoe and sowing corn seed. I stopped and talked with him and took a few pictures. A few weeks later he spoke of the days he used to sell his crop. "Used to come by here in cars and buy corn. I didn't know them, they didn't know me, but yet and still they see it. You want to sell me that corn? How much you want for it? Two dollar. Get out there and pull it. I used to let them get out there and pull it theyself." Mr. Whitlow was born in Tuskegee, Alabama, in 1891 and came to Detroit in 1940. He died in 1992 and is buried in Elmwood Cemetery. "I do for myself, I take care of myself. What little I cook, I cook it myself. So I just stays here, do as best I can until the old Master gets ready to take me away from this world. Ain't nothing else I can do. Nobody bothers me and I don't bother nobody and don't nobody bothers me."

89. In the late 1970s, when Kim Jones was about eight years old, she lived with her mother in an apartment building on Trombly Street near Elmwood. Kim often visited her grandmother, Mrs. Willie Dortch, who lived close by on Dubois Street, south of the Edsel Ford Freeway. "It was just usually to visit my grandmother and play with the kids in the neighborhood." Kim met the pastor of St. Stanislaus Church, near her grandmother's home. "We used to play in the church parking lot and he used to come out and we would talk to him. He was friendly and nice. Later we found out that he had died, and we went to the funeral because he was really a nice man." In 1981, because of the impending demolition of the Trombly Street apartment building, Kim came to live in her grandmother's home.

90–92. Two generations of Kulwickis preceded Joseph Jr. (b. 1928, Detroit) as proprietors of the Kulwicki Funeral Home at 4186 St. Aubin Street—his grandfather Martin, who immigrated to the United States in 1873, and his father Joseph Sr. Joseph Jr. said of Martin, "I heard he was a very stately man. Everybody that I talked to said he seemed to be brought up for this special life, and they had respect for him." From 1950 to 1952, Joseph Jr. served as a battlefield mortician in Korea. In 1957 he married Jeanette Waldowski in Detroit. The Kulwicki and Waldowski families had been acquainted since Joe and Jeanette were children. Jeanette worked at the New Era Potato Chip Company from 1950 to 1965. "I was a packer. It was a common job." Joe and Jeanette were active members of the St. Albertus Parish, just across St. Aubin Street from their home. The year 1978 saw the last funeral at the St. Aubin location. In the mid-1980s, Constance (Connie), the first of four children, began managing the family business. "Most people now ask to make arrangements with my daughter. I'm on the sidelines now. There aren't too many people who want to come here because they're afraid of the neighborhood. They prefer to use other funeral homes." The family sold the building in 2000.

93–96. Born in Indiana in 1931, Johnny Smith was orphaned as a young boy. Relatives took him to Cleveland, Ohio, at age sixteen, and he later moved on his own to Philadelphia, Pennsylvania, then to Stratford, Connecticut. Johnny said when he was a young man, "I wanted to be a cab driver with a tie. I wanted to be able to wear a tie, and I wanted to be able to drive me a cab and have a tie. I never drove a cab in my life." Johnny came to Detroit in 1977 and worked security at Cobo Hall. He later started his own small maintenance business catering to neighborhood banks. When the banks began to close in the 1980s, he switched to supermarkets. "I had different people working for me—my baby sister, my nephew, my brother-in-law." Johnny purchased a station wagon for work. "I could put the lawn mower in it and everything I needed and still have room to haul my employees." In 1982, Johnny moved to his home on Joseph Campau Avenue and soon after met Laverne Little. "She asked me for a cigarette, then she came right here, had a drink, and she's still here." In the late 1980s Johnny stayed busy doing odd jobs for neighbors and working around his house. "I got this little heart trouble now. All I do is just paint and create odd jobs, just think of something to do."

97–99. When Mae Cole was born in 1907, her father, Jesse Gibson, tilled fields near Hickory, Mississippi. He also picked cotton and corn. "You was paid by the amount of pounds [of cotton] that you picked. They weigh it. If you got two hundred pounds, you get maybe two dollar and fifty cents. No price for the corn, just a dollar and a half a day." In the winter he worked in a sawmill. Mae's mother did domestic work and had sixteen children, fourteen girls and two boys. The family moved from Hickory to Noxapater around 1916. At twenty, Mae married James Cole, thirty-one, in Louisville, Mississippi. "I never should have married that man, because our minds don't be together. Always get your equal in age and in mind and nature, then there don't have to be no separating. He was mean and quarrelsome but I learned how to subdue him, and I hung on in there." James told Mae they should go to Detroit because "it sure is pretty and you can get a job like that." They came to Detroit in 1945 with James's four children and soon had two children of their own. James got a job loading trucks for Kroger. "He was never late

'cause I'd always get up and fix his lunch and have him ready on time to get the bus." Mae did domestic daywork. "I didn't have to go back and sign up, 'cause when one woman got through with me the other one wanted me 'cause they liked my work, you see. I bought myself clothes and shoes, such things as I need to put on my back." When James died in 1986 at age ninety, he and Mae had been married for fifty-nine years.

100–102. The home of Stanley Budnick (b. 1903), not visible in photo 100, was one in a small cluster of houses located at the end of Theodore Street, a short dead-end street west off St. Aubin Street. In the 1920s, Stanley's father owned a saloon on Chene Street, and Stanley and his brother made beer deliveries in a Ford Model T with *Budnick and Sons* lettered on its doors. Stanley loved baseball and was a good ballplayer, playing for the St. Stanislaus High School team and later in city leagues. "When I was a young kid, about fifteen, I would play that Victrola, and I'd be sitting there dreaming of what a great ballplayer I'd be. I'd be a hero, be a star, and I kept turning that old crank. That's how crazy I was about baseball." Stanley made connections through baseball, which led to a thirty-seven-year career with the Wayne County Department of Treasury. In 1941 he married and moved to Theodore Street, where he remained after his wife's death in 1988.

103. I met Estelle Laster, overseer of the Soul Saving Station for Every Nation, on July 4, 1989, as she stood outside her building, American flag in one hand and Bible in the other, eager to share the Good Word with anyone willing to listen. She was born in Vredenburgh, Alabama, in 1917 and in her twenties moved to Pensacola, Florida, then to Foley, Alabama, where she began preaching. Her parents never married. "They just went to shacking. They call it a sawmill license, common law." Her mother died when Estelle was in her teens. Her father and grandfather were both deacons in the local church. Estelle later traveled to Michigan by bus with a group of migrant farm workers she met in Foley. During harvest season they picked apples and cherries near the small town of Grawn, south of Traverse City. Estelle also became the group minister. "They give me Wednesday night

for ministering. They would sing and I'd have my Bible group reading. Anybody be sick or hurt, they come to me for prayer."

104–6. Estelle, or Sister Laster, as I came to call her, settled in Detroit in the early 1970s and ran revival meetings around the city. She acquired her Moran Street building in 1974, where she lived and had a chapel but no congregation. "I did outreach work, went around in the homes, walk around to many places." She started a lunch program for neighborhood children. "I would line them up out the side there, and have prayer with them. The truck come and bring the food. Neighborhood services. Whosoever come, let him come." In 1989, I asked her what the future held for her and for her neighborhood. "I don't have no care. I don't think of what's going to be, whereas now we got a place to rest and be at peace and pray." After standing empty for over two decades, Sister Laster's former building was resurrected by a group of young people as the Yes Farm, a neighborhood community arts organization. In 2010, I exhibited a selection of photographs at the Yes Farm in the same room where I had taken them twenty years earlier.

107. John Bukowczyk first noted and suggested we add Liberty Hall, Universal Negro Improvement Association (UNIA), Division 407, at the corner of St. Aubin Street and Warren Avenue, to our list of potential Urban Interiors subjects. I subsequently made efforts to get inside the building. I knocked on the door, pressed the doorbell button, peered through the windows, photographed the building, all to no avail. Sometime later, as I walked along Chene Street, camera in hand, I was approached by a man who inquired why I was taking pictures. As I described the Urban Interiors Project, he became animated and insisted I follow him. Several minutes later and five blocks away, he inserted a key into the front door of the UNIA building and I followed him inside. It was a wonderful place, with a large meeting room and an office in back, walls covered with UNIA photographs and documents. The man's name was Layopo. He was a UNIA member, the building's caretaker, and lived in an apartment on the upper floor.

108–10. A few weeks later I photographed the UNIA officers, and John Bukowczyk interviewed Arthur Thomas (born in Stanford, Kentucky, in 1902), Division 407 president. Mr. Thomas's parents were Kentucky farmworkers, and his grandmother had been a slave. Arthur came to Detroit after a stint in the navy during the final months of World War I. "I heard talk of automobile work, so I decided to come to Detroit. I stayed in a rooming house in old Black Bottom, down around Mullet and Clinton Streets." He finished the tenth grade, worked at Briggs Manufacturing near the Dodge Main plant, and joined the UNIA. "The UNIA was having parades here in Detroit and I liked what they were doing. They were talking about freedom for the Black peoples of the world, and that was right up my alley." He married in 1922, had two children, and around 1937 began a career with the City of Detroit. "I was a plumber. That's the way I educated my children, and I retired when I was sixty-five." The Division 407 office moved from its downtown location to St. Aubin Street and Warren Avenue around 1940. The building had been a service station, and the division continued to sell gas as a revenue source. Two apartments on the upper floor were rented, and on Sundays a congregation headed by a UNIA member held services in the meeting room. Mr. Thomas was elected division president in 1977. "They chose me because I was a tradesman and I was always there when something happened at the hall. If you want it fixed, you call Thomas. So they chose me, and these twelve years I caught hell [with unending building-maintenance chores]." Mr. Thomas estimated UNIA Detroit membership at about four thousand when he first joined in 1921. By 1988 that number had dwindled to about one hundred members. The UNIA hall was demolished around 1995.

111–12. Clara Jozwiak's home stood on the northwest corner of Joseph Campau Avenue at Kirby. She and her dog Fritzie lived on the ground floor, and she rented the upper flat. Clara's parents, both born in Poland, emigrated to Detroit in the early 1900s and purchased a home on Grandy Street, where Clara was born in 1912. "My father had high hopes because we lived on Grandy. And he liked this one on the corner [of Joseph Campau, one street east of Grandy] and he wanted to buy it. My mother didn't want to but she finally agreed to buy it. We moved here around 1920, and in 1922 my father passed away when he was forty-seven." Clara attended Northeastern High School until, at age sixteen, her mother told her, "You don't need an education, the men need education. So before I knew it I worked at Johnson Optical as a messenger for ten dollars a week." Later, after a stint at Jenks & Muir, a spring and cushion manufacturer on Hastings Street near Milwaukee Avenue, Clara moved to Murray Body when they subsumed Jenks & Muir. "I got there in 1929 and worked there twenty-five years. But not steady, you know. The kind of work I did I liked to do. We used to buck the rivets together. . . . The guys called me an ace. And if it's blind bucking, you don't see it, just feel. And you take a mirror and you look in to see if they're all in a straight line. We worked on C-119s and B-17s." While at Murray Body, Clara married and had a daughter and son. After leaving Murray Body, she worked maintenance for the Detroit Board of Education, retiring in 1977. "My husband says, 'That's enough.'"

113. Edmund Thiede (b. 1947) lived on Lyman Street in Detroit until age ten. In 1957 his father moved the family less than a mile away to Ed's grandmother's house on Dubois Street, in the shadow of St. Stanislaus Church. The Thiedes belonged to the parish, where Ed attended parochial school, was an altar boy, and after graduation coached football and basketball at the school while working at Dodge Main. Ed served in Vietnam from 1967 to 1969. "Funny thing about it, I'm the one who's supposed to be in a war, and my parents and girlfriends, they're sending me pictures of the war going on right here in this neighborhood during the '67 riots. They had tanks right here in Perrien Park on Chene." Back home Ed found work at Peerless Induction on Mack Avenue and

resumed coaching at St. Stanislaus. He moved from his grandmother's home to a flat across Dubois Street. In 1972, Ed married and had two daughters, whom he raised by himself in a home he purchased in 1974 on Dubois Street, after acute pain from spinal arthritis led to the break-up of his marriage.

114–15. Ed experienced pain for the rest of his life but did his best to stay active. "I always try to find some kind of hobby to occupy myself, to get my pain off my mind." When he felt well enough, he hunted and fished (he was featured in a 1978 *Detroit News* editorial about the return of salmon fishing to the Detroit River). He learned taxidermy from books and correspondence courses and was an avid collector of small liquor bottles and beer cans, Elvis paraphernalia, and scores of personalized celebrity publicity photographs. He also played his guitar, in public when the opportunity arose.

116. Through the years Ed compiled a set of marvelous scrapbooks, lovingly preserving every family photograph, piece of correspondence, greeting card, newspaper clipping, funeral memorial card, and church notice that made up his daily life. (A photograph of Ed as a St. Stanislaus High School freshman appears in the upper left corner of the page at right.) "Terrific school, fondest memories of my life. I went from kindergarten all the way through twelfth. I made all-state in basketball, football, and track. I never drank or smoked, nothing. I was the homecoming king. I had lots of girlfriends." In 2010, I located Ed in a Southfield, Michigan, rehabilitation facility, his residence since 2007. I visited him in his small room every month or so. At his suggestion I was able to retrieve most of his scrapbooks from a home in his old Dubois Street neighborhood. When Ed died in 2012, the scrapbooks were given to his daughters.

117. Ed fought in 1973 alongside neighbors to keep St. Stanislaus High School open and again in 1989 to keep the church from closing. Both closed despite community efforts. In the 1970s and '80s neighbors and businesses alike departed the Dubois-Medbury neighborhood, but Ed remained on the street where he had lived since 1957. "Now a lot of them say, 'How can you still live there?' But deep in their hearts I think they wish they were back here. I meet people I went to school with and they say, 'Where you living now?' and I tell them I still live here. They can't believe it. They say, 'Whoa, you're still living there? How long have you been there?' I say, 'All my life.' 'In them ghettos?' They knock it and I'm defensive. I say, 'Hey, there ain't nothing wrong with it here.'"

118–20. In early July of 1989, I passed through the Medbury Street entrance of St. Stanislaus Church, following the same steps thousands of others had taken since the church first opened its doors in 1913. I thought I was alone at first but soon discovered a wedding in progress in the large sanctuary, which I observed from the choir loft, and I took a photograph (photo 118). In the church basement I found a large room with five tables placed end to end where the wedding guests would soon toast the newly married couple (photo 119). I returned a few days later to take more photographs in the church, as well as in the main entrance hall, dining room, kitchen, and office of the Dubois Street rectory. The church permanently closed soon after.

121. Winifred Stankowski (born in Poland in 1894 as Władysława Zielecki) lived alone on McDougall Street near Palmer Street. Her husband Joseph, who died in 1980, had worked for Ford and at Dodge Main, and she for Detroit Edison. "I don't speak English very good because I marry a man who was brought up in Poland and he spoke Polish and we always for sixty-three years we spoke Polish, nothing but Polish in our home." Mrs. Stankowski rented her upper flat to a young Yugoslav family. "The Polish don't want to rent here. They want to go somewhere out of the city, out of Poletown." Mrs. Stankowski died in 1997, at 103.

122. This arrangement of items was in the home of Antonina Szymczak, a seventy-year-old mother and grandmother who lived on Kirby Street between Chene and Grandy Streets. The young woman pictured in the framed photographs is her daughter, Mary Ann White, who, with her four children, lived half a block away on the corner of Grandy and Kirby Streets. Antonina also had three sons, who lived elsewhere with their families. Antonina and her husband Marion (1919–77) were born and raised in Poland. During World War II they worked in a Nazi forced labor camp in Germany, where, in 1946, Mary Ann was born. They came to America in 1949. Mary Ann said: "My father wrote a letter to his aunt, his mother's sister, and asked if she would sponsor him, which they did. We went by ship to New York, then to Detroit." They purchased their Kirby Street home in 1952. Antonina worked in a factory on Warren Avenue, separating egg whites from the yolks. "They would bring in eggs that you have to clean, then put them on an assembly line and break them, and the yolks would go one place and the whites would go someplace else. She stood in water almost halfway up her calf." Antonina spoke mostly Polish all her life. Marion worked at the Central Iron Foundry, near the Detroit River. Mary Ann married in 1972, and the couple moved into their new home on Grandy Street in 1975. They divorced in 1983.

123. Christopher and Jeffrey White, Mary Ann White's sons, playing in their grandmother's backyard on Kirby Street. I was graciously invited to several Szymczak family gatherings, including Christmas, Easter, and Jeffrey's first communion celebration.

124. Here Christopher (*left*) and Jeffrey White (*right*) and their friend Ian Kacouski (*center*) pose before the White family home on Grandy Street at Kirby. The Kacouski home, where Ian lived with his grandparents, father, and aunt, was located around the corner on Kirby Street. Tomislav Kacouski brought his family to the United States from Yugoslavia in 1972 and purchased the Kirby Street home in 1974.

125. Ray and Ann Harris (*extreme right*) lived on the second floor of a building located on the southwest corner of Dubois and Hendrie Streets. Born in 1953 in Pittsburgh, Ray came to Detroit in 1967. "At age fourteen I started working with my dad, and I was doing a man's job unloading lumber by hand out of a boxcar." Ann's mother was fifteen when Ann was born in Clarksville, Tennessee, and Ann had her first child at fifteen. She was raised by her grandparents. "They raised me as best they could. They loved me. I know they loved me, and especially my grandfather, because he spoiled me. He died in 1960, on Christmas Eve." Ann came to Detroit in 1982 and she and Ray married in 1985. Ann did housekeeping work in private homes and in a senior citizen home. As associate minister of the Seekwell Missionary Baptist Church, located near their residence, Ray conducted services and played piano and Ann taught Sunday school. The church's small congregation consisted of people from the neighborhood. "My wife and I, and Mrs. Dortch next door, we've taken it upon ourselves to go up there and clean up the church because some folks just refuse to do right."

127. In 1985, Cleo Neal (*extreme right*) moved across the street from 2277 to 2280 Frederick Street. "The guy who was living here [2280 Frederick], nice guy, was having problems and I was helping him out, you know, cooking for him, checking on him, and he told me that he would sell me the house. And him and his wife came over one morning and said they was just going to give me the house, for me being so nice to them. He had been in this house a long time and had raised their kids here." In 1989 three of Mrs. Neal's adult children, Joyce, Dennis, and Willie, lived in Detroit, and a second daughter, Ann, lived in St. Louis. Only Willie lived with his mother on Frederick Street, and both he and Dennis worked at Dan and Vi's Pizza on Chene Street near the Edsel Ford Freeway. Joyce worked as a cashier at Przybylski's, a variety store on Chene Street at Kirby. Mrs. Neal had been supervisor of housekeeping at the Westin Hotel in the Renaissance Center since 1978, a year after it opened. "I went to the Westin, down to the Renaissance Center, and I asked

them whether they were taking applications. I really didn't think they was going to hire me. The girl in personnel, whose name was Alice, told me, 'We'll get in touch with you.' The next day she called and told me be down there at two o'clock. And I've been working there ever since." Mrs. Neal was born in Tupelo, Mississippi, in 1939. In the early 1950s she worked on a farm. "We picked cotton, chopped cotton, pulled and chopped corn, baled hay. We would throw hay bales on the truck to make us some money to go out on the weekend." She moved to Detroit in 1969.

130. Adela Cieslak, in whose home this picture was taken and who, in the photograph on display, awaits a blessing from Pope John Paul II, was born in Cleveland in 1918. Her parents came to Cleveland from Poland in 1912. The family returned to Poland in 1921, where, in 1936, she married. Two years later, while six months pregnant, she returned alone to Cleveland. "My husband was not a citizen here and he can't come with me. Then the war broke out. He never came. He died in Poland in 1947. My daughter never see her father. My father pass away in Siberia." Mrs. Cieslak moved to Detroit in 1941 and worked as a seamstress, then in 1948 found employment in a GM parts factory located at Farnsworth and Riopelle Streets. "Even then I started working only forty-eight cents an hour, but I have something ahead [in the future] because that was big company." She later transferred to plants in Livonia and Ypsilanti. She retired in 1979. Mrs. Cieslak was a member of the St. Hyacinth Parish and active in several Polish Roman Catholic organizations. "I was brought up that way in Poland, to help somebody else. I helped the sisters at the orphanage because as Christians we should help one another."

132–37. I first photographed in Brush Park while walking home from downtown Detroit in the winter of 1977. Over the next forty years, by foot, bicycle, or car, I visited and photographed the district periodically. In 1994, after moving from Detroit to Dearborn, I returned to methodically photograph most of the buildings along Edmund, Alfred, Adelaide, and Winder Streets.

It seemed to me these structures might not long survive, and, as it turned out, many did not.

132. St. Patrick Catholic Church faced north on Adelaide Street, just west of John R Street. Its adjacent rectory fronted on John R Street. The church was built in 1862 and enlarged in 1872. In 1890 it was renamed the Cathedral of SS Peter and Paul and served as headquarters of the Archdiocese of Detroit but regained its original name in 1938 when the diocesan headquarters relocated. The church's weathered red brick and its elegant, slender twin spires made St. Patrick a beautiful ruin. St. Patrick closed in the early 1970s and was destroyed by fire in 1993.

133. Built in 1869, and one of Brush Park's oldest still-standing structures, the Horace S. Tarbell house has seen several attempted restorations over the years but remains empty as of 2021.

134. This half-block-long 1890s townhouse faced the St. Patrick rectory on John R Street just south of Adelaide. The building was renovated and fitted with condominiums in 2003.

135. This view looks west along Alfred Street from Beaubien Street to the intersection of Brush Street. All buildings up to and including the corner market are gone. From Brush to John R, four original Alfred Street homes remain today. The Masonic Temple, at Temple Street between Second and Cass Avenues, is visible above the roofline of the homes along Alfred Street.

136. This 1887 home was built for John Harvey (1840–1905), a Glasgow-born, University of Michigan–educated pharmaceutical magnate and philanthropist. After Harvey's death, his wife Jessie Harvey (née Campbell) lived here until the sale of the home in the 1920s. In the late 1930s the home became a boarding house. After standing empty or near empty for many years, the home was purchased in the 1980s and, following extensive renovation, opened in 2005 as the Inn at 97 Winder.

142–45. In 1997 a few friends, also blues devotees, suggested I tag along as they toured local venues to see and hear both the older generation of blues masters, born in the 1920s and '30s, and their younger musical successors. Our first stop was Sisko's on the Boulevard, in Taylor, Michigan, to see Monster Mike Welch, then a sixteen-year-old blues phenom, from Austin, Texas. On subsequent weekend evenings we hit the Soup Kitchen Saloon, where Willie D. Warren performed, and the Attic Bar in Hamtramck, twenty-year home base for Uncle Jessie White and the 29th Street Band. George "Wild Child" Butler and the Butler Twins, Clarence and Curtis, also played at the Attic Bar. In all we caught some sixteen acts, all familiar names to blues fans: Big Daddy Kinsey with Nate Armstrong on harmonica, Larry McCray, Robert Jones, Son Seals, Junior Wells, Tinsley Ellis, Blyther Smith, Lucky Peterson, and more.

146–51. The annual Concert of Colors, founded by Ismael Ahmed, is a free diversity-themed music festival first staged as a one-day event at Detroit's Chene Park in 1993. In 2005 the festival moved to the Max M. and Marjorie S. Fisher Music Center. Today the Concert of Colors spans nine days and four midtown venues. I photographed numerous Concert of Colors performers from 1995 to 2016.

152–59. The Zone Coffee House opened in 1994 and quickly became the popular Dearborn gathering spot for the local late-teen set. The location had housed several bars over many years, and the original large, long bar still ran the length of the room. The twenty-one-year-old owner of the Zone, along with his helpers, served a selection of coffee drinks, sodas, and light snacks. Wednesday was open mic night, when novice poets recited and bands or solo musicians performed. Artistic clients also displayed their work on the walls. Cigarettes, acquired elsewhere, were a common accessory of the young clientele. The Zone closed in early 1998.

160. Each spring since 1952 the City of Dearborn, together with Dearborn schools, has staged Clean-Up Parades throughout the city. Sporting handmade costumes and signs, students march through their school's neighborhood to encourage resident onlookers to "clean up, paint up, and fix up" their properties. As Dearborn city photographer for twenty years, I photographed many of these parades.

Publication of Work by Bruce Harkness

2021

Hedberg, Tim, dir. *Taking Poletown: A Community's Fight Over Economic Justice and Eminent Domain.* Motivo Media and FedSoc Films, June 10, 2021. https://www.youtube.com/watch?v=OaoessbpIIc. [A film examining the issue of eminent domain as it pertains to the Detroit-Hamtramck Poletown plant.]

Turczynski, Brianne. *Detroit's Lost Poletown: The Little Neighborhood That Touched a Nation.* Charleston, SC: History Press, 2021.

2018

"Art in Dearborn, Bruce Harkness Photo Gallery Exhibit." Video interview. City of Dearborn Television (CDTV). Aired throughout May 2018.

"Remembering Poletown." Produced by John Ciolino. WXYZ-TV Detroit, November 29, 2018. https://www.youtube.com/watch?v=8Is3BoqVisw. [A video profile featuring an interview with Bruce Harkness and samples of his Poletown photographs.]

Valdez, Ralph. "Library Features Work of Former City Photographer." *Press & Guide* (Dearborn, MI), May 20, 2018, 2.

2017

"The Bruce Harkness Photographs." *Newsletter, Walter P. Reuther Library Archives of Labor and Urban Affairs and University Archives* 21 (Fall 2017). http://reuther.wayne.edu/files/Reuther_Newsletter_2017.pdf.

Jackman, Michael. "Scenes from Yesterday's Detroit Appear in Hamtramck Photo Exhibit." *Detroit Metro Times,* February 17, 2017. https://www.metrotimes.com/the-scene/archives/2017/02/17/scenes-from-yesterdays-detroit-appear-in-hamtramck-photo-exhibit.

"Lecture: Eight Decades of Photographs of Dearborn City Hall." *Press & Guide* (Dearborn, MI), April 30, 2017, 6-A.

O'Kray, L. Glenn, and Bruce Harkness. *Before Fair Lane: Historic Houses from Henry Ford's Hometown, Dearborn Michigan (1832–1916).* Dearborn, MI: Museum Guild of Dearborn, 2017.

Svoboda, Sandra. "Taking a Chance on Photography." WDET.org, February 17, 2017. https://wdet.org/posts/2017/02/17/84725-taking-a-chance-on-photography/.

2016

"Exhibit Announcement: Bruce Harkness Poletown Photographs." *Public Relations Team Blog,* Walter P. Reuther Library, Wayne State University, December 7, 2016. http://reuther.wayne.edu/node/13609.

Jackman, Michael. "The Old Cass Corridor on Display in Ferndale." *Detroit Metro Times,* August 17, 2016. https://www.metrotimes.com /the-scene/archives/2016/08/17/the-old-cass-corridor-on-display -in-ferndale.

2015

DeVriendt, Erika. "Cardiovista: Detroit Street Photography Focuses the Lens on the Heartbeat of the City." *Daily Detroit,* January 14, 2015. http://www.dailydetroit.com/2015/01/14/cardiovista-detroit -street-photography-focuses-lens-heartbeat-city/#:~:text=%E2%80 %9CCardiovista%3A%20Detroit%20Street%20Photography%E2 %80%9D,The%20Heartbeat%20Of%20The%20City&text=For %20many%20years%2C%20architects%2C%20philosophers,and %20veins%20as%20do%20humans.

Jackman, Michael. "Looking at Poletown, Three Decades Later." *Detroit Metro Times,* July 20, 2015. https://www.metrotimes.com /the-scene/archives/2015/07/20/looking-at-poletown-three -decades-later.

Joseph, Gina. "Poletown 1981 Exhibit Brings Life to a City That's Been Gone for 30 Years." *Macomb Daily,* August 7, 2015.

Koppitz, Chene. "New Art Exhibit Shines Light on Detroit's LGBT History." PrideSource.com, January 8, 2015. https://pridesource .com/article/69679-2/.

Rottner, Nadja, ed. *Cardiovista: Detroit Street Photography.* Dearborn: University of Michigan-Dearborn Fine Arts. Published in conjunction with an exhibit of same name, organized by Nadja Rottner.

2013

O'Keefe, Peter, ed. *A Brief Peculiar History of Detroit.* Self-published, 2013. [Book features artwork by five Detroit artists.]

2010

Campbell, Eric T. "Detroit's East Side: Then and Now." *Michigan Citizen,* May 2–8, 2010, 1, 8, 14.

Jackman, Michael. "Just Say Yes." *Detroit Metro Times,* May 5, 2010. https://www.metrotimes.com/detroit/just-say-yes/Content?oid= 2197348. [Article about Yes Farm exhibit in Detroit.]

Kossik, John. *63 Alfred Street: Where Capitalism Failed.* Self-published, 2010.

2004

Clemens, Elizabeth. "The Bruce Harkness Poletown Collection." *Walter P. Reuther Library Newsletter* (Fall 2004): 5.

2000

Abraham, Nabeel, and Andrew Shryock. *Arab Detroit: From Margin to Mainstream.* Detroit: Wayne State University Press, 2000.

Kata, Lauren. "The Bruce L. Harkness Poletown Collection." *Walter P. Reuther Library Newsletter* (Fall 2000): 5.

1999

Johnson, Lois, and Margaret Thomas. *Detroit's Eastern Market: A Farmers Market Shopping and Cooking Guide.* Dexter, MI: Johnson Book Print & Binding, 1999. [Later editions published by Painted Turtle (2005) and Wayne State University Press (2016).]

1997

Brochure cover photo for "Arab Americans," 22nd Annual Symposium of the Center for Contemporary Arab Studies, Georgetown University, Washington, DC, April 3–4, 1997.

1996

Faires, Nora, with photographs by Bruce Harkness. "What Is a Community? Taking Documentary Photographs of Urban Americans into the Middle School Classroom." *OAH Magazine of History* 10, no. 4 (Summer 1996): 73–78.

Walbridge, Linda S. *Without Forgetting the Imam: Lebanese Shi'ism in an American Community.* Detroit: Wayne State University Press, 1996.

1995

Craig, Gerry. "Outer Bounds." In "Gender Issue[s]," special issue of the *Michigan Photography Journal* 7 (1995): 5. [Publication of the Michigan Friends of Photography.]

Faires, Nora. *Teachers Guide: Reinforcing Community Values: A Middle School Enrichment and Training Program*, edited by John J. Bukowczyk, photographs by Bruce Harkness. Flint: University of Michigan-Flint, 1995.

"Strengthening Community through Research." *Link: The Newsletter of the Project for Urban and Regional Affairs, The University of Michigan-Dearborn* 7, no. 2 (Fall 1995): 1.

1994

Faires, Nora, and John J. Bukowczyk, with photographs by Bruce Harkness. "The American Family and the Little Red Schoolhouse: Historians, Class, and the Problem of Curricular Diversity." *Prospects: An Annual of American Cultural Studies* 19 (Fall 1994): 24–74.

1992

Junior Leagues of Michigan. *Focus on Michigan Families: Resource Guide.* 1992. [Cover photo.]

1990

Crombie, Kathleen Bordo. "Photo Exhibit among Best Around." *Dearborn Press and Guide* (Dearborn, MI), August 9, 1990, 15-A.

Faires, Nora. *Teachers Guide: The Families of the City—a Project in the Schools*, edited by John J. Bukowczyk, photographs by Bruce Harkness. Detroit: History Department, Wayne State University, 1990.

"Opening at the City Gallery: Photos by Bruce Harkness." *Dearborn Press and Guide* (Dearborn, MI), July 12, 1990, 7-C.

"A Photographic Exhibition of Urban Interiors at City Gallery." *Dearborn Times Herald* (Dearborn, MI), July 17, 1990, 10-A.

Was, Elizabeth. "Spotlight on Bruce Harkness." *Dearborn Press and Guide* (Dearborn, MI), August 2, 1990, 7-B, 8-B.

1989

Aikenhead, D., and R. DeSloover, ed. *URBANology: Artists View Urban Experience.* Detroit: Dart Press, 1989. [Exhibition catalog. See page 86.]

Barron, John. "Urbanology." *Detroit Monthly*, June 1989.

Carducci, Vincent A. Review of Urban Interiors Project. *Artforum International*, December 1989.

"Cass Corridor" and "Poletown" sections of *Detroit Images: Photographs of the Renaissance City*, edited by J. Bukowczyk and D. Aikenhead, 81–94, 107–20. Detroit: Wayne State University Press, 1989.

Christian, Nichole M. "Photos Unveil Domestic Detroit." *South End* (Detroit), September 8, 1989, 1, 4.

"Portraits of Poletown." *Dearborn Press and Guide*, September 14, 1989, 12-A. [Photographic essay on Urban Interiors Project.]

Sercombe, Charles. "Historian Takes a Peek Inside Eastside Homes." *The Citizen* (Hamtramck, MI), September 28, 1989, 1.

"'Urban Interiors.'" *Polish Daily News*, English edition, August 30, 1989.

"'Urban Interiors' Exhibit." *University Libraries Newsletter* (Wayne State University) 21 (Fall 1989): 1–2.

"'Urban Interiors' Focuses on East Side Neighborhood." *The Monitor* (Detroit), September 7, 1989, 5.

"'Urban Interiors' Photo Exhibit Comes to Campus." *Inside Wayne State* (Detroit), August 31, 1989, 2.

"Urban Snapshots Plus." *Detroit Metro Times*, October 4–10, 1989.

"WSU's 'Urban Interiors' Photo-Exhibit Opens." *Michigan Chronicle*, September 9, 1989, 1-C.

1988

"Inside the East Side: 'Urban Interiors' Project Documents an Old Detroit Neighborhood." *Wayne State: The Alumni Magazine of Wayne State University* 2 (Fall 1988): 20–25.

1986

Slowinski, Dolores S. "Detroit: Sourcebook of Images in Twentieth-Century Art." *Michigan Quarterly Review* 25, no. 2 (Spring 1986): fig. 12.

1984

"Design in America: The Cranbrook Vision, 1925–1950." *Cranbrook Quarterly* 9, no. 3 (February 1984): 13. [Photographs taken of the exhibition at the Detroit Institute of Arts.]

"The Smallest Show on Earth." *Detroit News*, September 17, 1984, 8-E. [Back-page photo story.]

1983

"Down on the Farm." *Detroit News*, December 21, 1983, 12-D. [Back-page photo story.]

1979

"The University Art Galleries, Wright State University, Dayton, May 7th–May 24th: National Endowment for the Arts Ohio Arts Council Fellowship Recipients Exhibition." *Dialogue*, May–June 1979. [Publication of the Akron Arts Institute.]

1978

"3154 Third Street." *Detroit* (Sunday supplement to the *Detroit Free Press*), November 12, 1978, 22–23, 26–27, 30–31. [Photographs and story of a decaying Cass Corridor apartment, collected over a two-year period.]

"At Work: Impersonating Females." *Detroit*, July 9, 1978, 113. [Profile and photographs of Lisette Cristal, Gold Dollar Show Bar performer.]

Catalog for National Endowment for the Arts regional fellowship recipients, through Wright State University, Dayton, Ohio. Quotation and five photographs reproduced.

Works in Progress. Detroit: Detroit Institute of Arts, 1978. [Exhibition catalog.]